Extinct & Endangered

Extinct & Endangered

INSECTS IN PERIL

PHOTOGRAPHS BY LEVON BISS

From the collections of the

AMERICAN MUSEUM OF NATURAL HISTORY

Foreword by

DAVID A. GRIMALDI

ABRAMS, NEW YORK

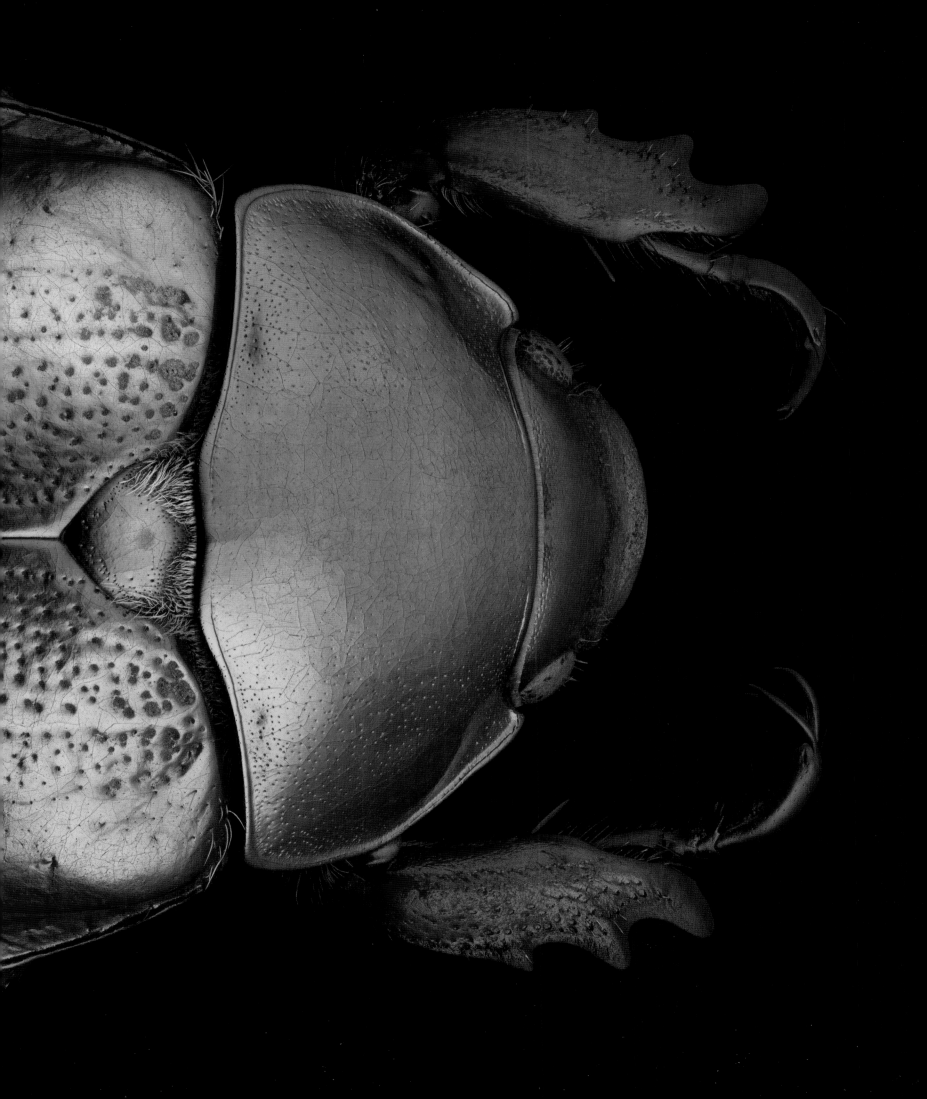

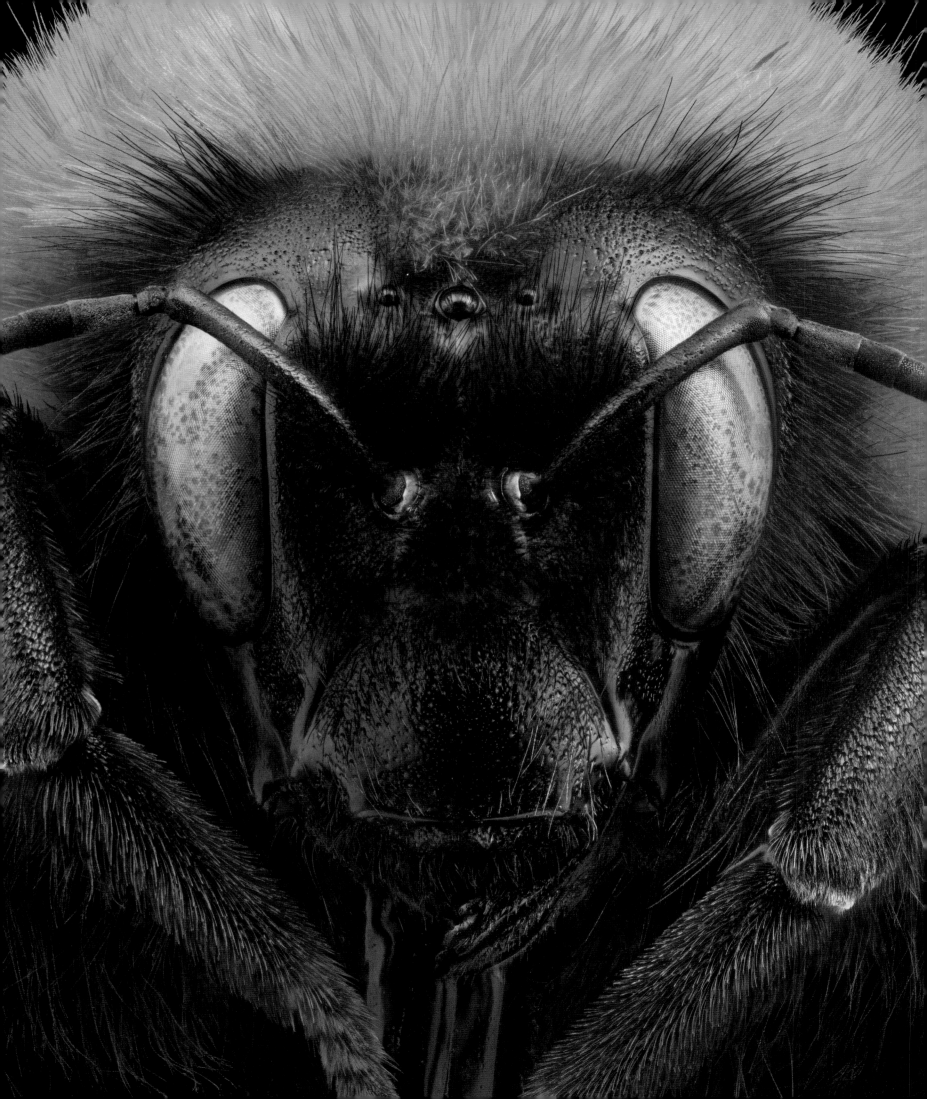

Contents

INSECTS IN PERIL
David A. Grimaldi 7

Nevares Spring naucorid bug 13
Monarch butterfly 14
Hourglass drone fly 18
Raspa silkmoth 20
Ninespotted lady beetle 24
Xerces blue butterfly 26
Northern bush katydid 31
Alpine longhorn beetle 32
Florida least spurthroat grasshopper 35
Yellow-edged pygarctia moth 38
Christmas beetle 42
Apacha sweat bee 44
Seventeen-year cicada 46
Giant Patagonian bumblebee 50
Cousin tiger moth 52
Elderberry longhorn beetle 54
Louisiana eyed-silkmoth 58
Lesser wasp moth 60
Blue calamintha bee 64
Johnson's waterfall ground beetle 68
Thick-horned plant bug 70
European hornet 72
Puritan tiger beetle 76
Shining Amazon ant 79
Mount Hermon June beetle 82
San Joaquin Valley flower-loving fly 86
Coral Pink Sand Dunes tiger beetle 90
Florida dark cuckoo bee 94
Sabertooth longhorn beetle 96
Phaeton primrose sphinx moth 100
Hawaiian hammerheaded fruit fly 104
Stygian shadowdragon 108
Esperanza swallowtail 112
Lord Howe Island stick insect 116
Aralia shield bug 120
Luzon peacock swallowtail 122
American burying beetle 126
Madeiran large white 130
Madeira brimstone 132
Rocky Mountain locust 136

Acknowledgments 141
Annotated Index of Insects 142

Insects in Peril

DAVID A. GRIMALDI

t is often said that the reality of war is known only to those for whom it is up close and personal. Humans of course have constantly been at war with ourselves, but also against nature. In both conflicts the vanquished include legions of the obscure, as invisible in death as they were in life.

Here, photographer Levon Biss makes brilliantly visible some of the obscure victims in the assault on nature, the insects. Everyone knows what pandas and whales look like, but behold: the giant Patagonian bumblebee, *Bombus dahlbomii* (page 50), also called "the flying mouse," the largest bumblebee in the world; the puritan tiger beetle, *Cicindela puritana* (page 76), ironically named for the pious New England settlers and its predatory stealth; the Hawaiian hammerheaded fruit fly, *Idiomyia heteroneura* (page 104), probably the most distinctive among the hundreds of native fruit flies in this archipelago. These and thirty-seven other species are a selection of insects from the collections of the American Museum of Natural History that are vulnerable, threatened, endangered, imperiled, critically imperiled, and even extinct, according to the official designations used for conservation.

One reason insects are so obscure to us, of course, is their size. Biss brings great clarity. His extraordinary photos capture the intricate microscapes of insects—the eye facets, fine hairs, punctures, mouthparts, wing veins, minutely latticed scales, and sensory structures. This infinite detail beguiled me as a student, peering through a microscope, and it still does. "Size means nothing," according to Sir Martin Rees, Astronomer Royal of the United Kingdom, "an insect is more complex than a star." Indeed. Among scientists, complexity can become an obsession, one to which entomologists are especially prone. In our fervor to discover, describe, and name the millions of species of insects before many are lost, entomologists are ridiculously outnumbered. "So many species," a recently late colleague of mine used to say, "and so little time."

Vertebrates are far better monitored and protected than most insects, a consequence of the fact that for most people insects are not just simply unknown but seriously misunderstood. I commonly hear—in reference to roaches, mosquitoes, bedbugs, and the like—that "insects will outlive us!" While the few human commensals may indeed outlive us, please don't equate those with 99.99 percent of all other insects. (I never hear that, with all the rats, mice, pigeons, and starlings, the world's mammals and birds will be just fine.) To a scientist concerned for all of nature, this focus on large animals is myopic, since insects are far more important ecologically just by virtue of pollination, let alone all the other ecosystem services they provide, as well as being beautiful. Insects were also the first

TITLE-PAGE SPREAD: Christmas beetle (see page 42).
PREVIOUS SPREAD: Giant Patagonian bumblebee (see page 50).
OPPOSITE: Louisiana eyed-silkmoth (see page 58).

animals to fly (100 million years before pterosaurs), the first to live in complex societies, the first gardeners, and it was their early partnership with plants that probably allowed for the flowering of the world. Take away the world's mammals and the planet would not look much different; take away just the bees and other insect pollinators, the ants and termites, and life on land could collapse.

The monarch butterfly, *Danaus plexippus* (page 14), North America's favorite and most recognizable insect, has been steadily declining for decades but is still not officially protected. Monarchs are carefully monitored at their wintering roosts in Mexico (for the eastern population) and in California (for the western population). Both populations have plunged. But in November 2020 a court ruled that the western population can't be protected because the California Endangered Species Act doesn't include insects. And the U.S. government determined in 2020 that, while the monarch overall "qualifies" for protection under the federal Endangered Species Act, *actual* protection is "precluded at this time by higher priority actions."

Meanwhile, as California continues to dry out and be consumed by fires, the western monarch is perilously close to extinction, despite its celebrity. This is ominous for the many obscure plants and animals endemic to California, like the cousin tiger moth, *Lophocampa sobrina* (page 52); the Mount Hermon June beetle, *Polyphylla barbata* (page 82); and the San Joaquin Valley flower-loving fly, *Rhaphiomidas trochilus* (page 86). Australia is in a similar predicament. Island biotas are even more fragile but for different reasons. Species on islands, like the Lord Howe Island stick insect, *Dryococelus australis* (page 116), which succumbed to introduced rats, mongoose, and insect species, lose their defensive and competitive abilities. The Hawaiian Islands, home to thousands of species living only there, have been called "Extinction Central."

The world was awakened by two major studies on insect populations in Germany published in 2017 and 2019. These reported an alarming decline over several decades of 70–80 percent in the number of insect individuals overall and about 30 percent in the number of species. It quickly became the "Insect Apocalypse." Severe declines have also been documented from Puerto Rico to Greenland, and numerous studies on most continents are underway. They are quantifying and verifying what naturalists have been observing for a long time: Where are all the insects? In meadows, at the porch light, on the car windshield, anywhere?

Insecticides, habitat loss, and climate change are leading the offensive against insects, but the compounded causes of decline make their relative effects very difficult to tease apart. On the coasts of the U.S., the Atlantic Forest of Brazil, and the vast plains of India, for example, habitat loss is profound, but these areas are also flooded with biocides and artificial light (myriad insects are attracted to lights at night, not just moths). Reasons for the decline of some species are simply perplexing. The American burying beetle, *Nicrophorus americanus* (page 126), a large, distinctive beetle that was once widespread throughout the eastern half of North America, has gone through a mysterious disappearing act over

the last century. Likewise, causes are murky for the significant decline in Europe of the striking European hornet, *Vespa crabro* (page 72), although it is doing well in eastern North America where it has been introduced. Then there are the unintended consequences: In an effort to improve crop yields, European bumblebees were introduced to Chile, along with a pathogen that is sickening the rust-furred giant Patagonian bumblebee.

Insecticides have more pervasive effects than had previously been thought. This is primarily because the current darlings of industrial agriculture and suburban lawn lovers are the neurotoxic neonicotinoids, some seven-thousand times more toxic to insects than DDT, which persist in the environment. These have been identified as a main reason for the loss of pollinators, which is why neonicotinoids have been banned in some countries, though not in the U.S. Add to this the widespread use of herbicides and fungicides (which can also sicken insects), and insects stand little chance.

Whether or not insects are sickened by biocides or their numbers squeezed by habitat loss, other stresses may finish them off, heat and drought from human-caused climate change being the most ominous. According to the 2021 report of the Intergovernmental Panel on Climate Change, the evidence for human-caused climate change is "unequivocal" and the change is upon us. As temperatures rise and heat waves are more intense, droughts are longer and more severe, which culls populations of plants, insects, and birds. Species whose ranges have shrunken to a tiny refugium, like the pollinating San Joaquin Valley flower-loving fly, are then easily snuffed out by a wildfire, a major storm, or a housing complex.

Earth has undergone mass extinctions five times in the history of life. Whether the triggering event in each case was meteorite impacts or massive volcanic eruptions, abrupt changes to Earth's climate and geochemistry, such as ocean acidification, were the ultimate causes for the extinctions. As a paleontologist as well as an entomologist I can say it's clarion we are in a mass extinction, on a scale not seen for insects and other life since the big one at the end of the Permian about 250 million years ago. Insects were not decimated like now even at the end of the Cretaceous 66 million years ago, when the non-avian dinosaurs, ammonites, and other groups died out. Some of my colleagues estimate that post-human extinction rates may be as high as one-thousand times the pre-human rates. "Extinction" can be a misnomer, though. Over steady periods of evolutionary time, when a species disappears in the geological record the fossils can be seen to bud or morph into several new species. However, evolutionarily, human-caused extinctions are, always and utterly, a dead end.

Conservation begins with knowledge, like any legislation should. We are able to monitor historical changes in plants, insects, and other animals using unique archives of data going back well more than a century, in the form of museum collections and herbaria. All the specimens in this book were selected from the 20-million insects in the American Museum of Natural History, including specimens of four species donated from breeding programs (pages 24, 104, 116, and 126). But, some may ask, haven't museums contributed to

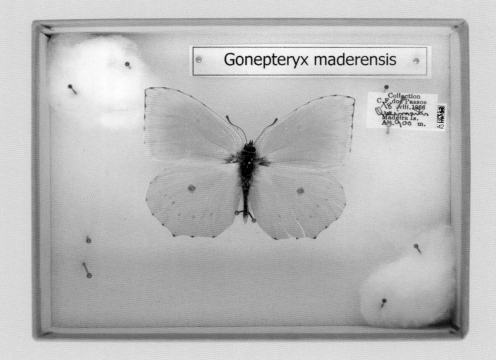

The pinned specimen of the Madeira brimstone, *Gonepteryx maderensis*, from the research collections of the American Museum of Natural History, that Levon Biss photographed to produce the images on pages 132–135. The label indicates that the butterfly was collected by Cyril F. dos Passos, who was a cousin of the author John Dos Passos, on Madeira Island in 1966, more than fifty years ago. The specimen is shown at actual size.

the demise of these species? Actually, it's quite the opposite: Museum collections are made judiciously and they, along with the extensive scientific research on them, are absolutely necessary for the protection of species. Every time a new species or subspecies is named, a typical specimen (called the "type") needs to be deposited in a museum.

Ambiguities about species status are settled by study of the type and other museum specimens, which is the first step toward determining legal protection. Museums house the gold standards that *define* each of the world's species. In 2021, for example, entomologists from Cornell and Harvard studied DNA from a ninety-year-old museum specimen of the extinct Xerces blue butterfly, *Glaucopsyche xerces* (page 26), thought for a long time to possibly be just a highly variable subspecies of *Glaucopsyche lygdamus*. Genetically, the Xerces blue was confirmed as a distinct species. While it's far too late to use this information to protect the blue's former habitat (now occupied by the city of San Francisco), or the species, the discovery shows how learning anything new about rare and extinct species requires a museum specimen.

To stanch the sixth extinction, the world needs to wean itself off carbon and biocides, develop better models of agribusiness, control invasive species, and preserve wild and other natural areas. Some are now advocating that one-third of Earth be preserved for wild areas; E.O. Wilson famously called for humans to relinquish half of Earth. Scientifically, we know how to end our unilateral war on nature; political resolve is required. In that regard, people need to *care*. We can begin by getting up close and personal with the legions of the obscure, "all the little things" that, as Wilson said, "run the world."

OPPOSITE: Nevares Spring naucorid bug (see overleaf).

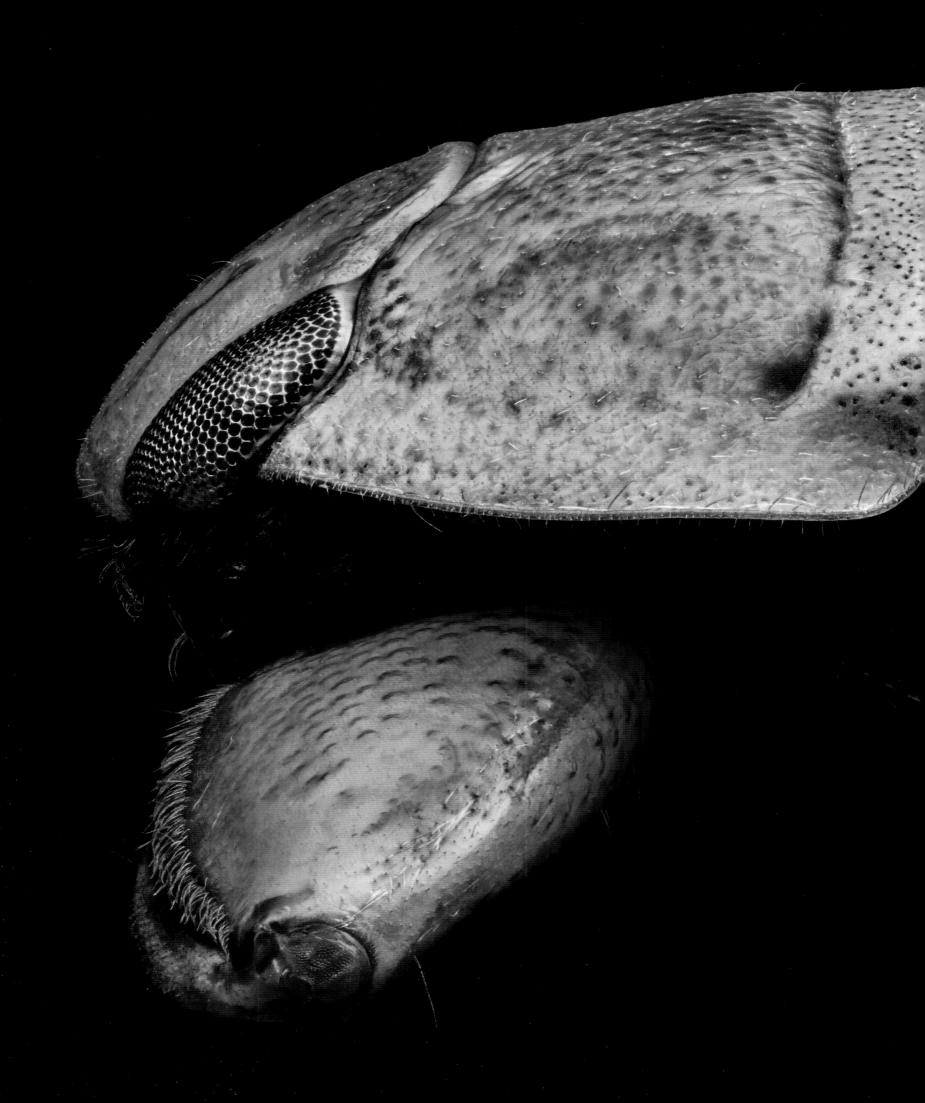

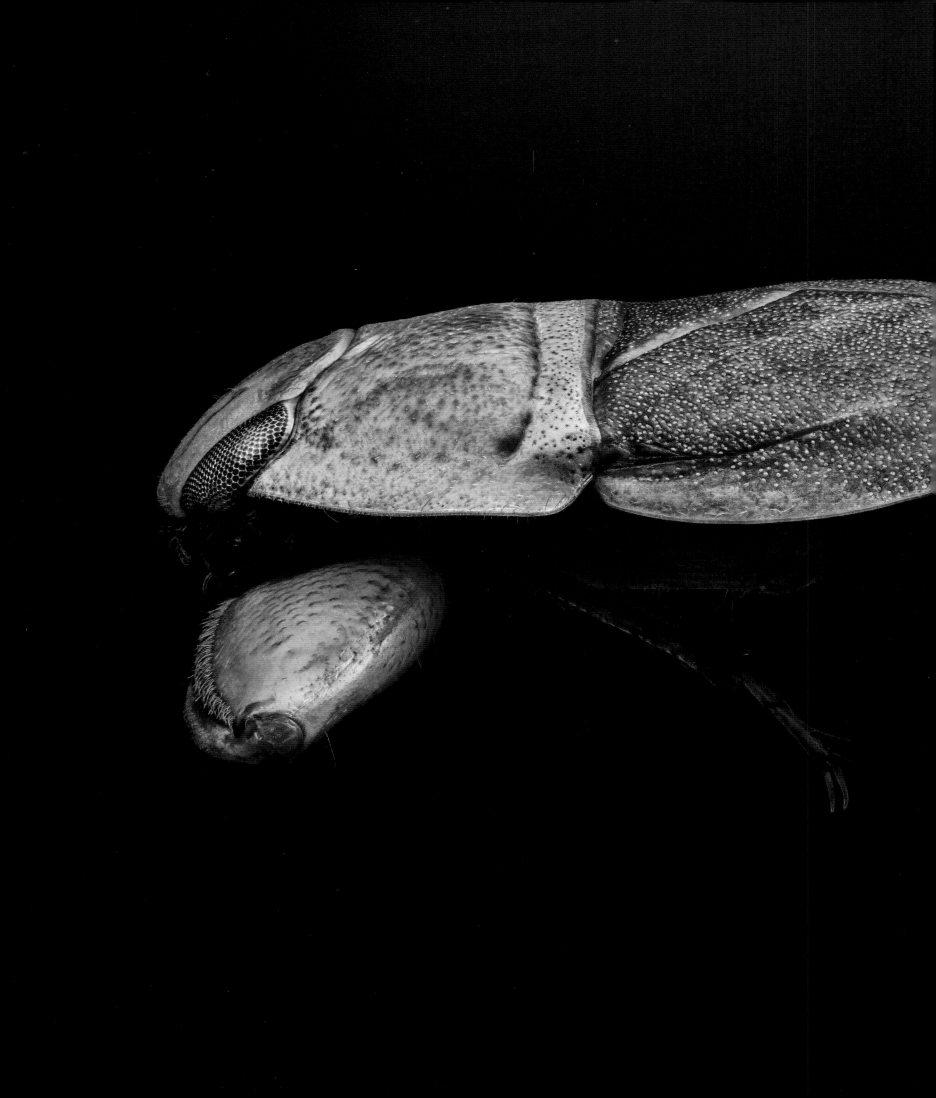

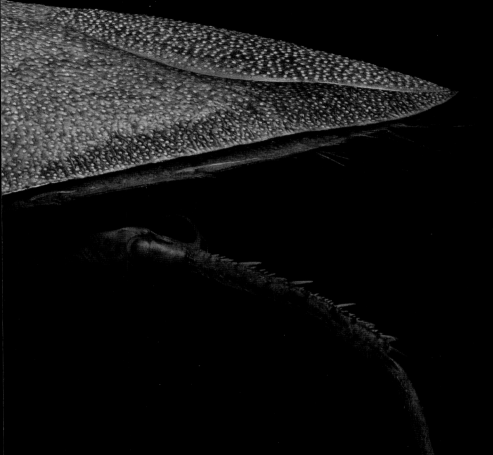

NEVARES SPRING NAUCORID BUG
Ambrysus funebris

Tucked under this bug's head is a piercing proboscis, used to suck out body fluids from the animals it feeds upon. And jutting out from underneath its thorax is a powerful foreleg, used to grasp insects, mollusks, and other prey in the stream riffles where it lives.

Most members of this insect family, the Naucoridae, come from tropical or subtropical Africa, Asia, and Australia, but some live in fresh water in temperate areas. This imperiled species spends its life in a series of streams flowing from a single thermal spring in California's Death Valley National Park. Over the years, people have diverted this water for irrigation and housing, putting these insects under pressure. If their streams are depleted enough, these water bugs, which are flightless, will have a very difficult time finding a new home.

MONARCH BUTTERFLY
Danaus plexippus

A number of insect species migrate long distances, but monarch butterflies stand out for their epic North American migrations. Each spring and fall, monarchs travel thousands of miles to and from their winter roosts. A western population overwinters in California and travels inland in warmer months. An eastern population flies from Mexico to Canada and back again. It takes the butterflies several generations to complete the journey—they reproduce along the way, and a new group continues on. But even a portion of the trip is serious mileage for a flying insect that weighs as little as a paper clip.

Before the year 2000, hundreds of millions of eastern monarch butterflies overwintered in central Mexico each year; at least four million western monarch butterflies did so in California. But since then, numbers in both populations have fallen dramatically; though they fluctuate from year to year, a downward trend is clear. The reasons are many: Monarch caterpillars eat only milkweed plants, but these are being plowed under or sprayed with herbicide. Insecticides also play a role in declines, as does illegal logging near the butterflies' roosts in Mexico and development in California near overwintering sites. But people all over North America are stepping up to plant native milkweed and nectar plants, and government agencies in Canada, Mexico, and the U.S. are working to protect overwintering sites and to restore breeding habitat.

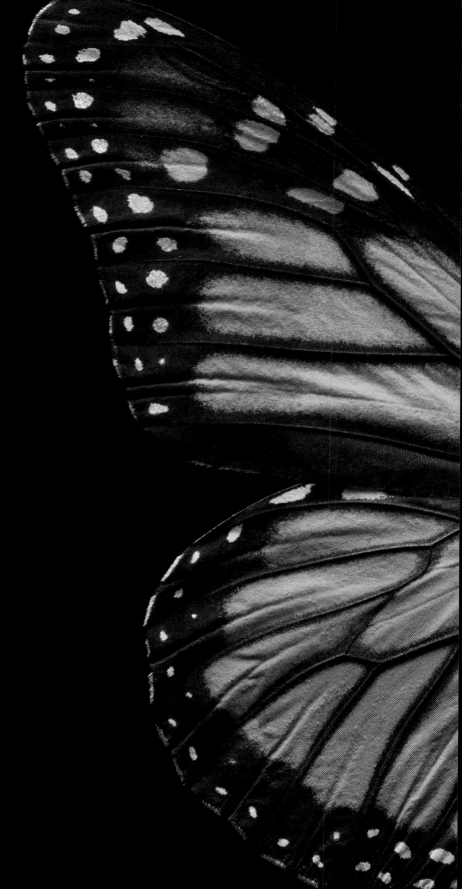

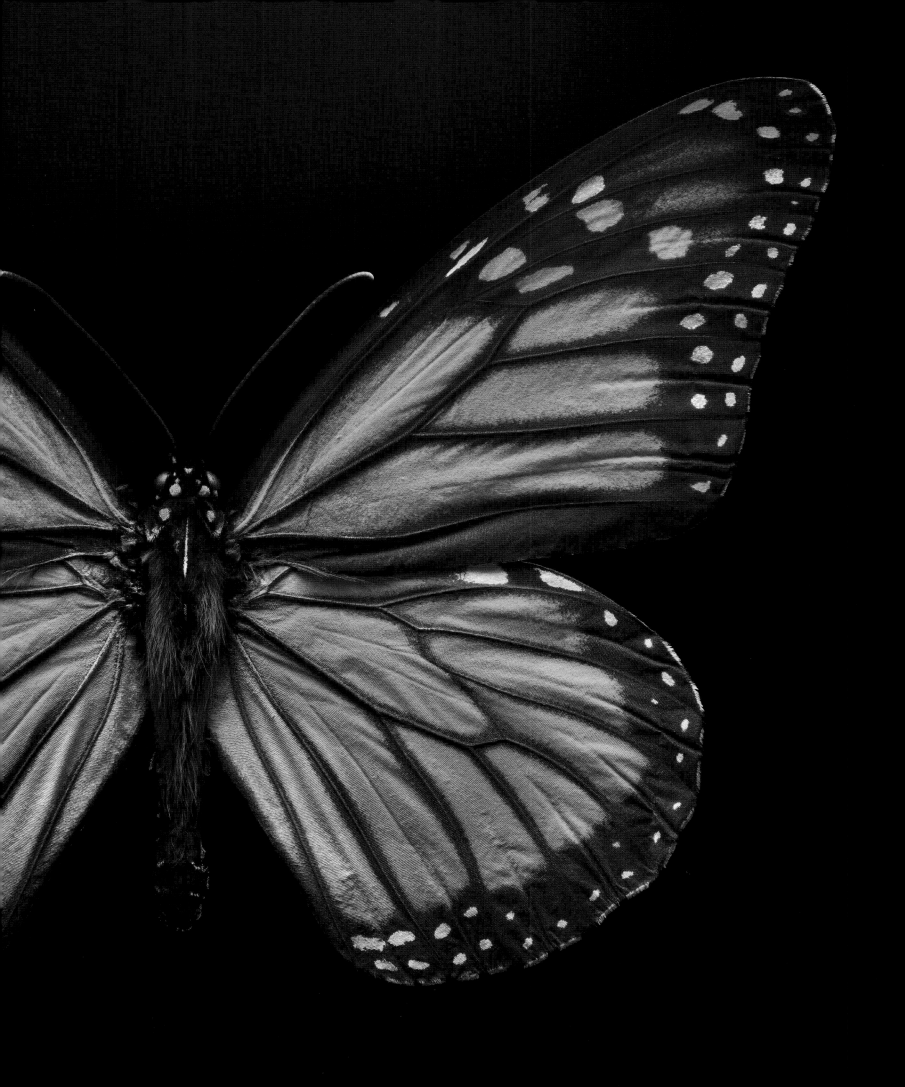

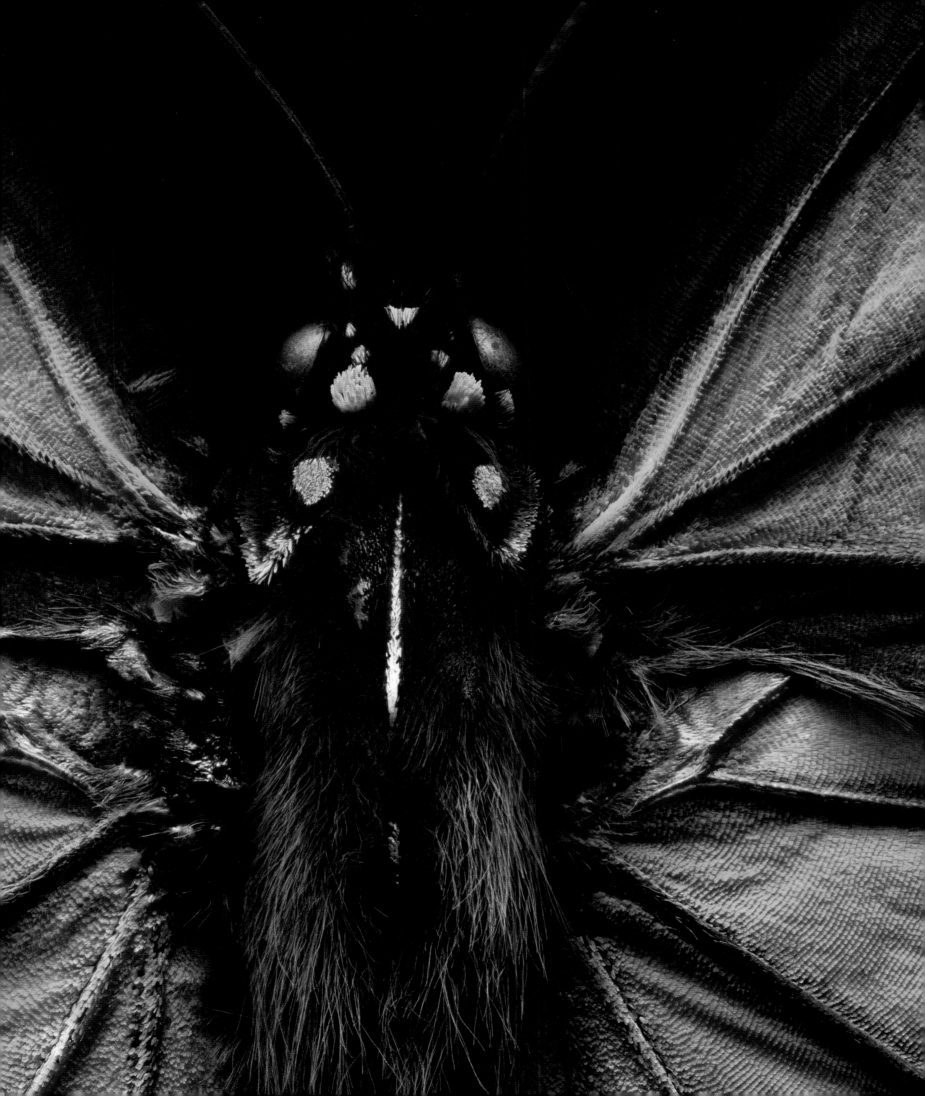

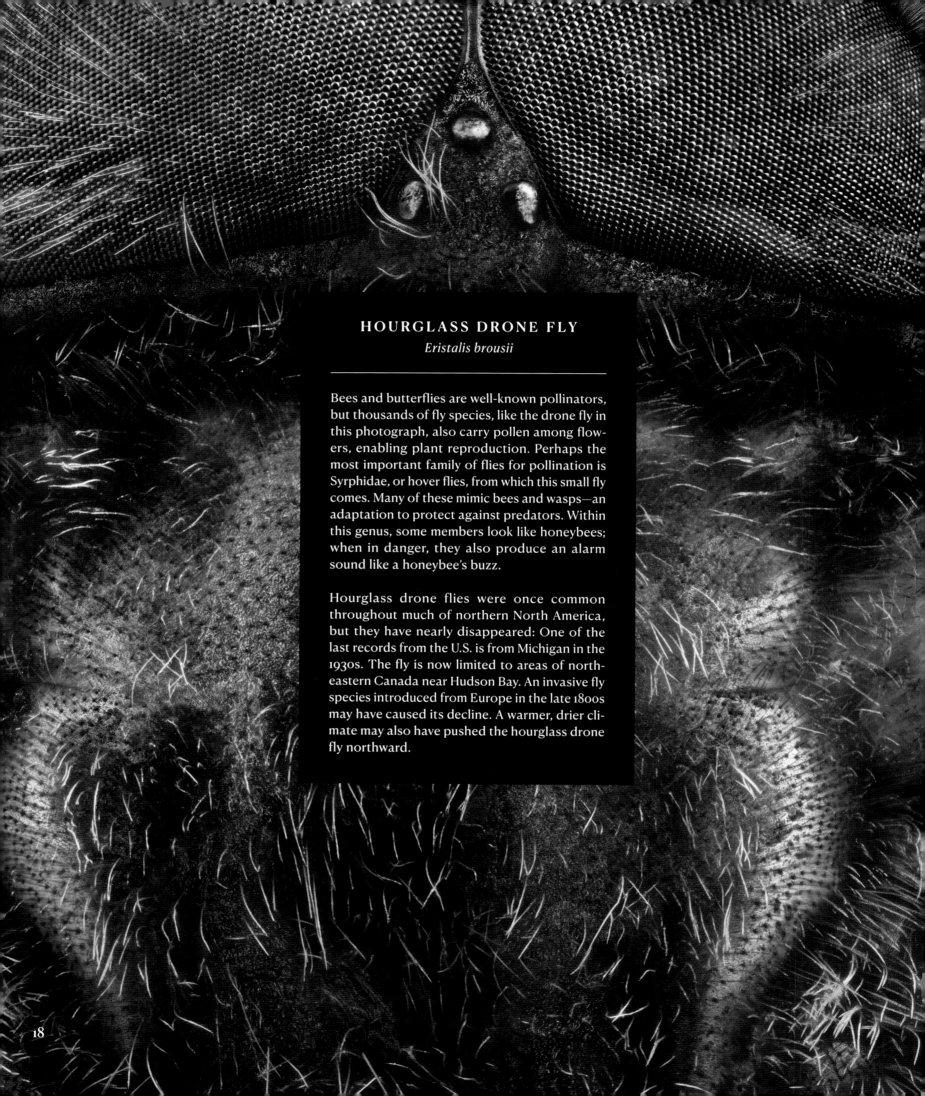

HOURGLASS DRONE FLY
Eristalis brousii

Bees and butterflies are well-known pollinators, but thousands of fly species, like the drone fly in this photograph, also carry pollen among flowers, enabling plant reproduction. Perhaps the most important family of flies for pollination is Syrphidae, or hover flies, from which this small fly comes. Many of these mimic bees and wasps—an adaptation to protect against predators. Within this genus, some members look like honeybees; when in danger, they also produce an alarm sound like a honeybee's buzz.

Hourglass drone flies were once common throughout much of northern North America, but they have nearly disappeared: One of the last records from the U.S. is from Michigan in the 1930s. The fly is now limited to areas of northeastern Canada near Hudson Bay. An invasive fly species introduced from Europe in the late 1800s may have caused its decline. A warmer, drier climate may also have pushed the hourglass drone fly northward.

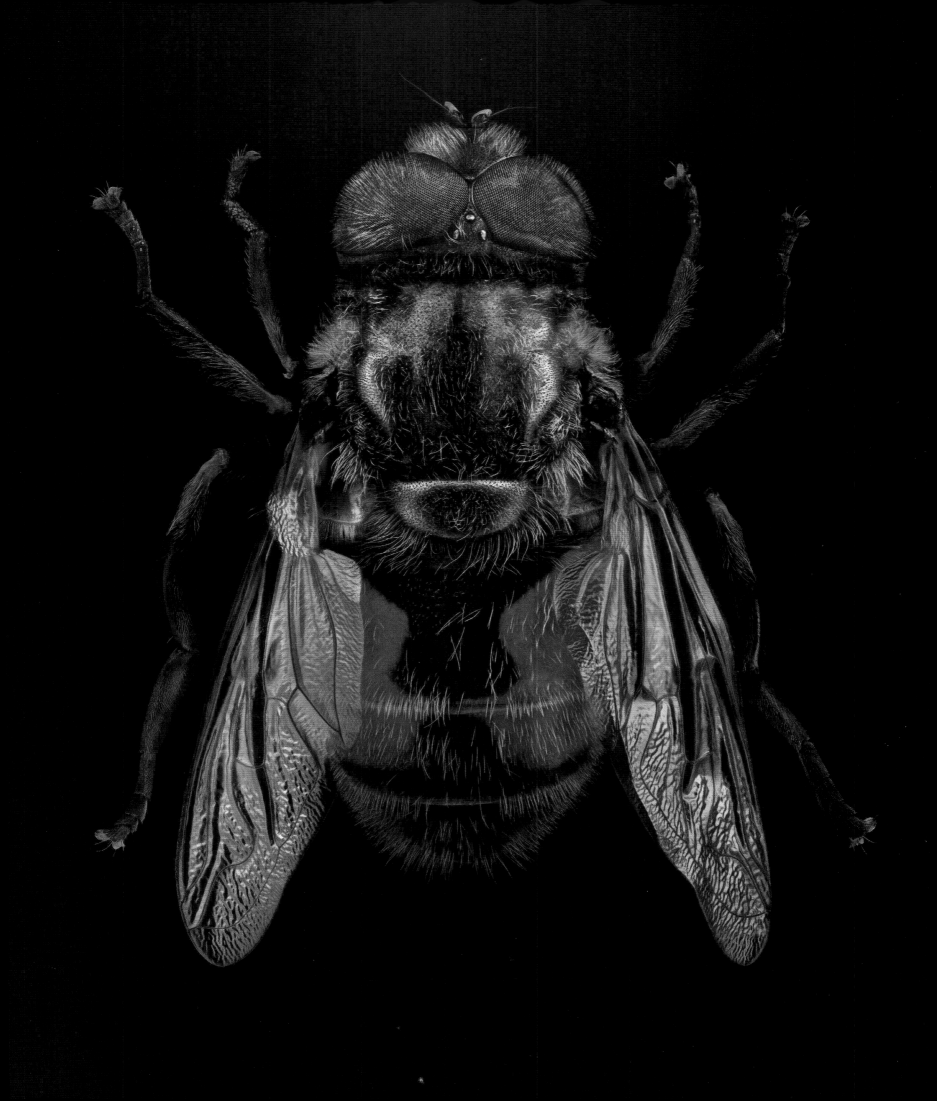

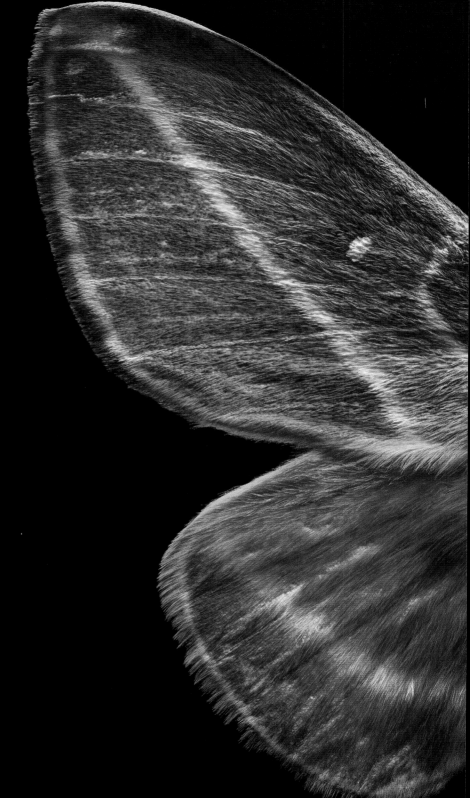

RASPA SILKMOTH
Sphingicampa raspa

Many silkmoth caterpillars spin thick silken cocoons that they attach to branches or plant stems. When it's time for raspa silkmoths like this one to transition into their adult form, however, they metamorphose down in the soil. Underground, they create chambers by tying pieces of soil and humus together with silk.

Living in isolated populations in Arizona, West Texas, and Mexico, these moths face threats including climate change. In the hot, arid areas where they live, there is usually very little precipitation. But in July, August, and early September, there are reliable rainstorms. It's during this so-called "monsoon" season that these moths emerge as adults. If that weather pattern is shifted dramatically by ongoing drought or otherwise becomes erratic, it could imperil these and other southwestern moths and butterflies.

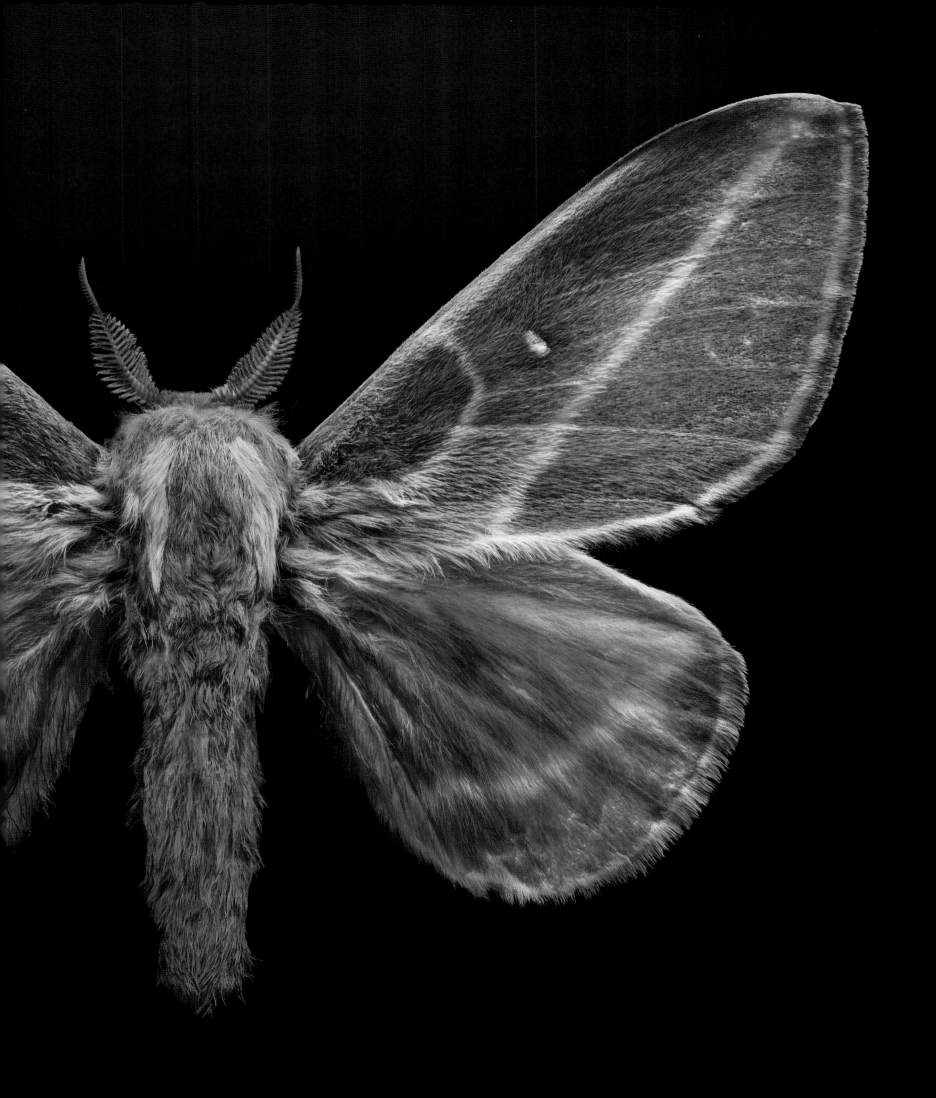

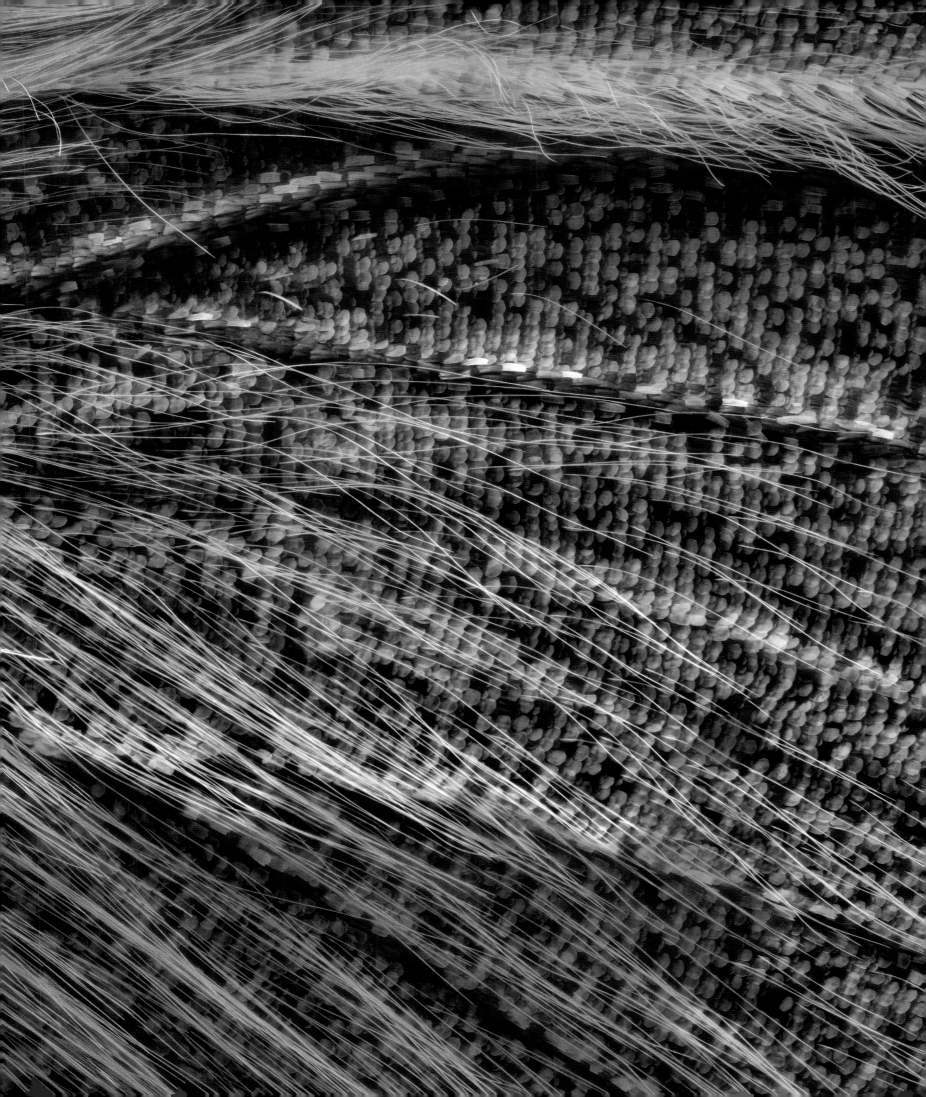

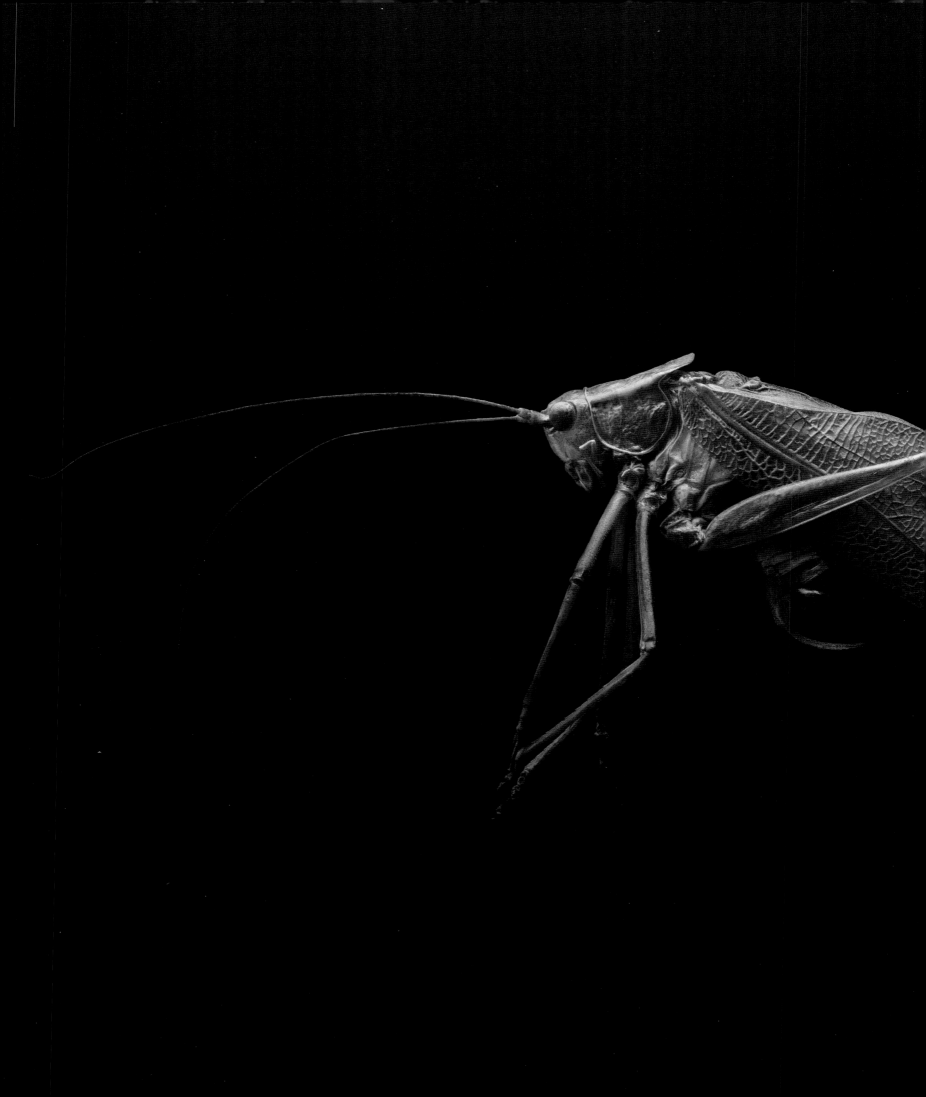

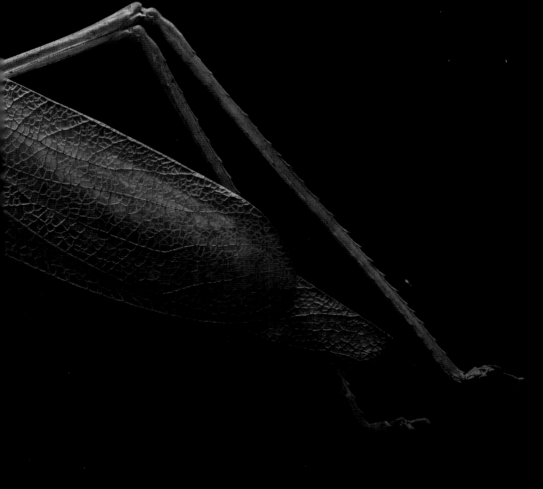

NORTHERN BUSH KATYDID
Scudderia septentrionalis

Starting in July, northern katydids use their wings to sing in the darkness. To lure a mate, a male (shown in the photograph) scrapes together special structures on its forewings to create a distinctive, rasping call. But in the day, they stay quiet, and these bright-green insects—closely related to crickets, as well as grasshoppers and locusts—fade into the trees, often oaks, avoiding the attention of birds and other hunters.

At home in the eastern tier of the U.S. and in southeastern Canada, northern katydids were once considered uncommon. But entomologists found the katydids could be lured from the tree-tops with lights and have identified more abundant populations. Still, the leaf-eating herbivores are vulnerable to decline, from such causes as light pollution, habitat fragmentation, and pesticide use in both residential backyards and fields near forested lands.

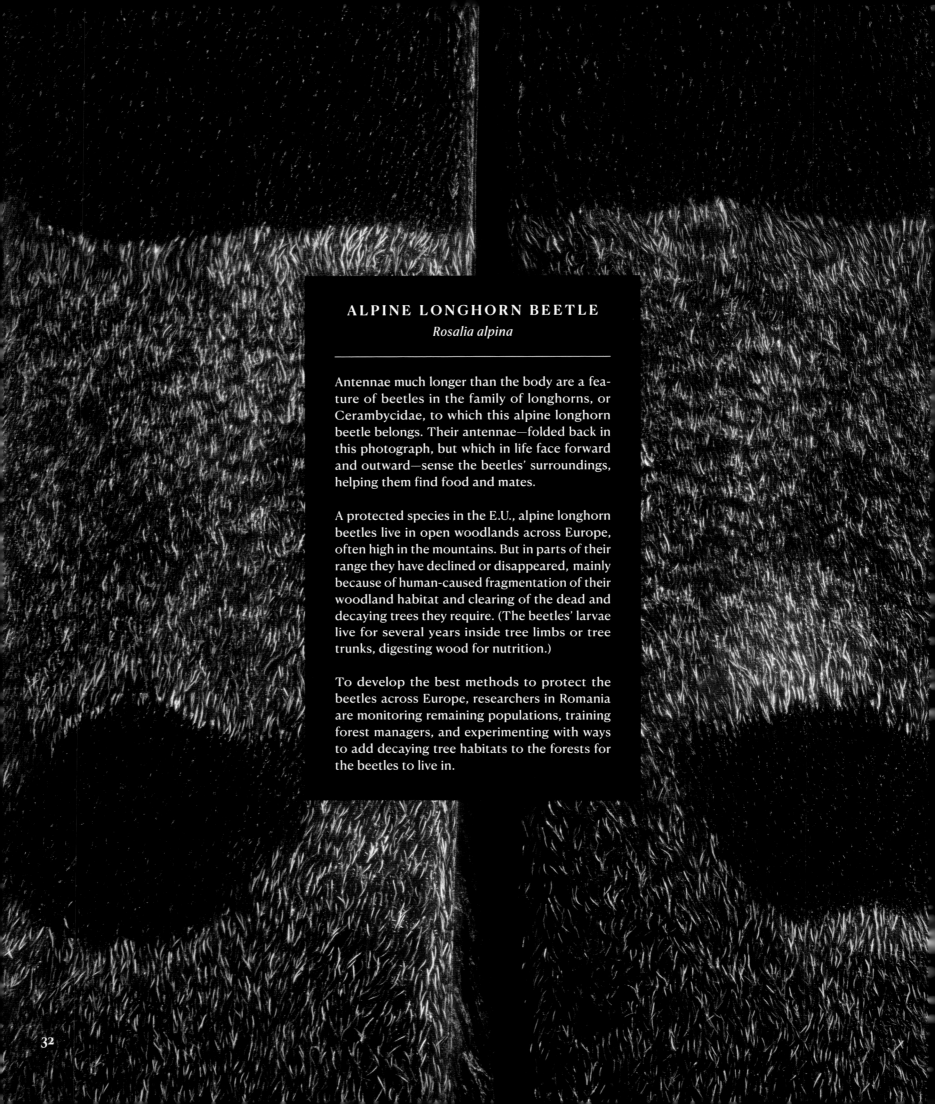

ALPINE LONGHORN BEETLE
Rosalia alpina

Antennae much longer than the body are a feature of beetles in the family of longhorns, or Cerambycidae, to which this alpine longhorn beetle belongs. Their antennae—folded back in this photograph, but which in life face forward and outward—sense the beetles' surroundings, helping them find food and mates.

A protected species in the E.U., alpine longhorn beetles live in open woodlands across Europe, often high in the mountains. But in parts of their range they have declined or disappeared, mainly because of human-caused fragmentation of their woodland habitat and clearing of the dead and decaying trees they require. (The beetles' larvae live for several years inside tree limbs or tree trunks, digesting wood for nutrition.)

To develop the best methods to protect the beetles across Europe, researchers in Romania are monitoring remaining populations, training forest managers, and experimenting with ways to add decaying tree habitats to the forests for the beetles to live in.

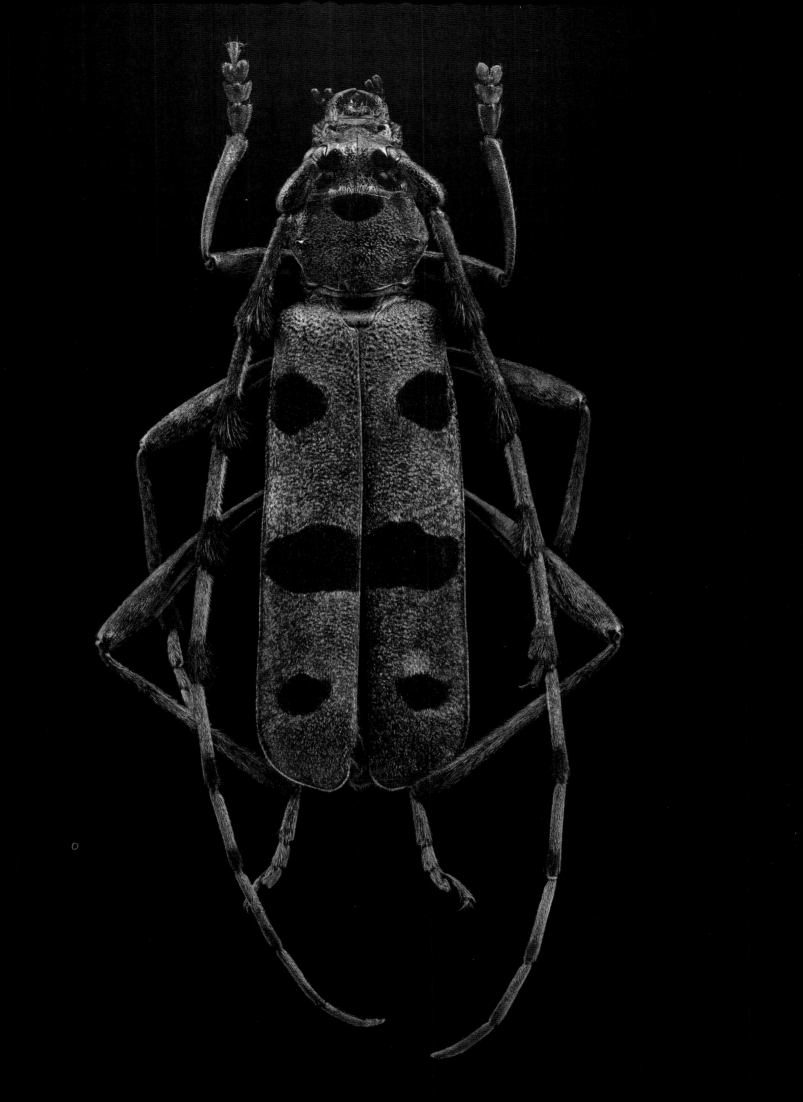

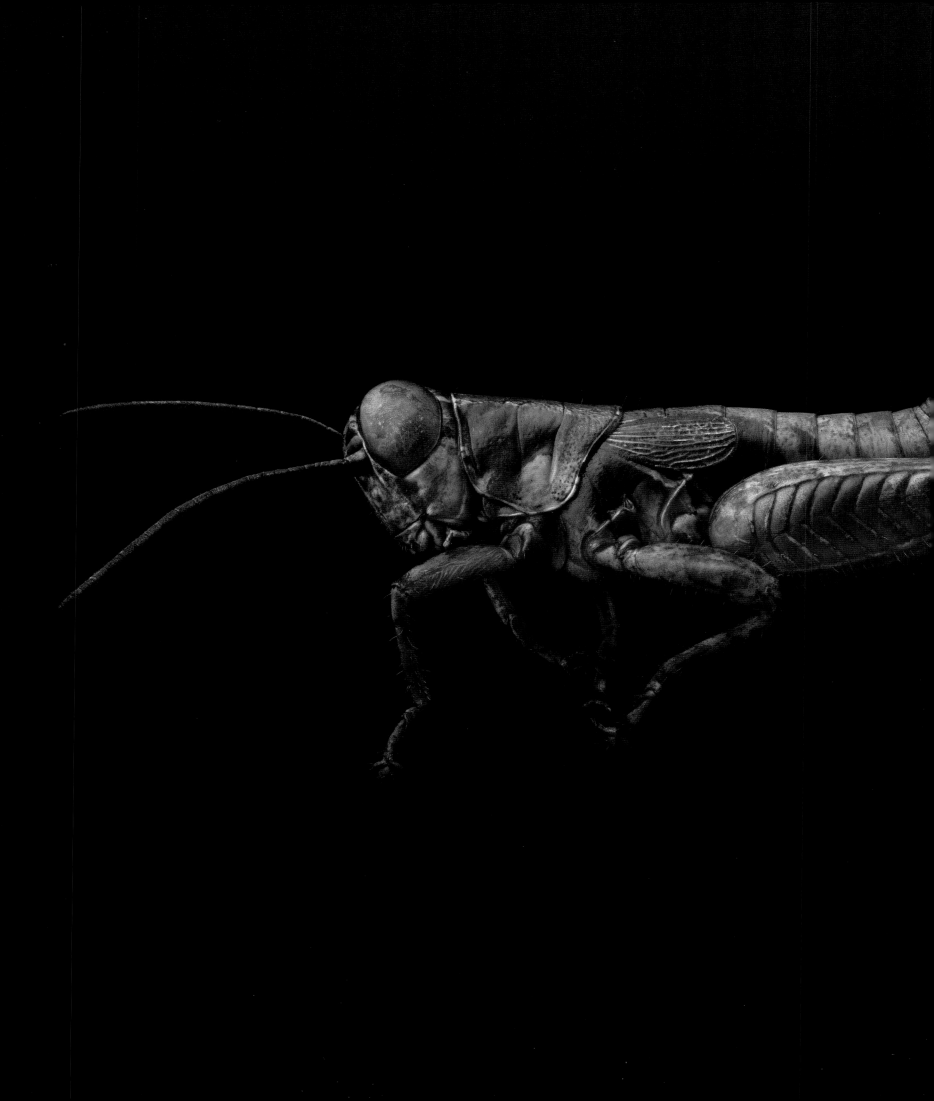

FLORIDA LEAST
SPURTHROAT GRASSHOPPER
Melanoplus puer

In environmental circles, Florida is less famous for tourism than for its distinctive ecosystems and wildlife. On the state's peninsula, dotted amid the sandhills and scrub lands, you'll find this rare grasshopper. With very short wings, this species cannot fly—although many grasshoppers can. Instead, it walks or uses its strong back legs to leap through tawny grasses in the sandy soil.

Perhaps only about 15 percent of the Florida scrub lands remain intact, so for this and other closely related *Melanoplus* grasshoppers, habitat loss and fragmentation are a major threat. But there are bright spots, including a national wildlife refuge protecting portions of scrub land and sandhill habitats. The state is also creating an ambitious wildlife corridor to link its protected public lands to one another. If completed, the corridor will connect many millions of acres, providing an invaluable buffer and a byway for wild animals—including insects.

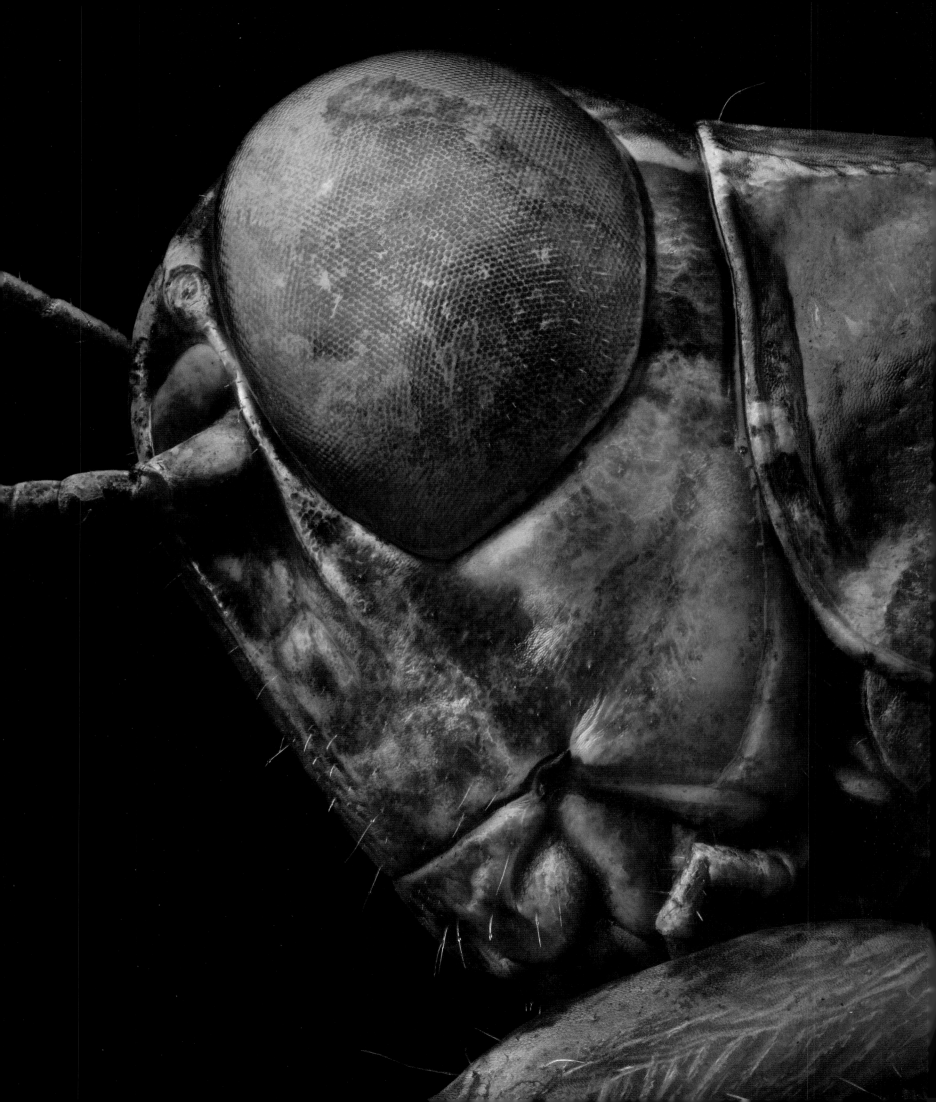

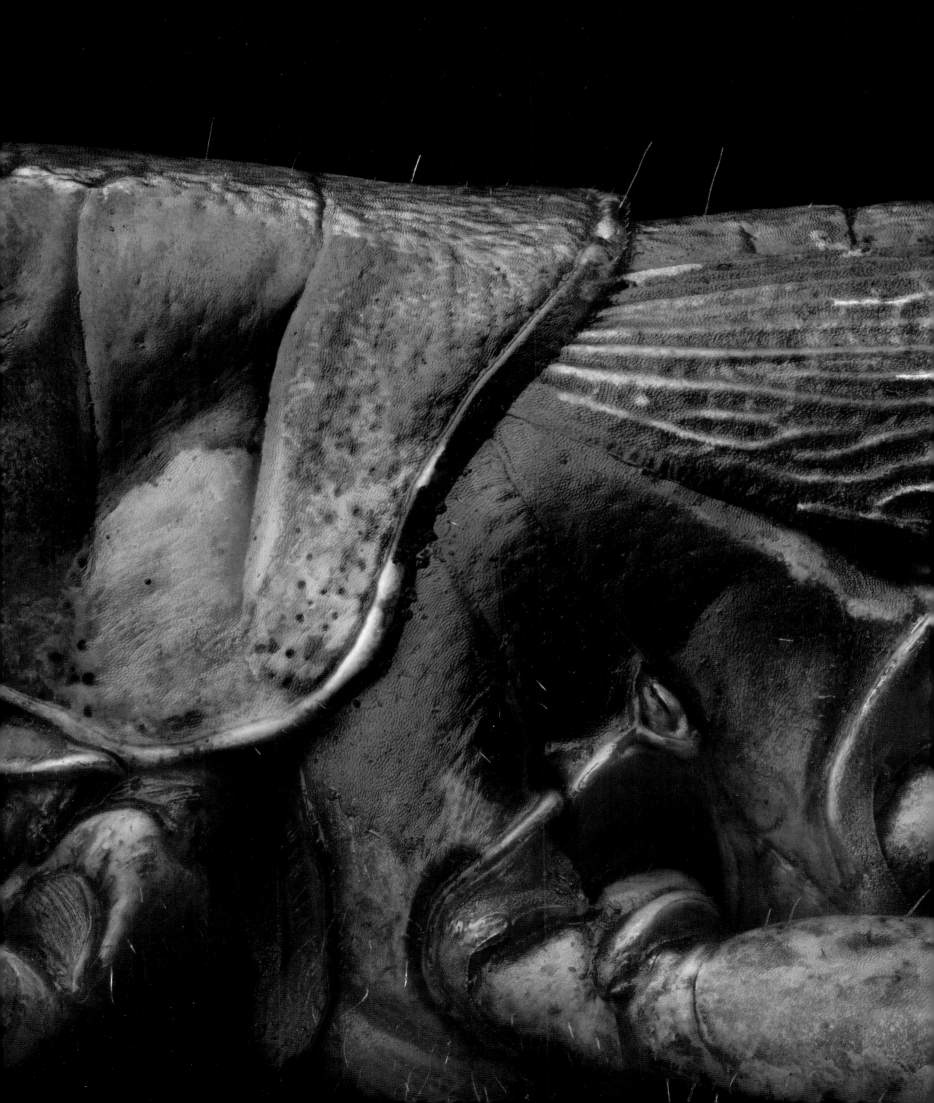

YELLOW-EDGED PYGARCTIA MOTH

Pygarctia abdominalis

At home in pine woodlands, this is the yellow-edged pygarctia moth, whose larvae feed on plants with milky sap that is extremely toxic to humans, like spurge and dogbane. It was once common in the pine barrens of New Jersey, but yellow-edged pygarctia moths haven't been seen there since the 1950s. The species is now found in the southeastern U.S.; its range has been both fragmented and contracted over time.

The reasons are many: A pathogenic bacterium—called Bt for short—was used widely to control certain pest moth species, but it also kills other moths and butterflies. Planting tree plantations in place of wild forests, intense real estate development, and changing fire-management practices left the moths vulnerable to further decline.

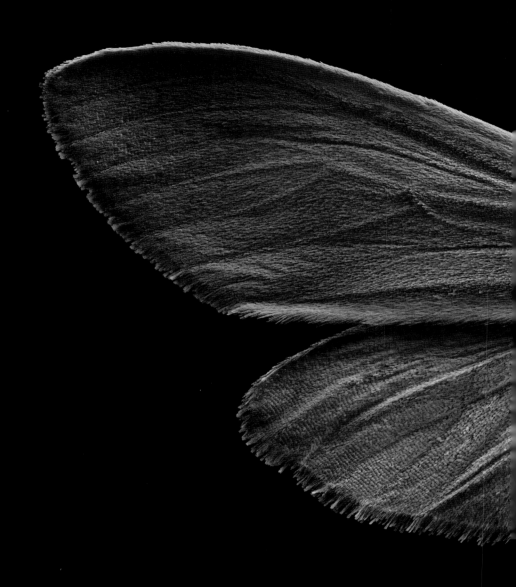

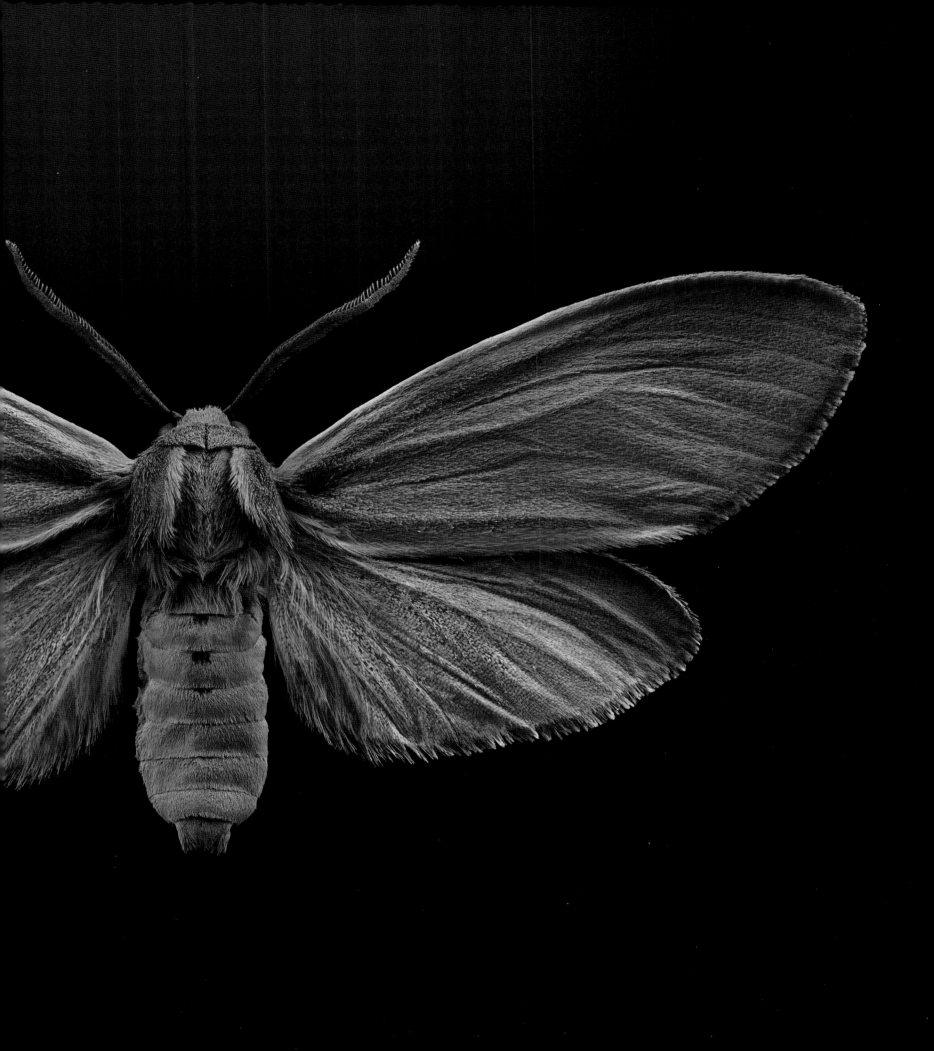

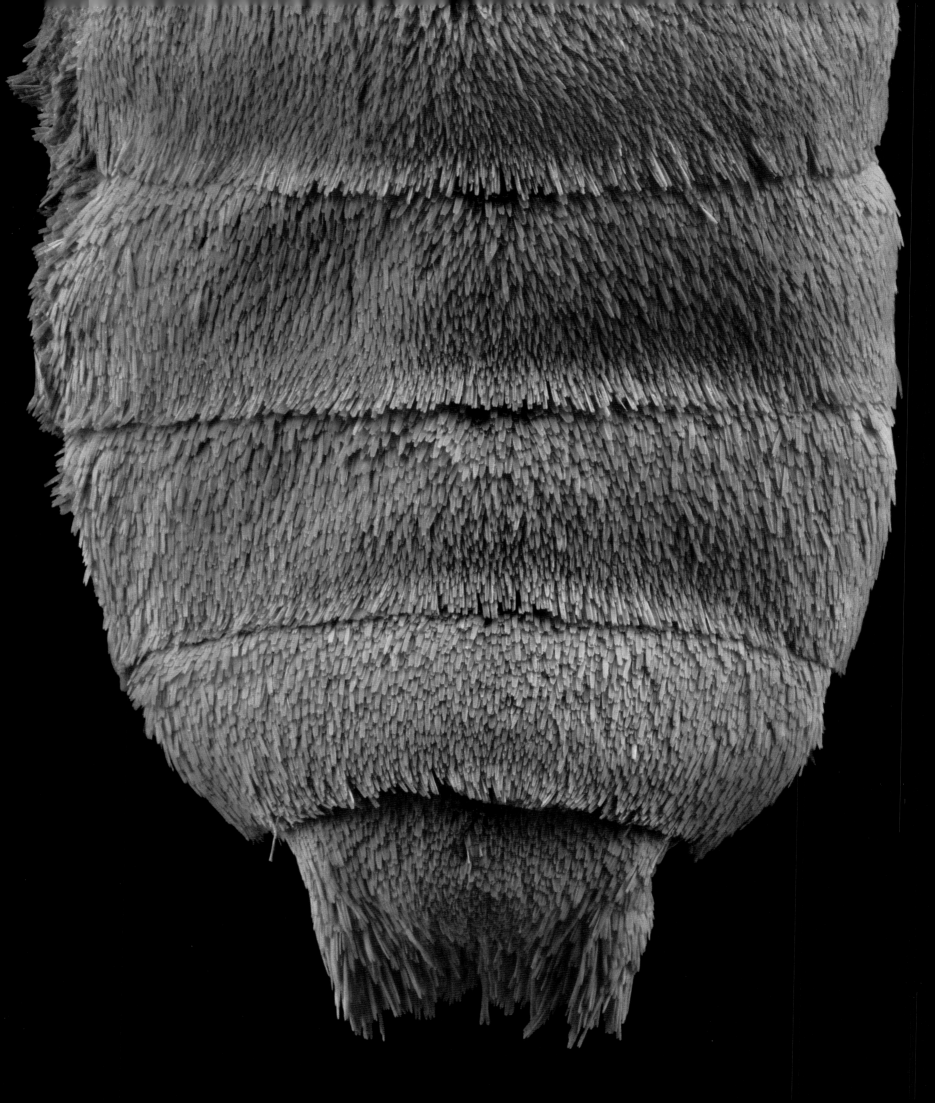

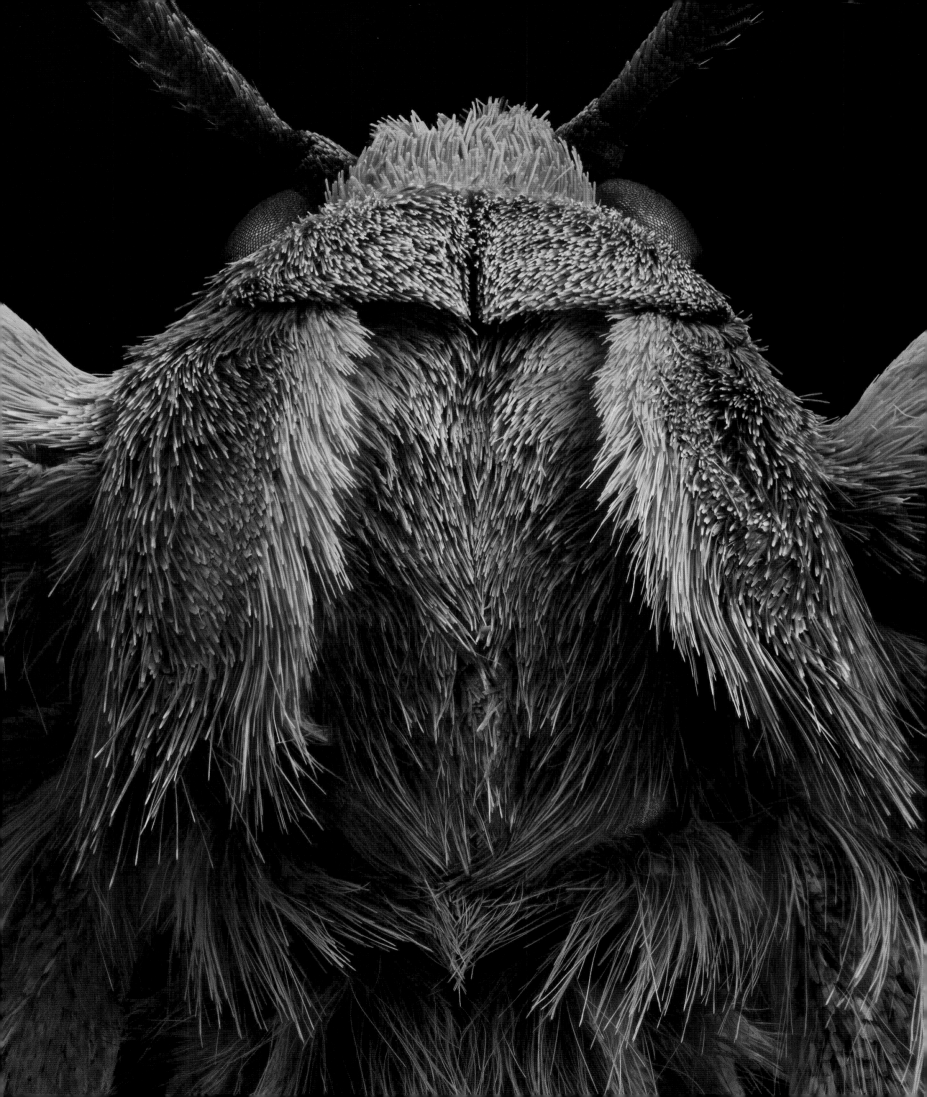

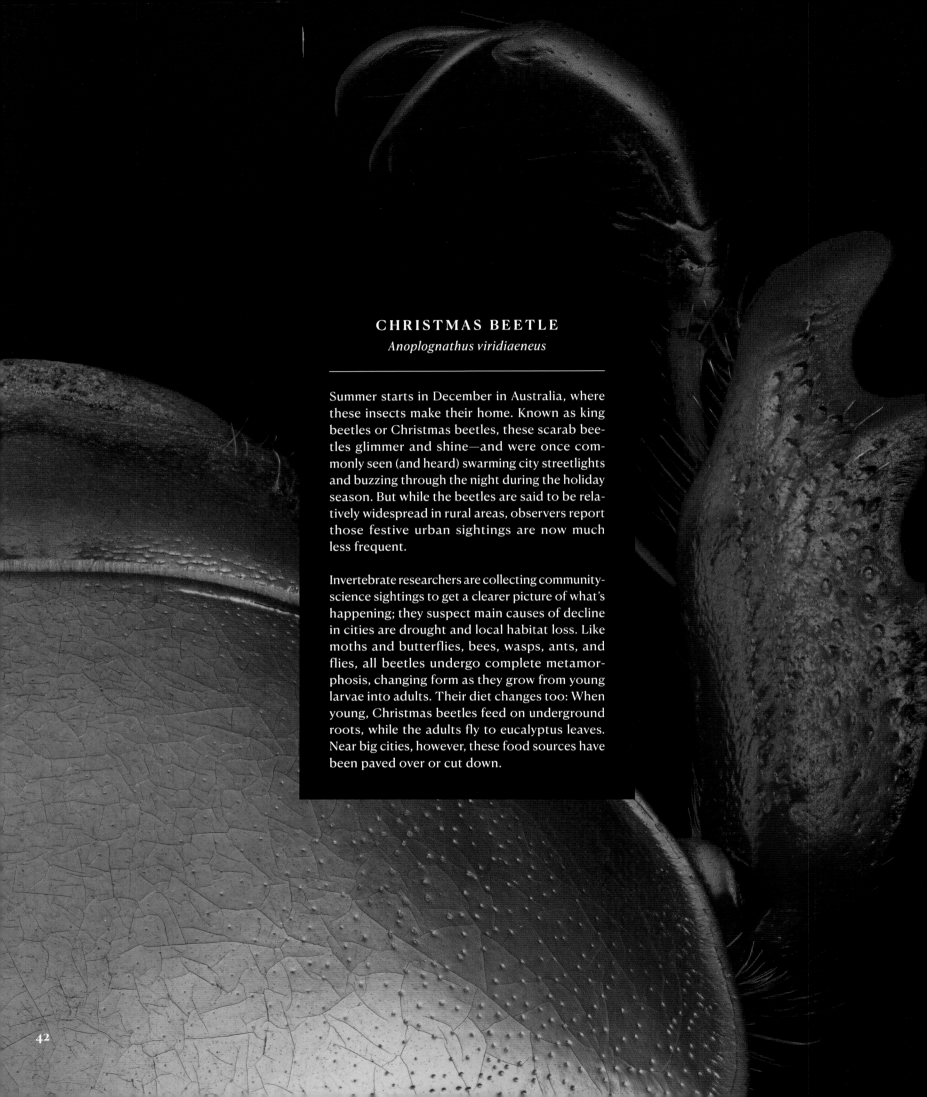

CHRISTMAS BEETLE
Anoplognathus viridiaeneus

Summer starts in December in Australia, where these insects make their home. Known as king beetles or Christmas beetles, these scarab beetles glimmer and shine—and were once commonly seen (and heard) swarming city streetlights and buzzing through the night during the holiday season. But while the beetles are said to be relatively widespread in rural areas, observers report those festive urban sightings are now much less frequent.

Invertebrate researchers are collecting community-science sightings to get a clearer picture of what's happening; they suspect main causes of decline in cities are drought and local habitat loss. Like moths and butterflies, bees, wasps, ants, and flies, all beetles undergo complete metamorphosis, changing form as they grow from young larvae into adults. Their diet changes too: When young, Christmas beetles feed on underground roots, while the adults fly to eucalyptus leaves. Near big cities, however, these food sources have been paved over or cut down.

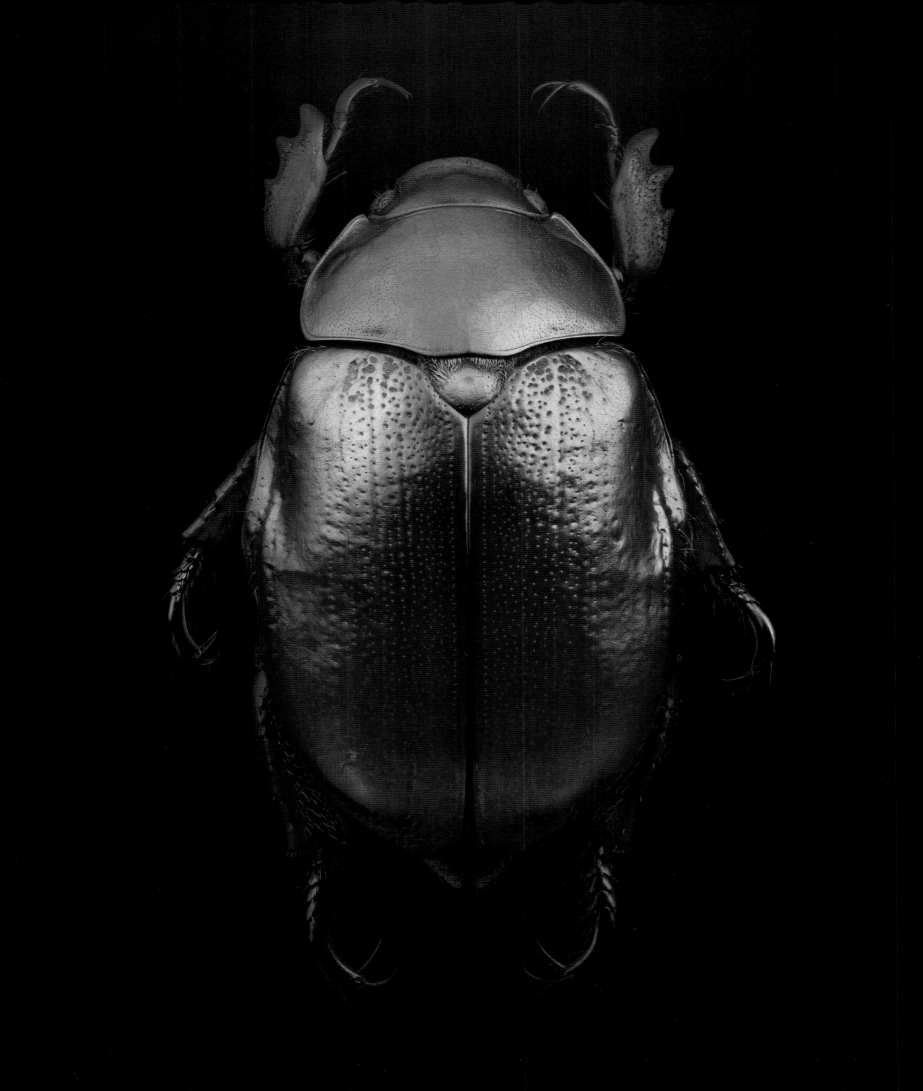

APACHA SWEAT BEE
Dieunomia apacha

The American Southwest is home to more species of native bees than any other part of North America. The sandy soil of the region can be good for building nests in the ground—where this species, *Dieunomia apacha*, makes its home. Also sometimes found in the prairie states, it's a member of the Halictidae, or sweat bee family, which is named for some species that are attracted to perspiration.

But biologists have recorded very few sightings of these bees since 2000. Insect numbers often fluctuate for a combination of reasons: In the case of this rare bee, one main reason their numbers may be dwindling is destruction and fragmentation of their habitat. Their nesting grounds are being replaced by both cropland and oil and gas fields. Off-road vehicles can also destroy nests.

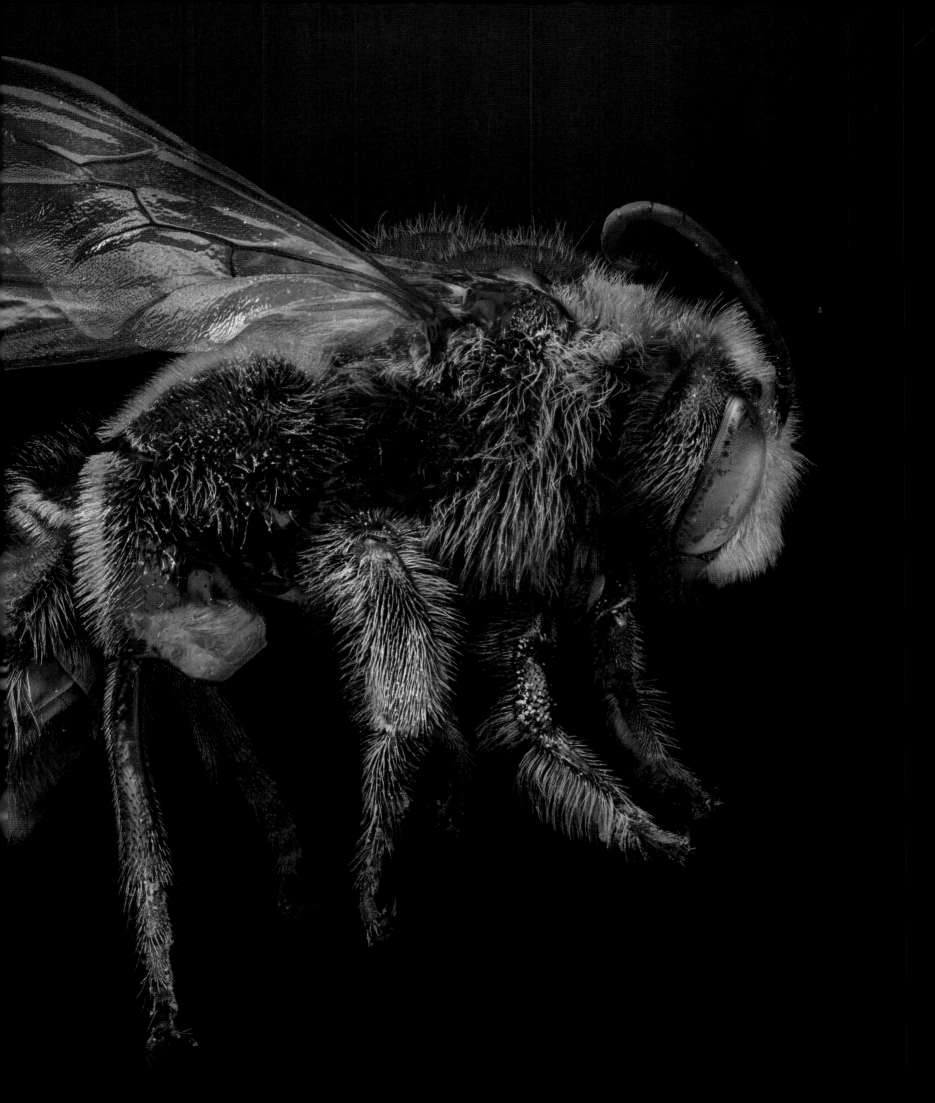

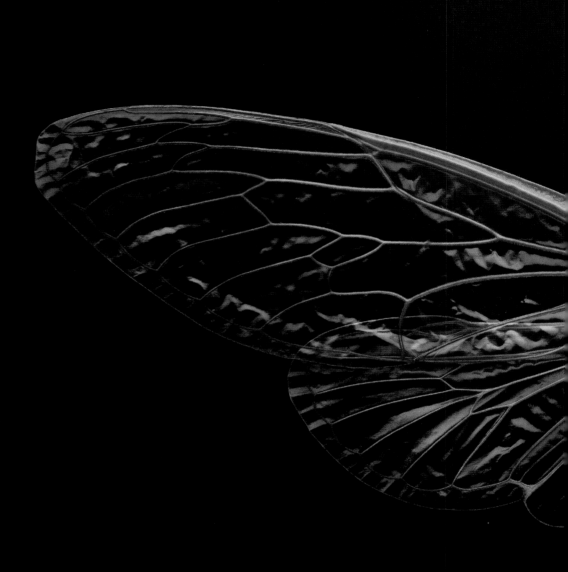

SEVENTEEN-YEAR CICADA
Magicicada septendecim

Every seventeen years when the weather warms, periodical cicadas become a news event. East of the Great Plains in the northern U.S., millions burst forth from the ground. Using specially adapted forelegs, the mature nymphs dig themselves out of the soil where they've been feeding on fluids in tree roots. They climb up trees, split out of their skins into winged adults, then eat and mate. During the day, you'll hear a chorus of wailing males calling out to females, who click in response.

Mass emergence is an effective adaptation that allows these insects to overwhelm potential predators. But sheer numbers shouldn't lull cicada fans into complacency, for the insects do face stressors, particularly ongoing forest habitat destruction and pesticides. Land clearing and development may destroy the underground nymphs before they can emerge and reproduce. And pesticides applied to lawns, golf courses, and parks seep into the ground where the nymphs feed. For now, research into the actual numbers and population dynamics of periodical cicadas is more important than ever.

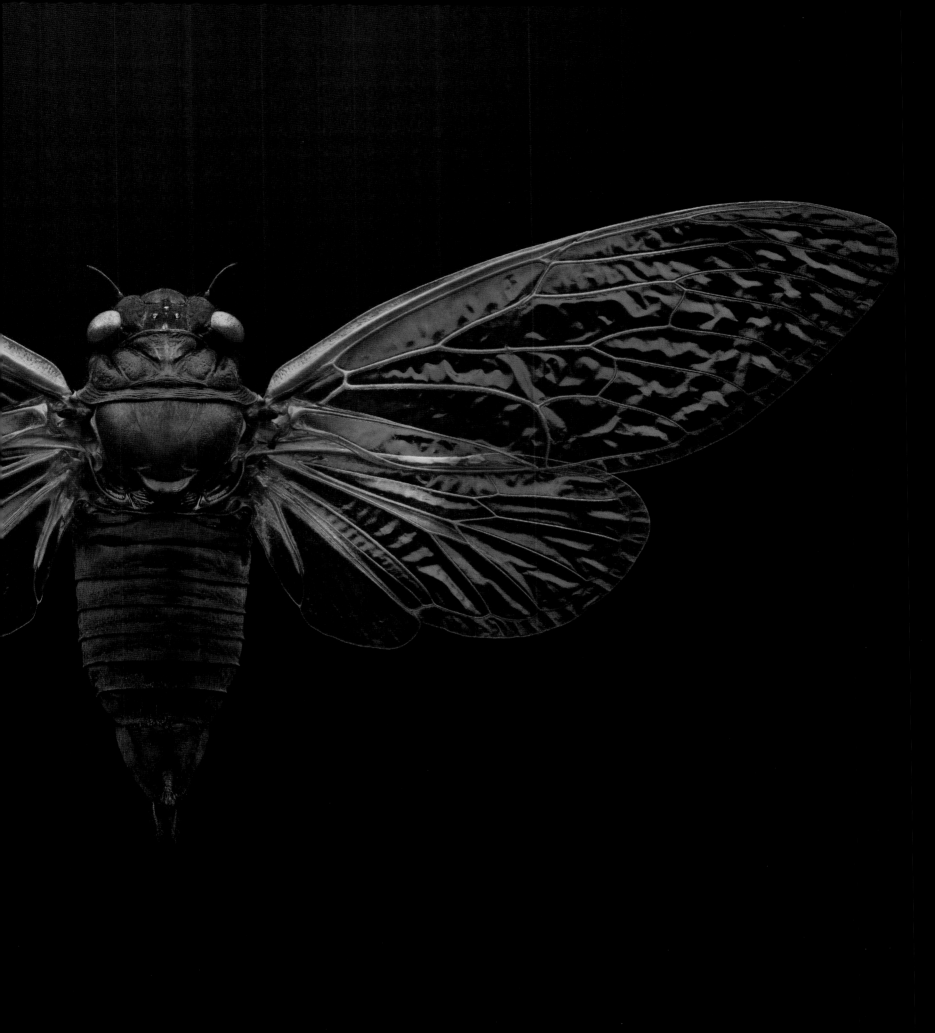

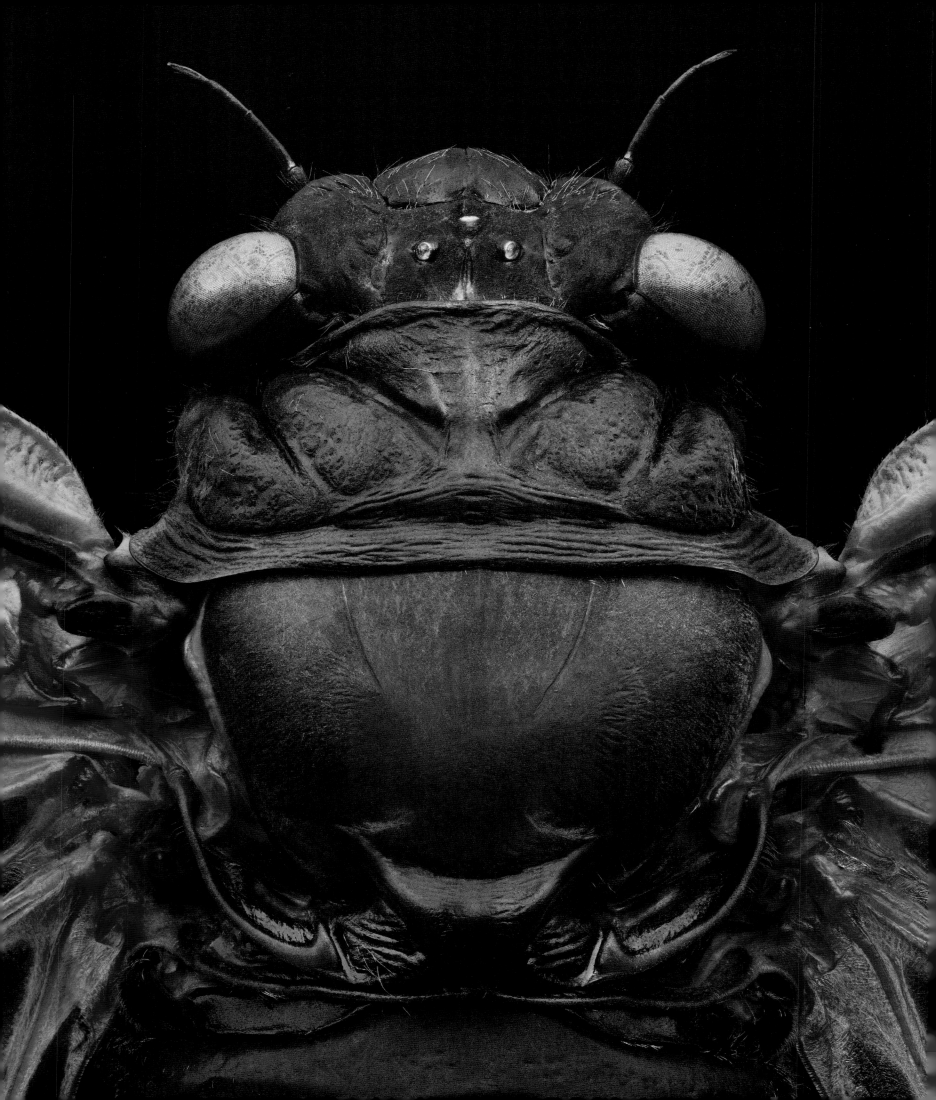

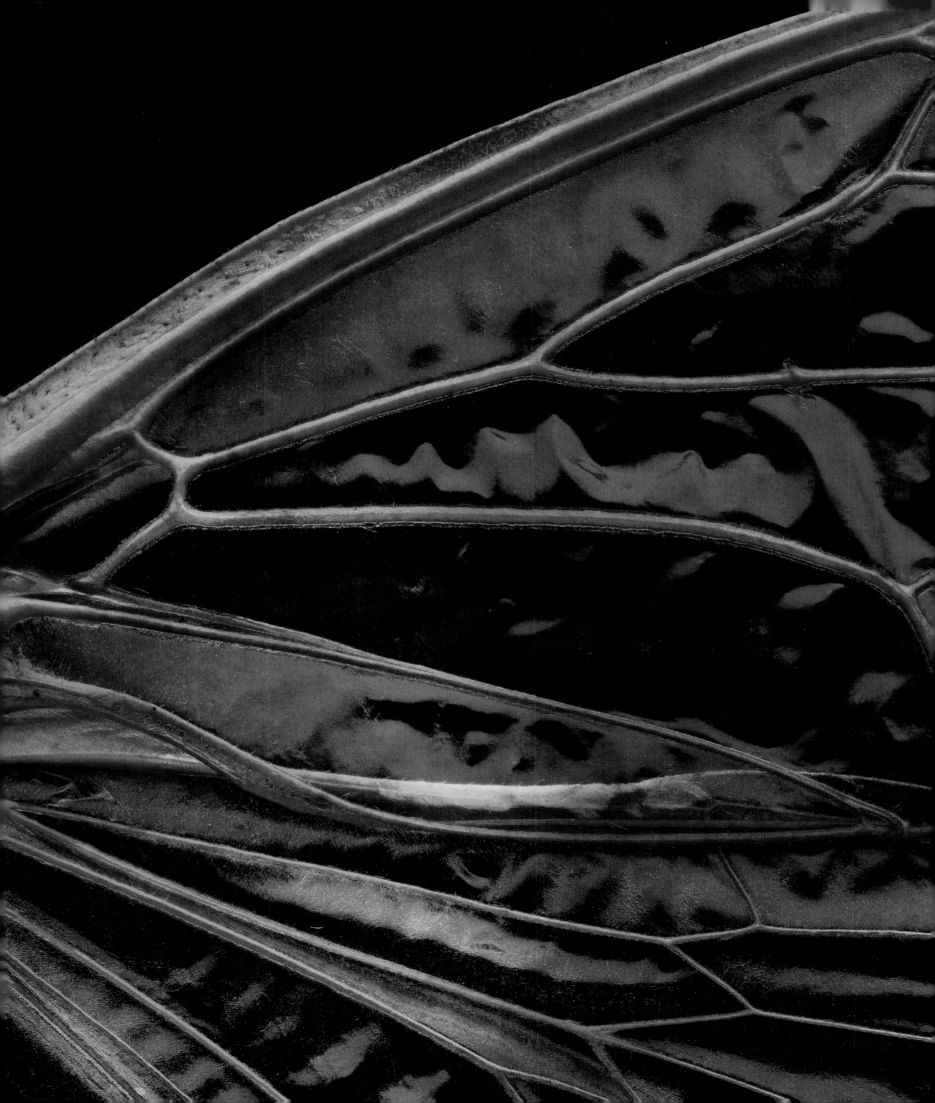

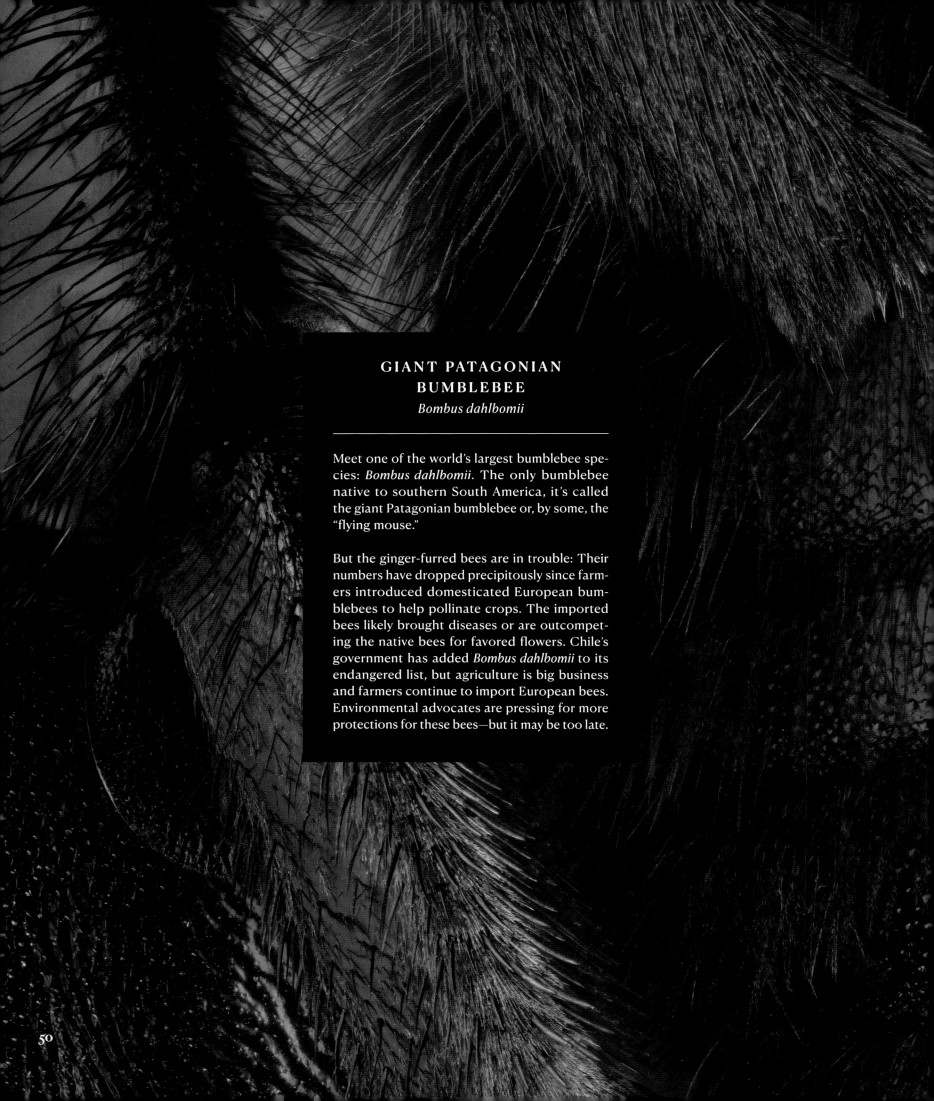

GIANT PATAGONIAN BUMBLEBEE
Bombus dahlbomii

Meet one of the world's largest bumblebee species: *Bombus dahlbomii*. The only bumblebee native to southern South America, it's called the giant Patagonian bumblebee or, by some, the "flying mouse."

But the ginger-furred bees are in trouble: Their numbers have dropped precipitously since farmers introduced domesticated European bumblebees to help pollinate crops. The imported bees likely brought diseases or are outcompeting the native bees for favored flowers. Chile's government has added *Bombus dahlbomii* to its endangered list, but agriculture is big business and farmers continue to import European bees. Environmental advocates are pressing for more protections for these bees—but it may be too late.

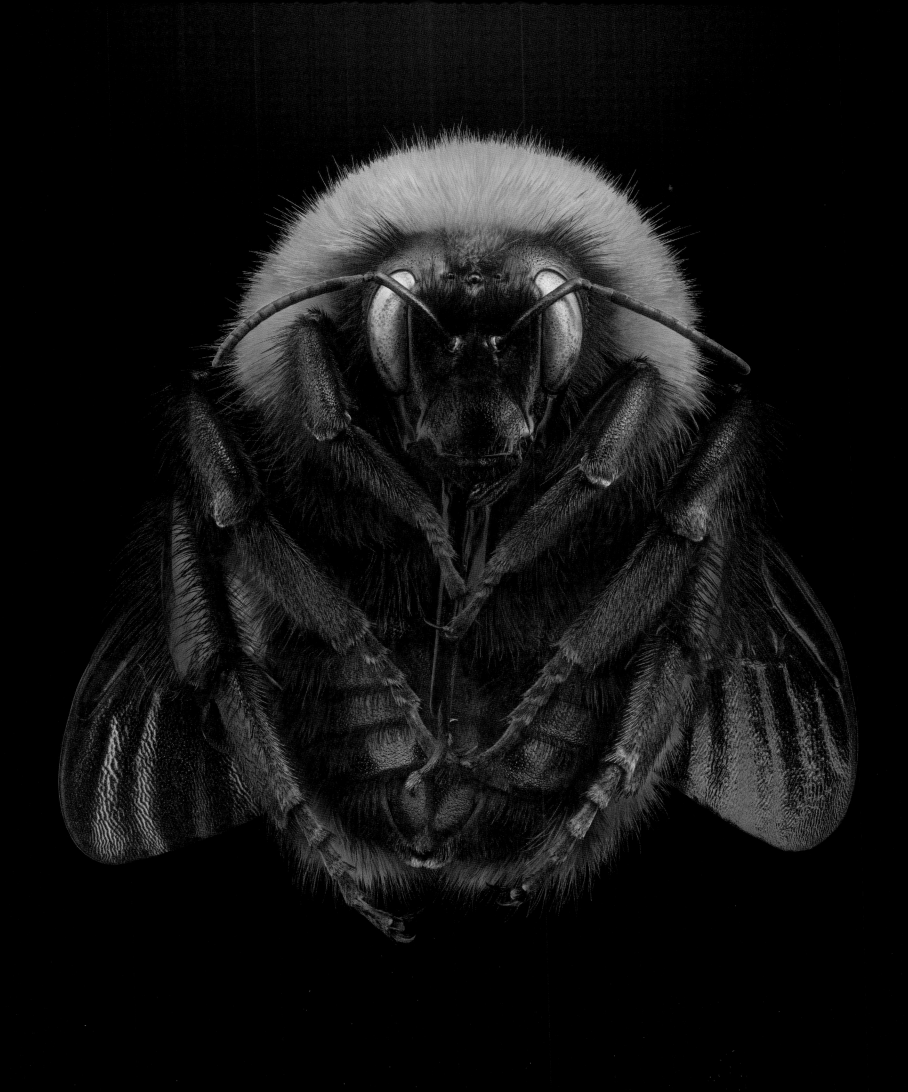

COUSIN TIGER MOTH
Lophocampa sobrina

This fuzzy moth may appear delicate, but tiger moths like this one are good at defending themselves. To ward off predatory birds and bats, many tiger moths create high-frequency clicks with organs called tymbals. Some tiger moth caterpillars also feed on plants with chemical compounds that make them distasteful or toxic; the moths' clicks warn predators that the moths are not safe to eat.

Lophocampa sobrina is vulnerable to decline, not from predators but from fragmentation of its very restricted habitat. Found only in coastal central and northern California—prime real estate—the moths' caterpillars feed primarily on native Monterey pine trees, as well as some other plants. When their favored host plants are cut down or removed, the moths' populations decline.

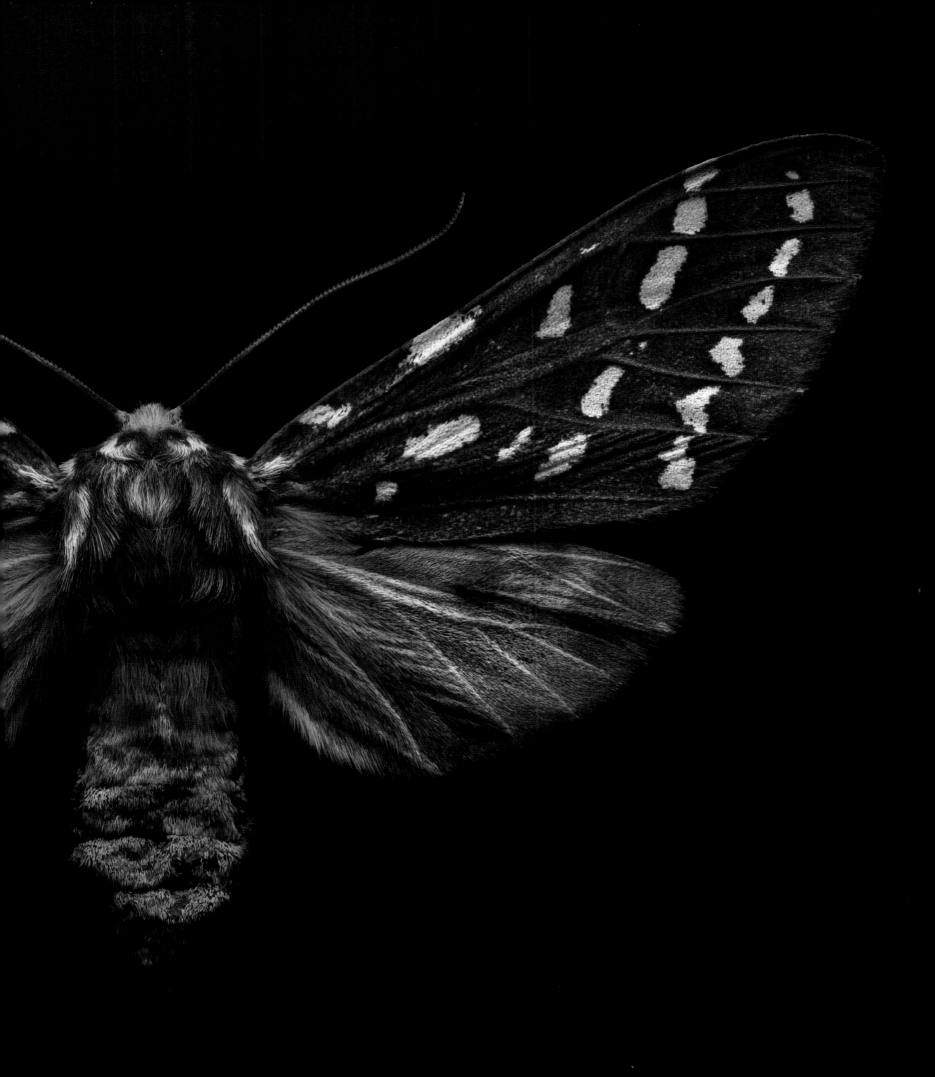

ELDERBERRY LONGHORN BEETLE

Desmocerus palliatus

To find this yellow-and-blue beetle, head for a wet forest edge in the eastern U.S. or in southeastern Canada. Then find an elderberry shrub, which has berries that ripen in late summer. Elderberry longhorn beetles are specialists: They rely on just this one host plant. The larvae eat only elderberry wood. The adult beetles gather pollen from flowers, including elderberry, and mate on or near the plants. And they may also gain toxicity by ingesting the plant, which can be toxic too.

The fate of these insects is entwined with the populations of the plant they rely on, but as is common with many insects (and plants), we don't know for certain how robust they are. In parts of the northeastern U.S., the beetles are declining, but elsewhere in their range, their status is unknown. For now, studies here and there bring a bit of positive news. Once officially endangered in Massachusetts, this beetle was removed from that state's list after a new survey located many more of the iridescent insects.

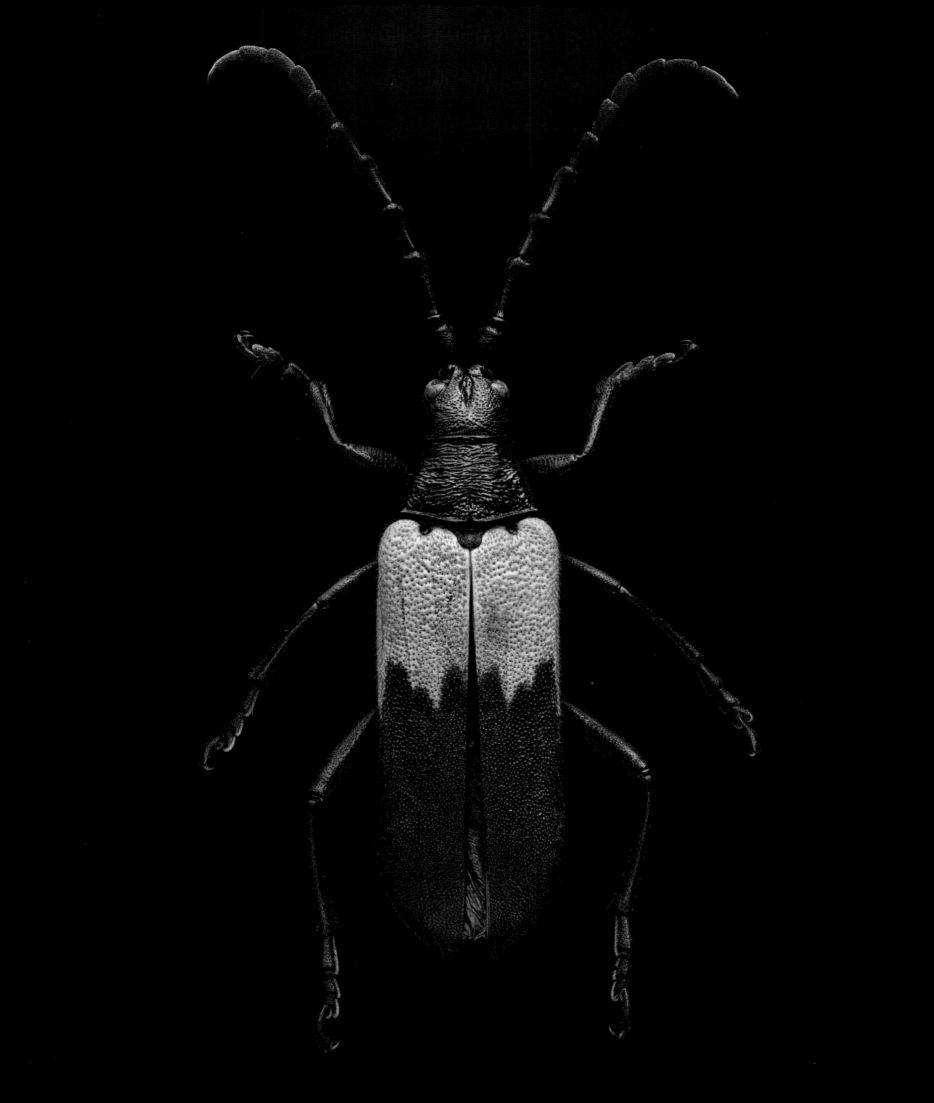

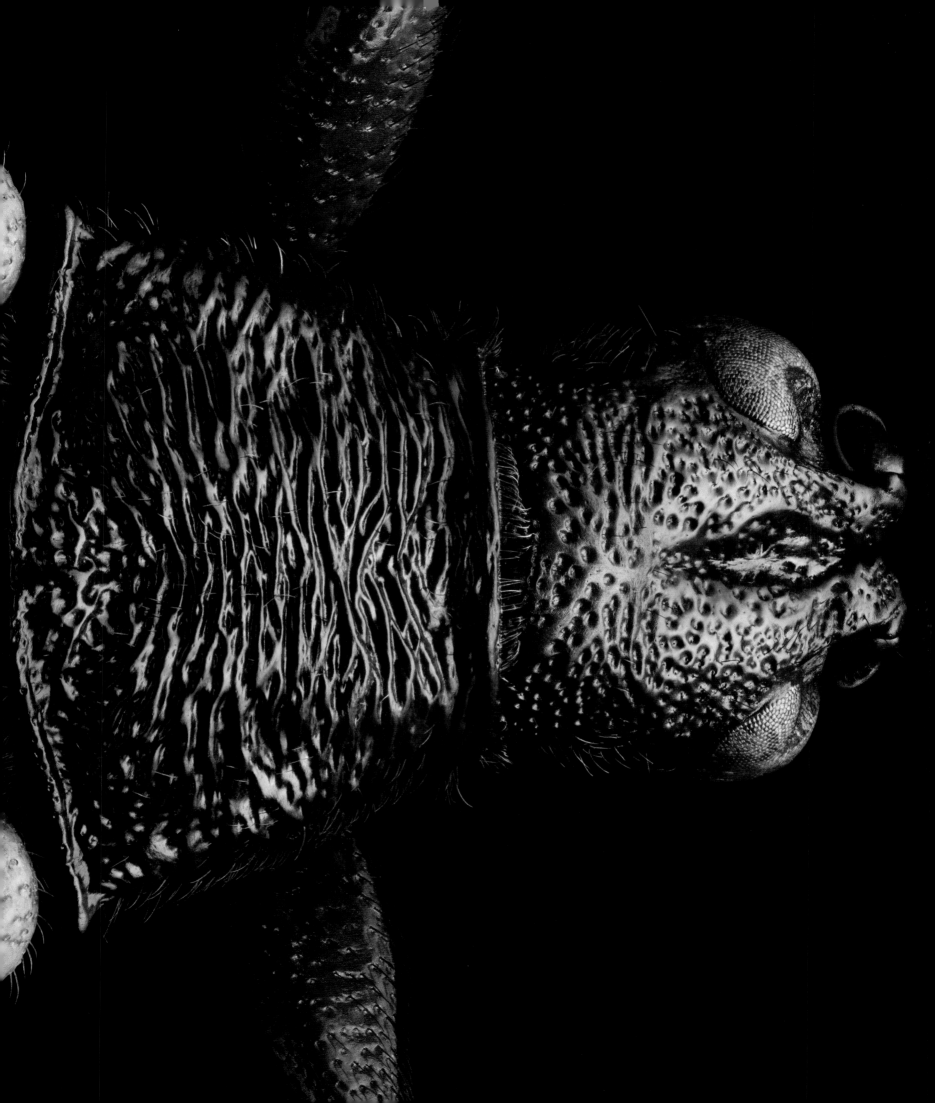

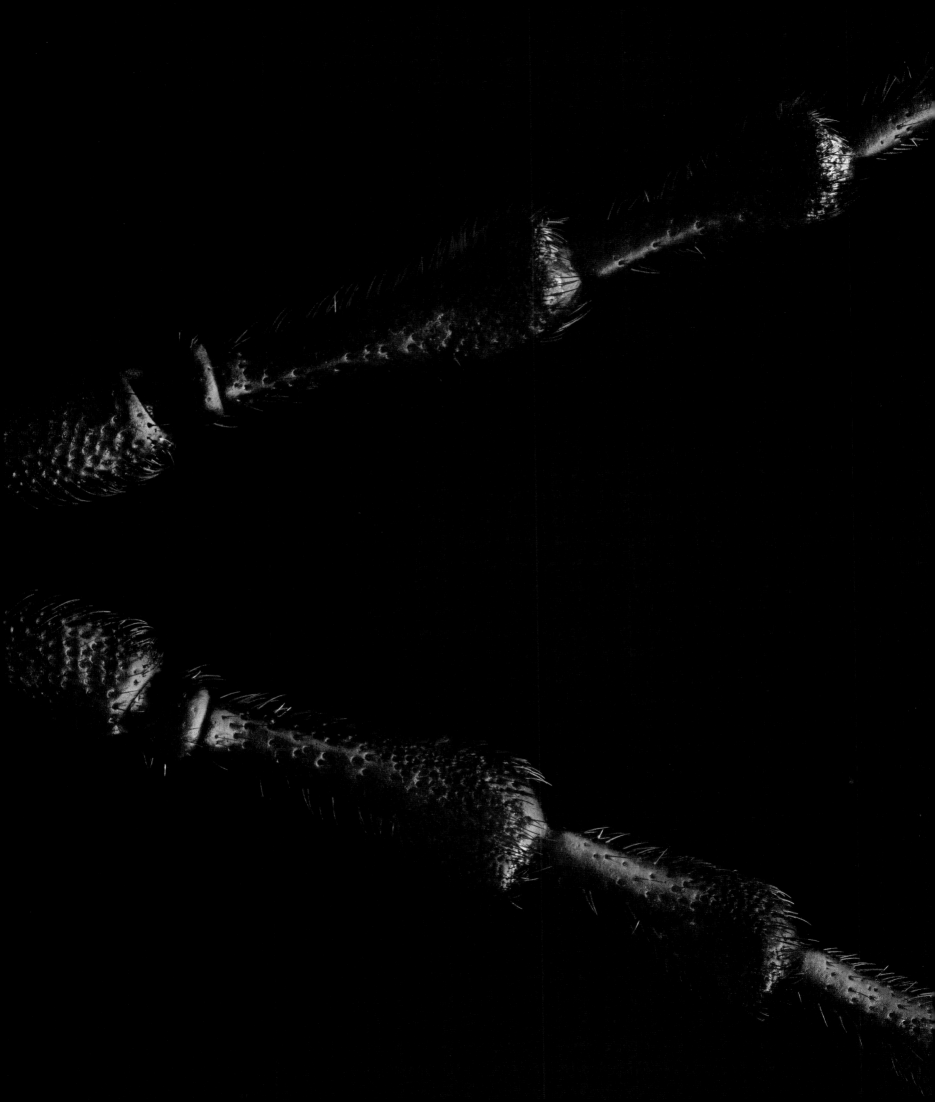

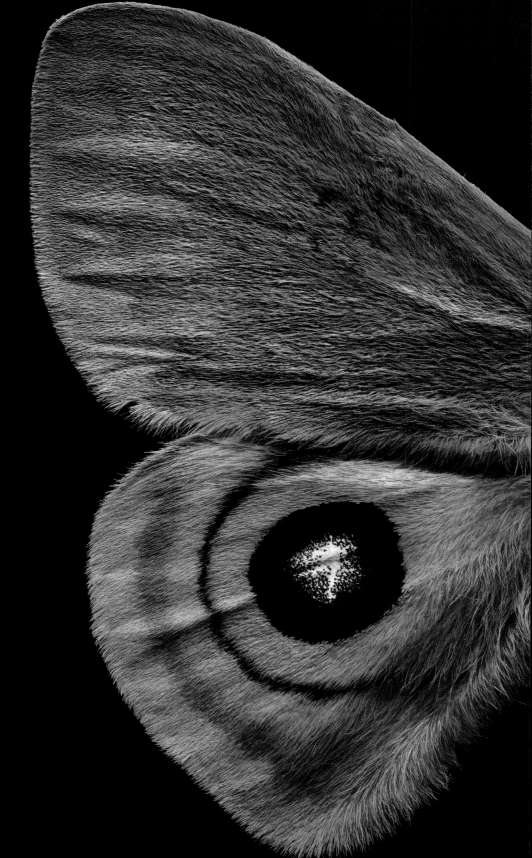

LOUISIANA EYED-SILKMOTH
Automeris louisiana

In the dark of night, across the Mississippi Delta and the eastern Gulf Coast of Texas, Louisiana eyed-silkmoths rise from the marshes and take wing, looking for mates or a place to deposit their eggs. With flashing eyespots on their hindwings to scare off birds or other predators, the adults of this striking species live only for a few days. They do not eat, but instead live off abundant fat developed as bright-green caterpillars feeding on cordgrass and other plants.

Today, these moths face pressures from many directions. The coastal marshes are disappearing and may take the caterpillars' cordgrass with them. The reasons for the disappearance of this ecosystem are numerous: erosion, land subsidence, as well as human-caused climate change, which intensifies flooding, hurricanes, and sea-level rise. Oil spills and rice farming can also damage marsh ecosystems, while insecticides used to kill mosquitoes or other insect pests may harm these moths.

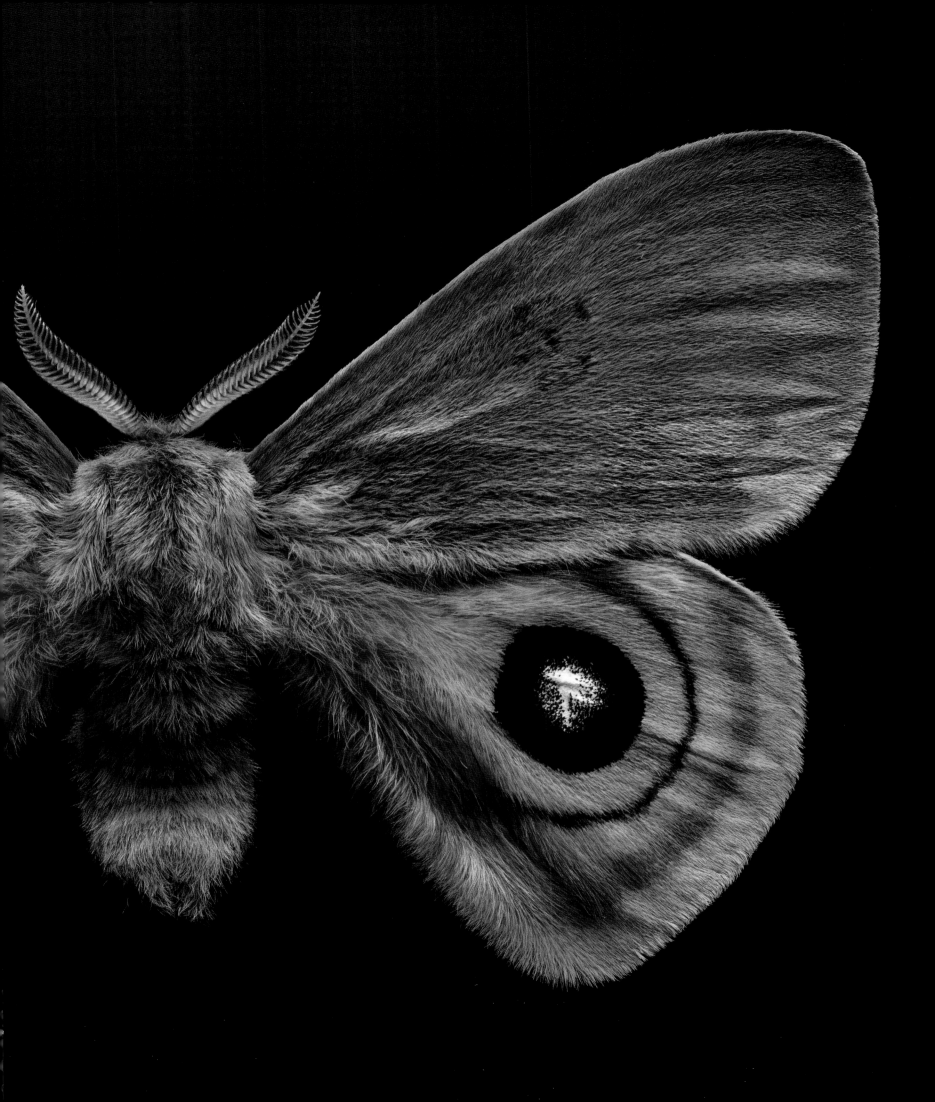

LESSER WASP MOTH
Pseudocharis minima

If you see one of these insects flying in southern Florida and parts of the Caribbean, you might mistake it for a stinging wasp. It's a day-flying moth that looks, flies, and acts like a wasp, which is a great defense against natural predators. Its vivid colors also advertise its toxicity.

But no visual display will protect it from the human activities that now threaten this species. Insecticides for mosquitoes and crop pests are systematically sprayed in areas near where they live—and even limited use may harm these and other insects. Invasive plants may crowd out the moths' favored host plants, on which they lay eggs and feed as larvae.

One potentially bright spot is that some of the rocky habitat where the lesser wasp moth lives is within Florida's protected Everglades National Park. Preserved lands might seem ideal habitats for conserving vulnerable species, but fertilizer runoff and pesticide drift from nearby farms can spread, sometimes harming wildlife within a park's boundaries.

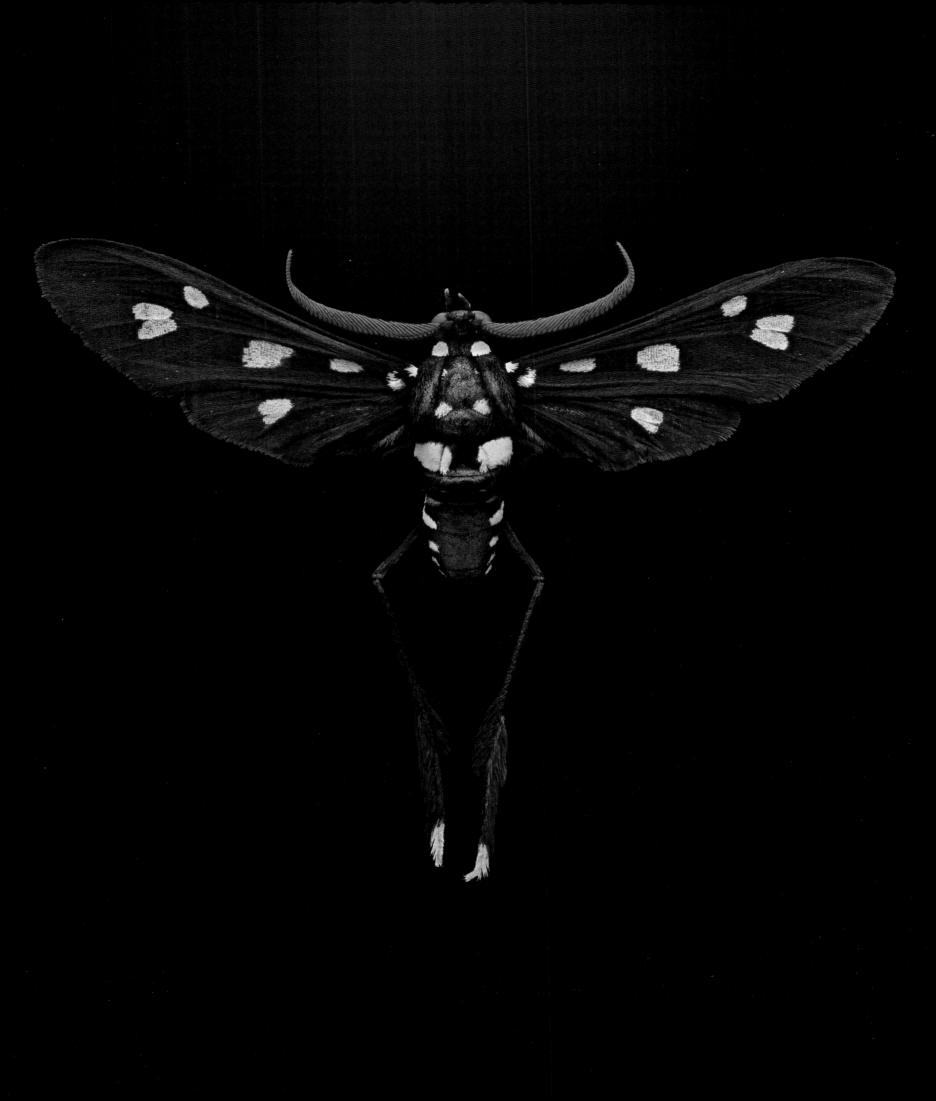

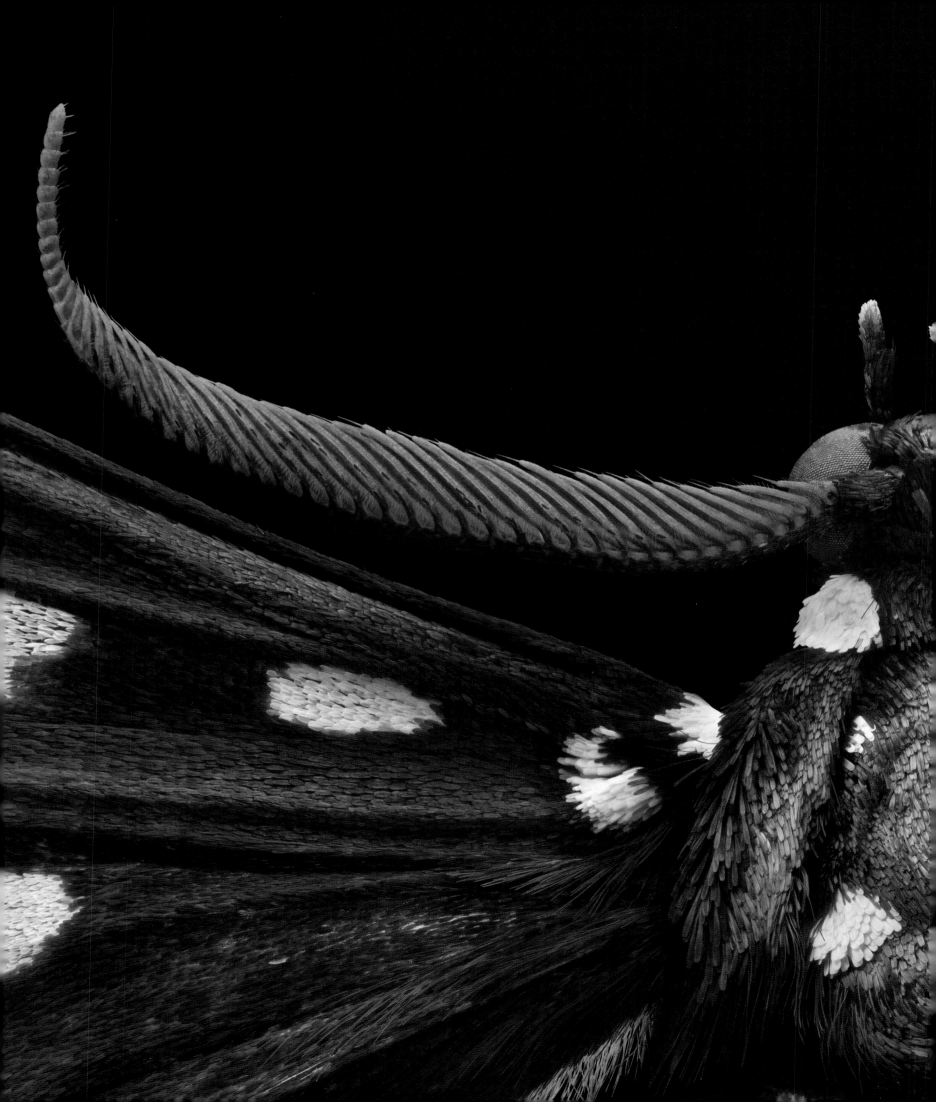

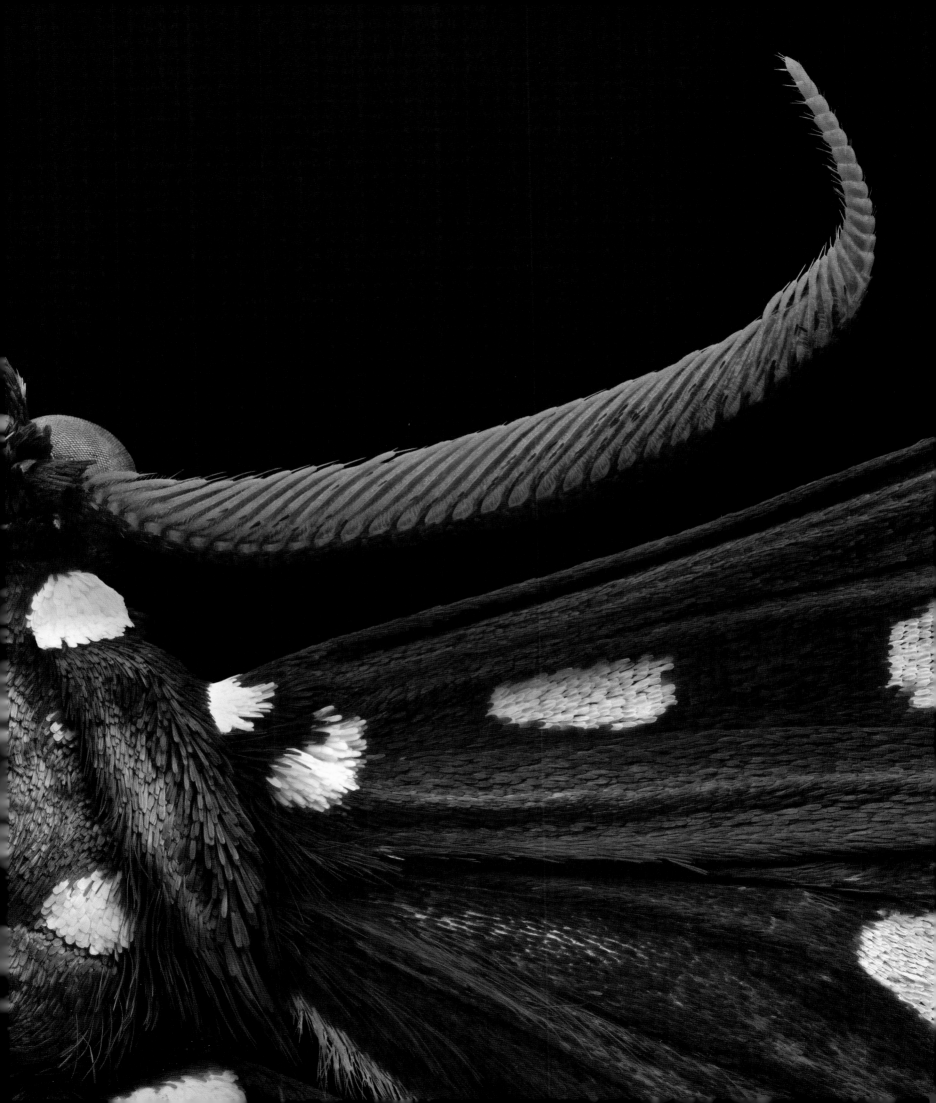

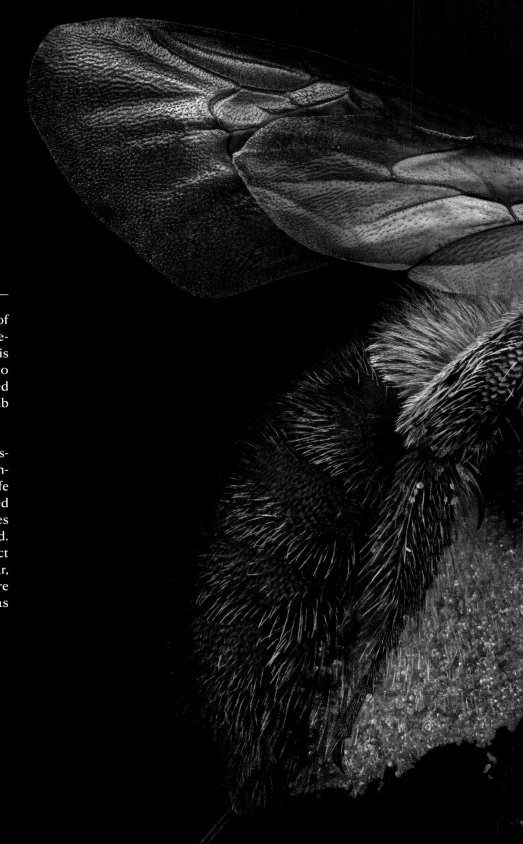

BLUE CALAMINTHA BEE
Osmia calaminthae

Notice the bright yellow under the abdomen of this bee—that's pollen, and females of this species carry it back to their nests this way. This pollen almost certainly came from one of two species of mint plants that live, like the imperiled blue calamintha bee, in Florida's dwindling scrub regions, and on which the bees rely.

The host mint plants are very rare, putting pressure on the blue calamintha bees. In 2015, conservationists petitioned the U.S. Fish and Wildlife Service to add the bees to the U.S. endangered species list, which would provide the species with protection, but so far that hasn't happened. And while it's hard to say for certain, since insect populations often fluctuate from year to year, researchers estimate the numbers of these rare blue bees may have dropped by as much as 90 percent.

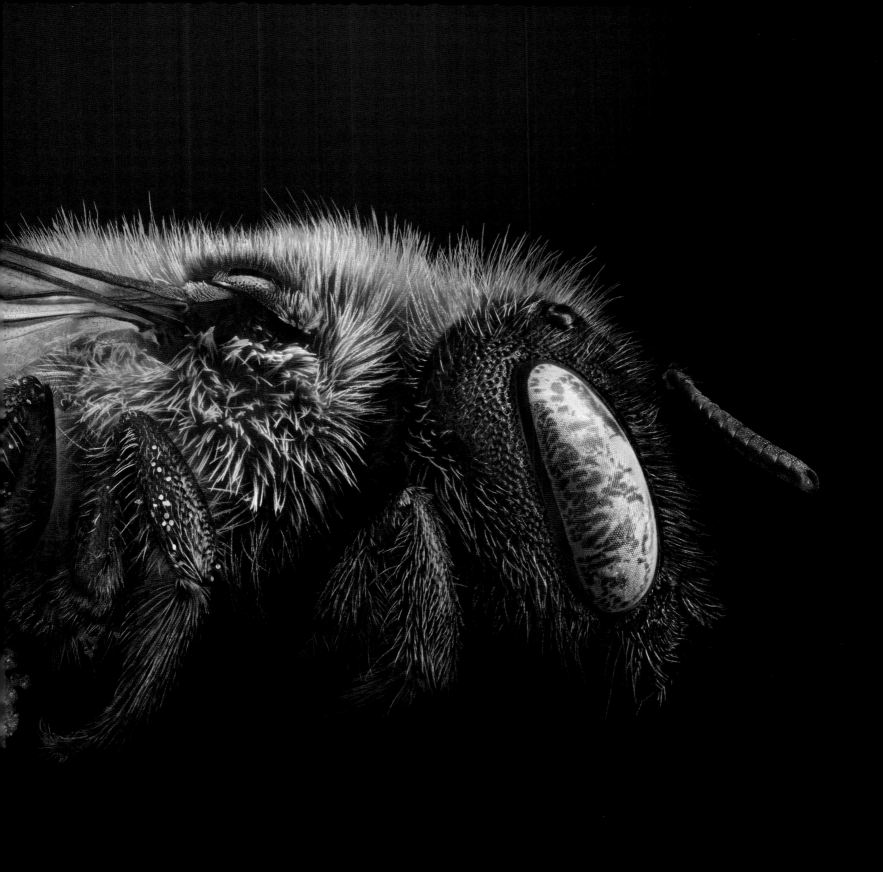

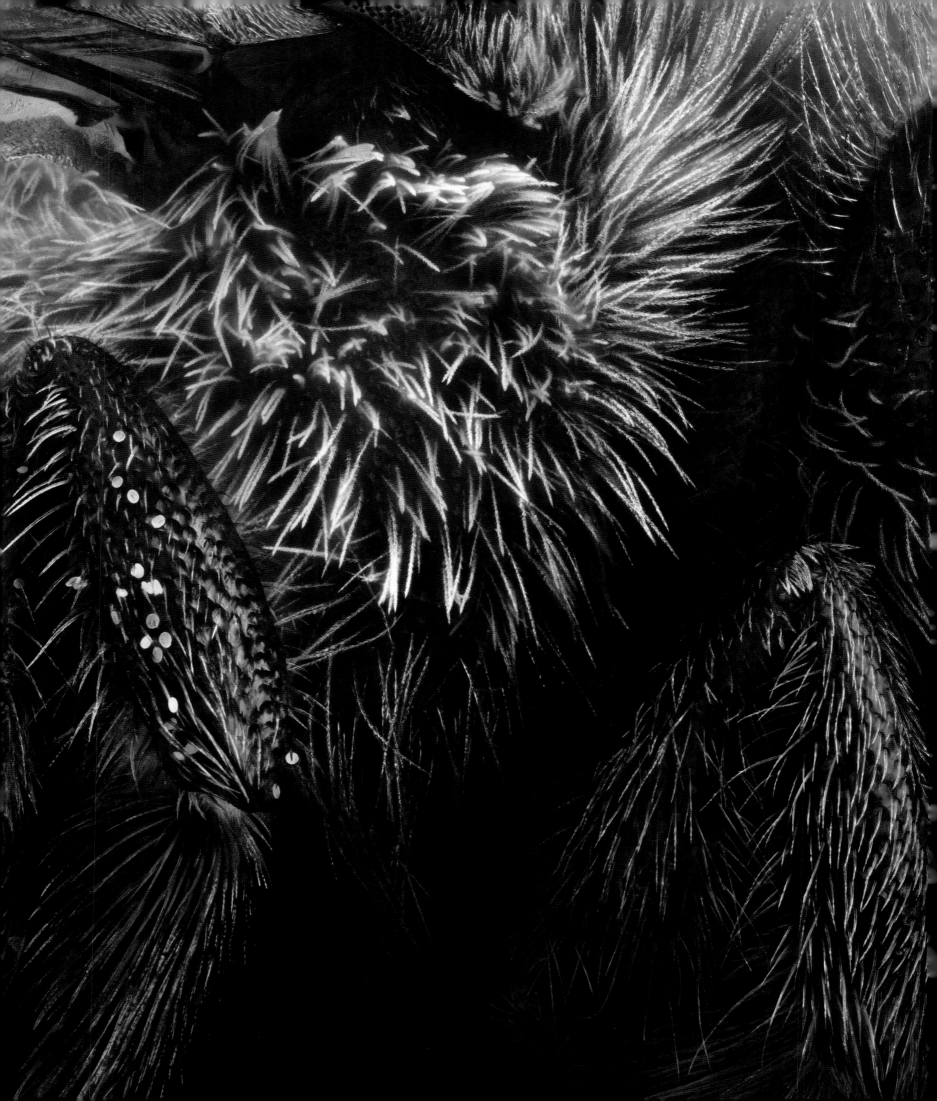

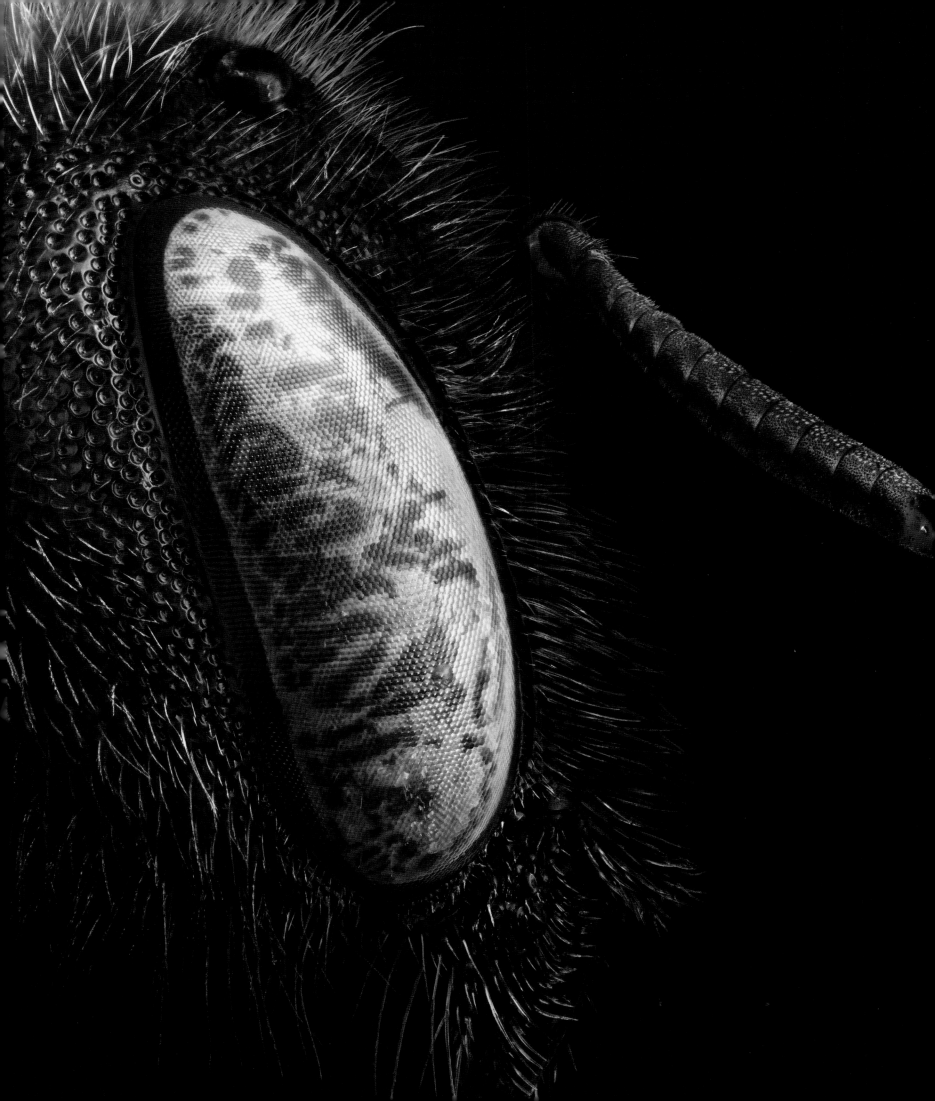

JOHNSON'S WATERFALL
GROUND BEETLE

Pterostichus johnsoni

Along mossy, shaded forest creeks in western
Oregon and Washington State, these predatory
beetles hunt and scavenge for insects and other
small animals among the rocks.

In their forest habitat, logging can damage water-
ways and threaten life in and along the water. But
there are no direct conservation programs for
this small, sensitive species. Sometimes, however,
protections for one species can afford some pro-
tection for others in the same habitat.

In this case, salmon swim in waters near these
ground beetles, and there are federal and state
regulations aimed at trying to protect the fish. In
Washington State, government ecologists require
loggers to keep broad stands of trees along the
edges of salmon streams. These buffer zones may
shield the beetles' streamside haunts from some
logging impacts.

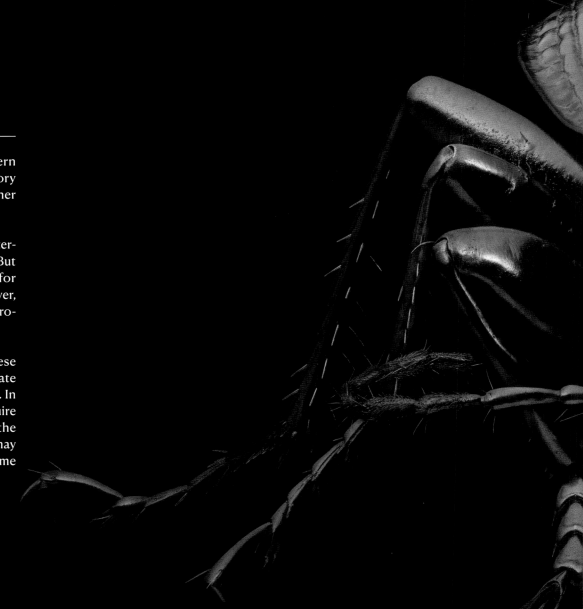

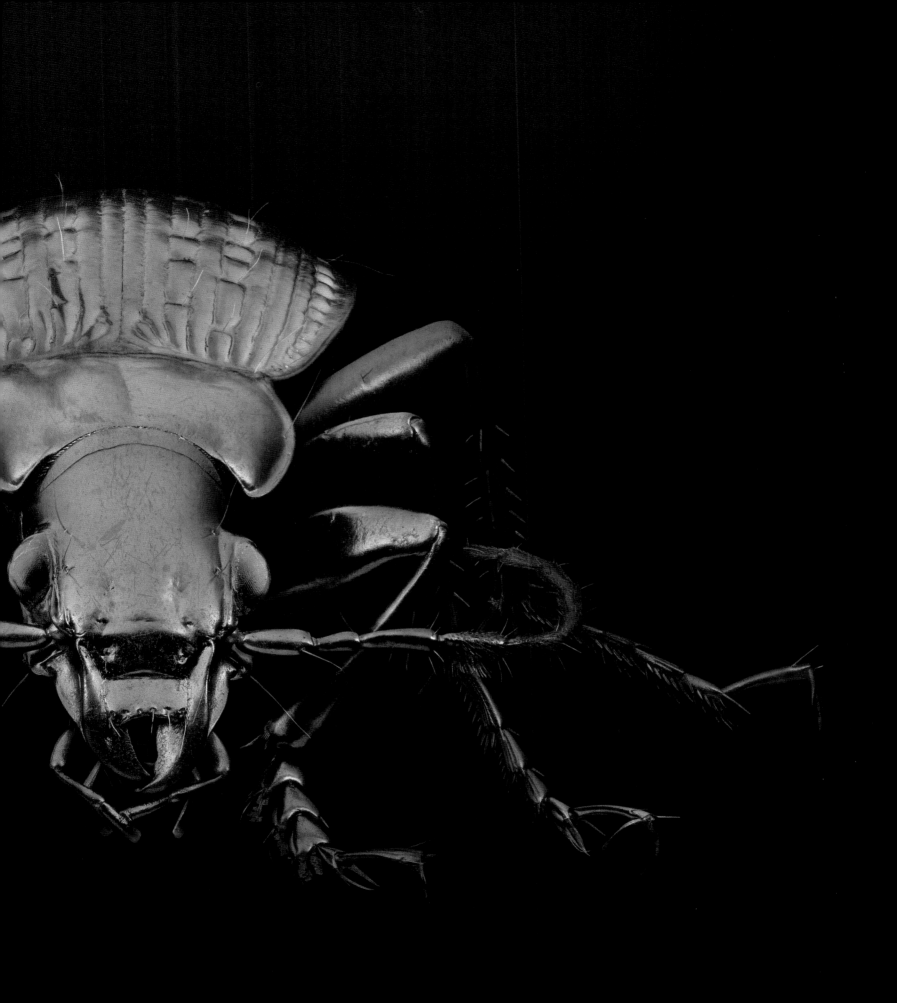

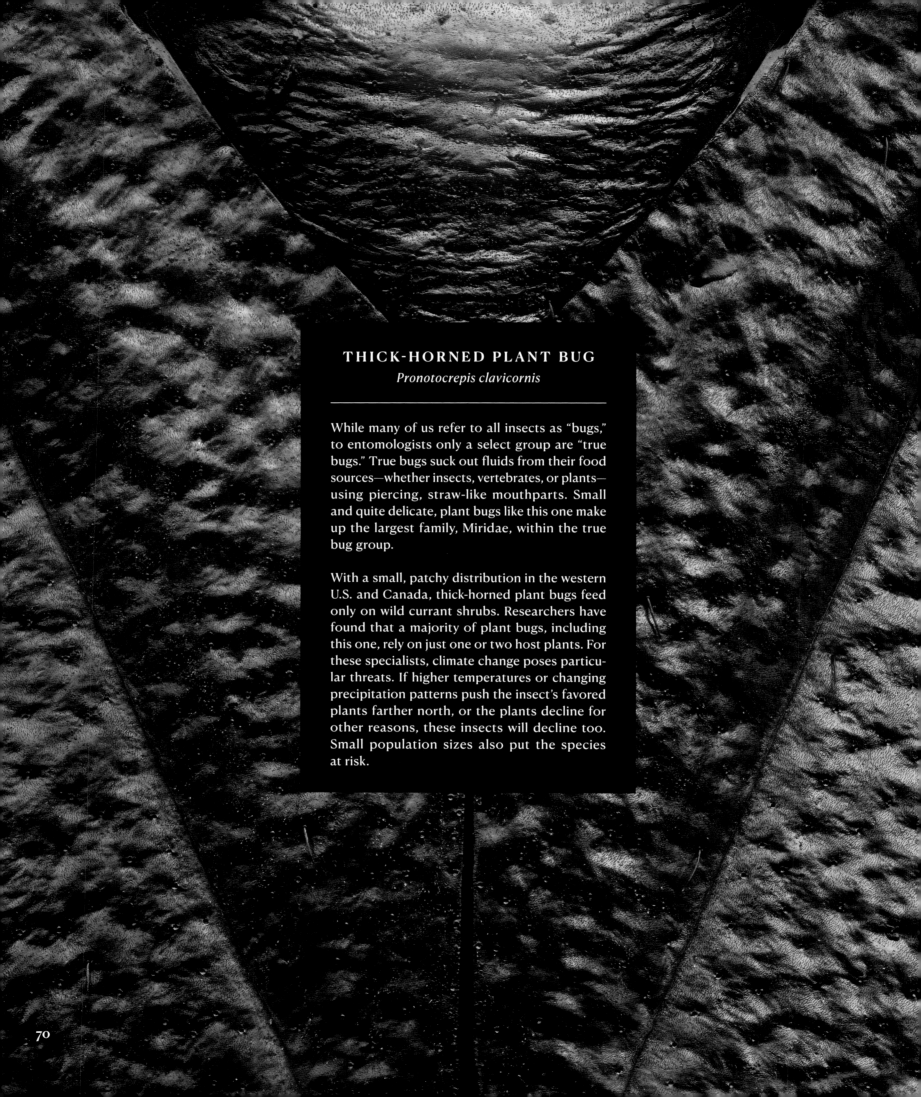

THICK-HORNED PLANT BUG
Pronotocrepis clavicornis

While many of us refer to all insects as "bugs," to entomologists only a select group are "true bugs." True bugs suck out fluids from their food sources—whether insects, vertebrates, or plants—using piercing, straw-like mouthparts. Small and quite delicate, plant bugs like this one make up the largest family, Miridae, within the true bug group.

With a small, patchy distribution in the western U.S. and Canada, thick-horned plant bugs feed only on wild currant shrubs. Researchers have found that a majority of plant bugs, including this one, rely on just one or two host plants. For these specialists, climate change poses particular threats. If higher temperatures or changing precipitation patterns push the insect's favored plants farther north, or the plants decline for other reasons, these insects will decline too. Small population sizes also put the species at risk.

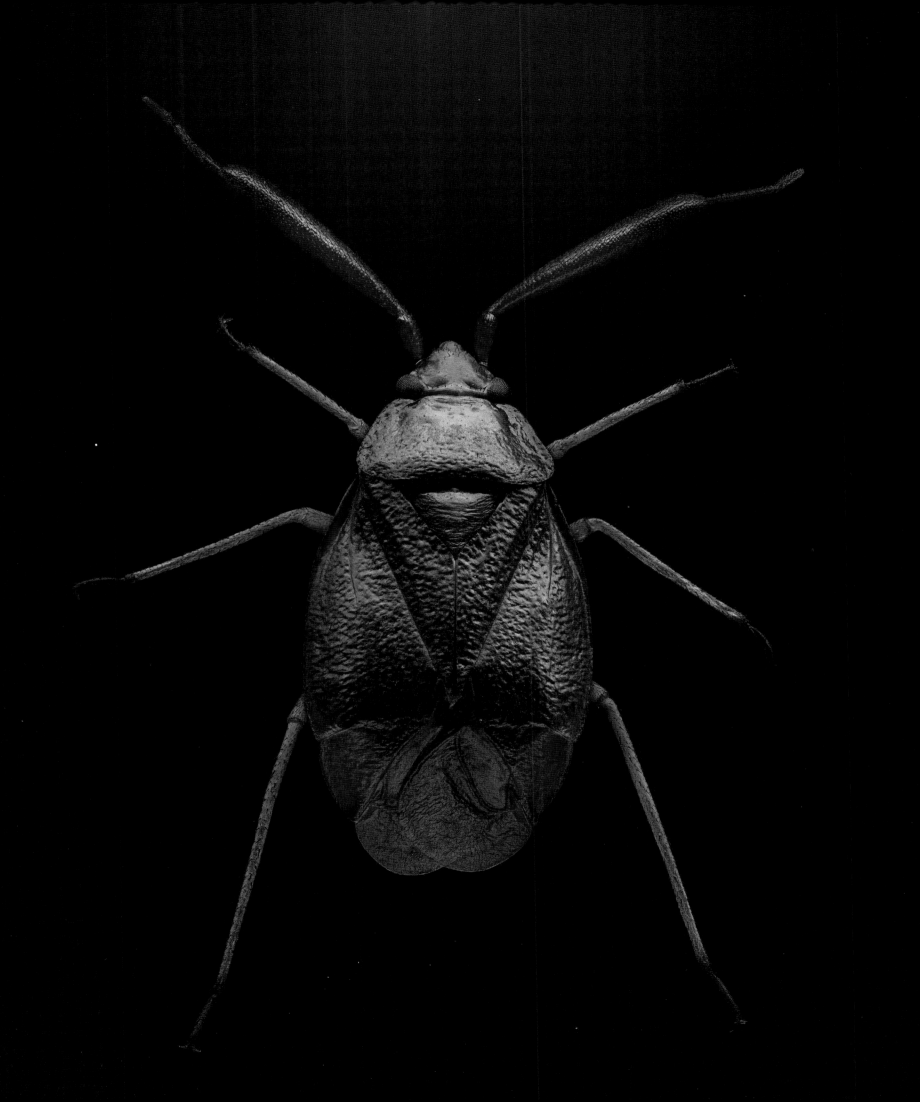

EUROPEAN HORNET
Vespa crabro

Known for their large size and painful stings, hornets can evoke fear and anxiety. But most species of these social wasps, including European hornets like this one, are not aggressive unless their nests are threatened. Native to Europe and Asia and also found in eastern North America, European hornets construct their paper-like nests in hollows high in buildings or treetops.

A protected species in Germany, they face threats, including other hornets. In recent decades, invasive hornet species have been preying on honeybees and sometimes disrupting European farmers' ability to pollinate crops. Today, researchers are studying whether a newly arrived invasive species may also disrupt the European hornets' ability to find insect food. Climate change may be affecting European hornets too: A survey in England and Scotland found that over the past fifty years the wasps have moved northward, potentially in response to warming conditions.

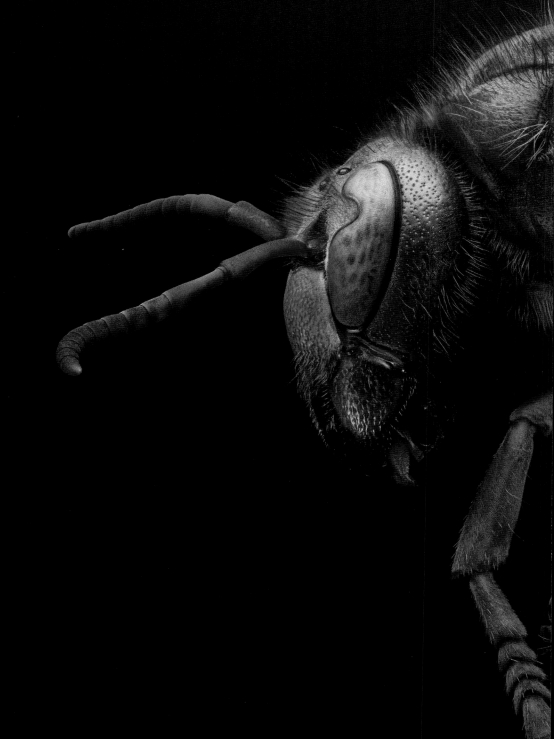

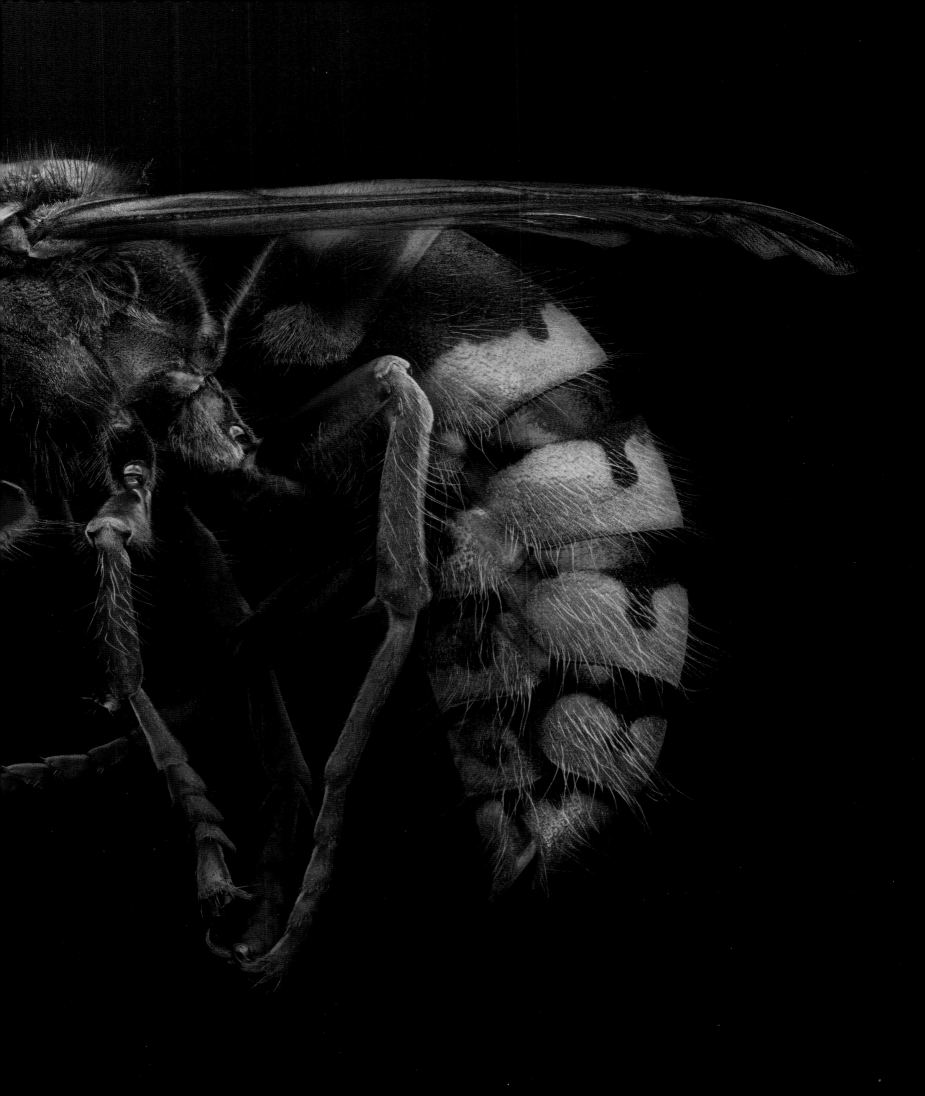

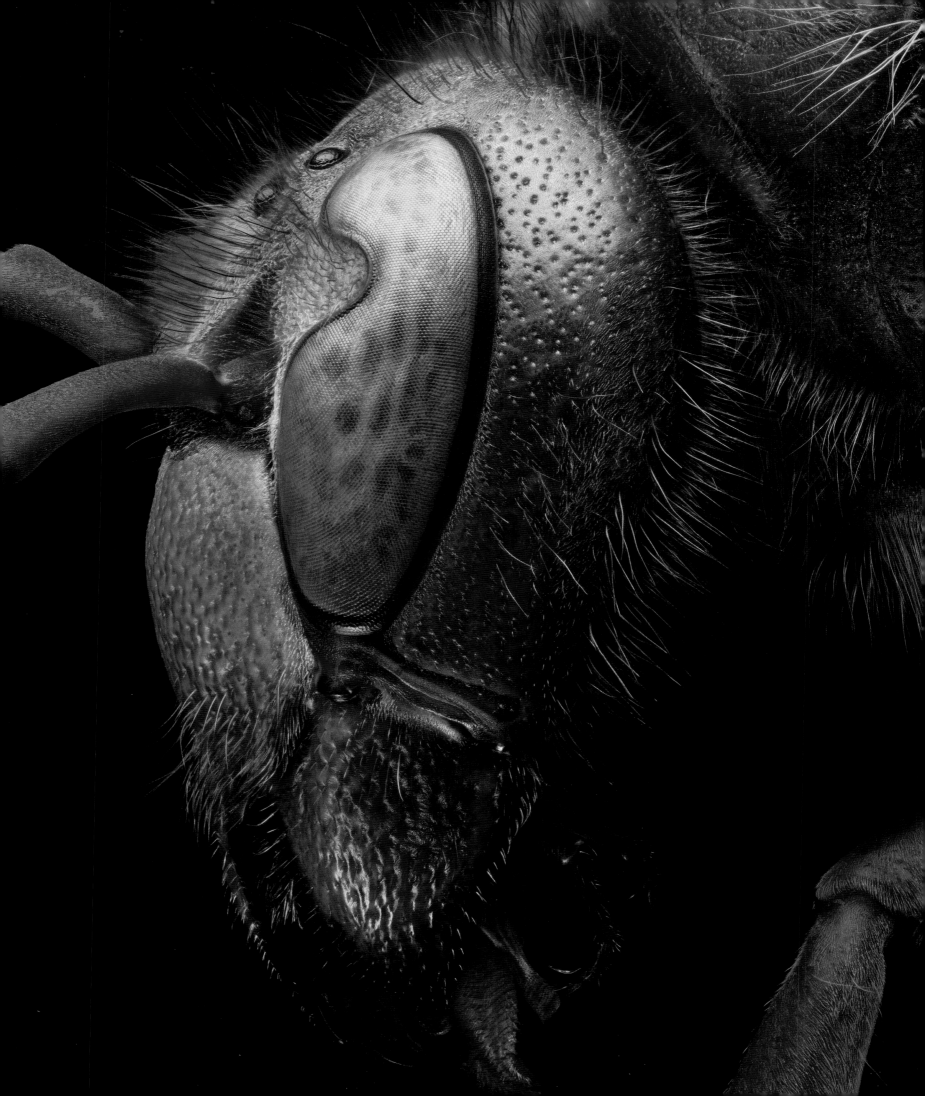

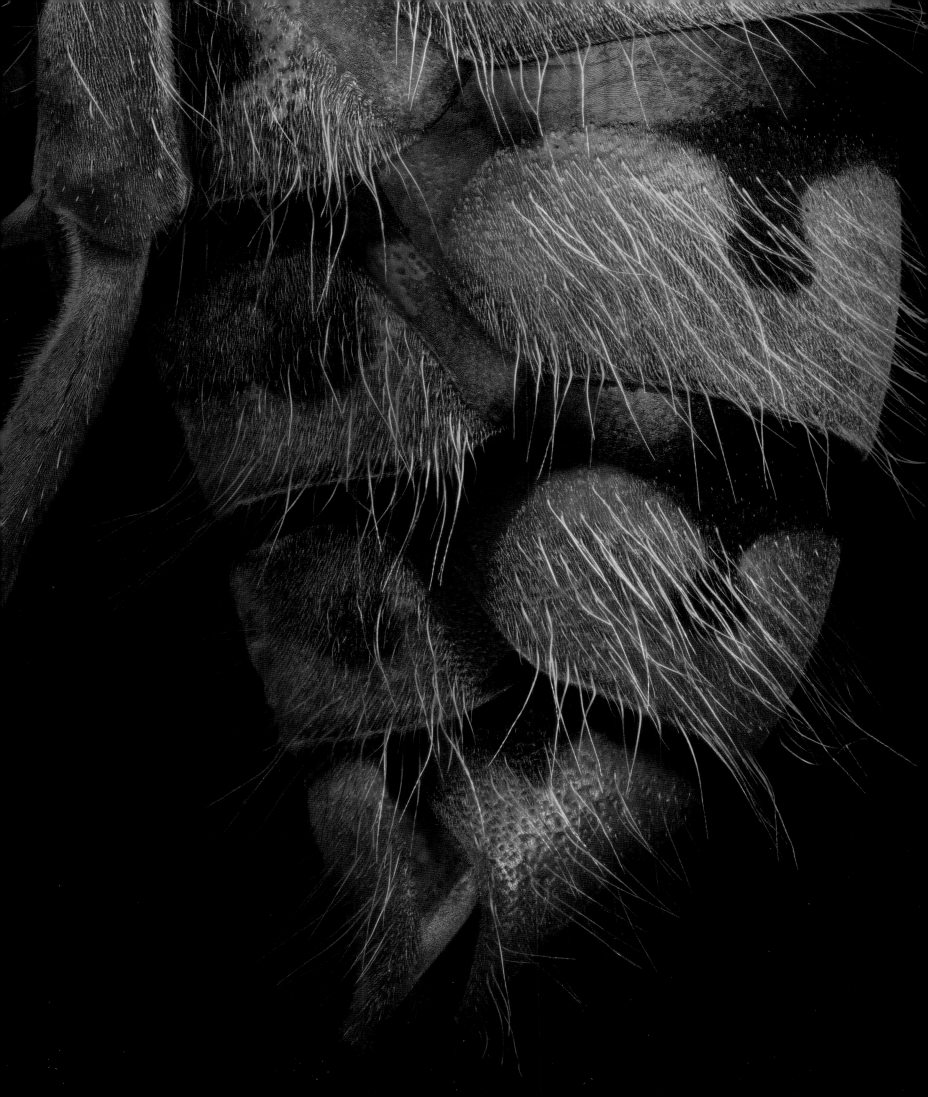

PURITAN TIGER BEETLE
Ellisoptera puritana

These tiger beetles may be small, but with their very long legs and fierce jaws, they are fast and formidable hunters, running down insects and small crustaceans near the waters of the Chesapeake Bay and along the Connecticut River.

Today, these predators are in severe decline, down to just a few remaining populations. Because their habitat includes popular beaches, their ground nests can be trampled or driven over by beachgoers. Along the Connecticut River, dams and modified shorelines have changed the natural river patterns that they relied on. And extreme weather events due to climate change have made flooding more common and more severe than in the past.

But a diverse team of students, volunteers, and federal and state biologists has been working on ways to help this species survive. At the University of Massachusetts-Amherst, researchers learned to rear the larvae in a laboratory in order to make new populations. Releasing tiny animals into the wild is challenging. But for several years, the team placed lab-reared larvae at several Connecticut River sites, and returning to those places in the summer of 2021, they found more Puritan tiger beetles than ever before.

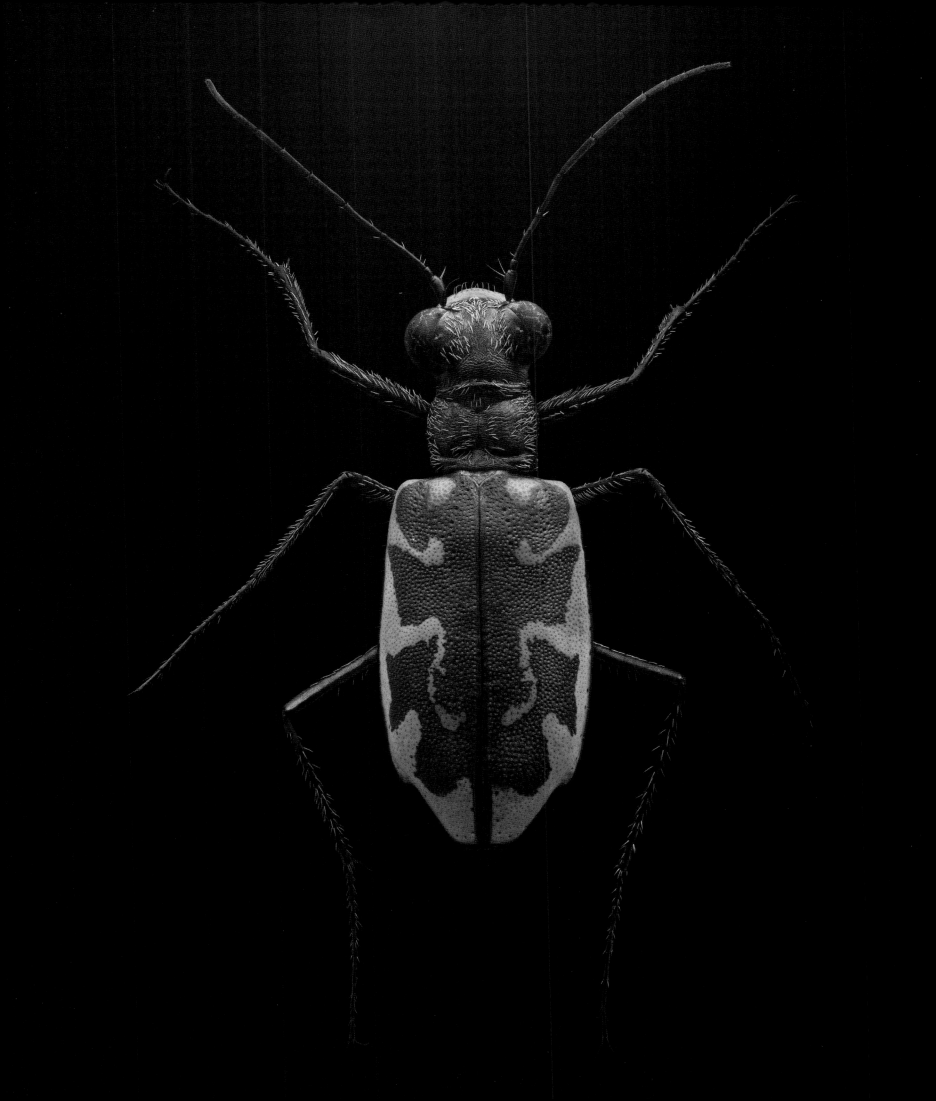

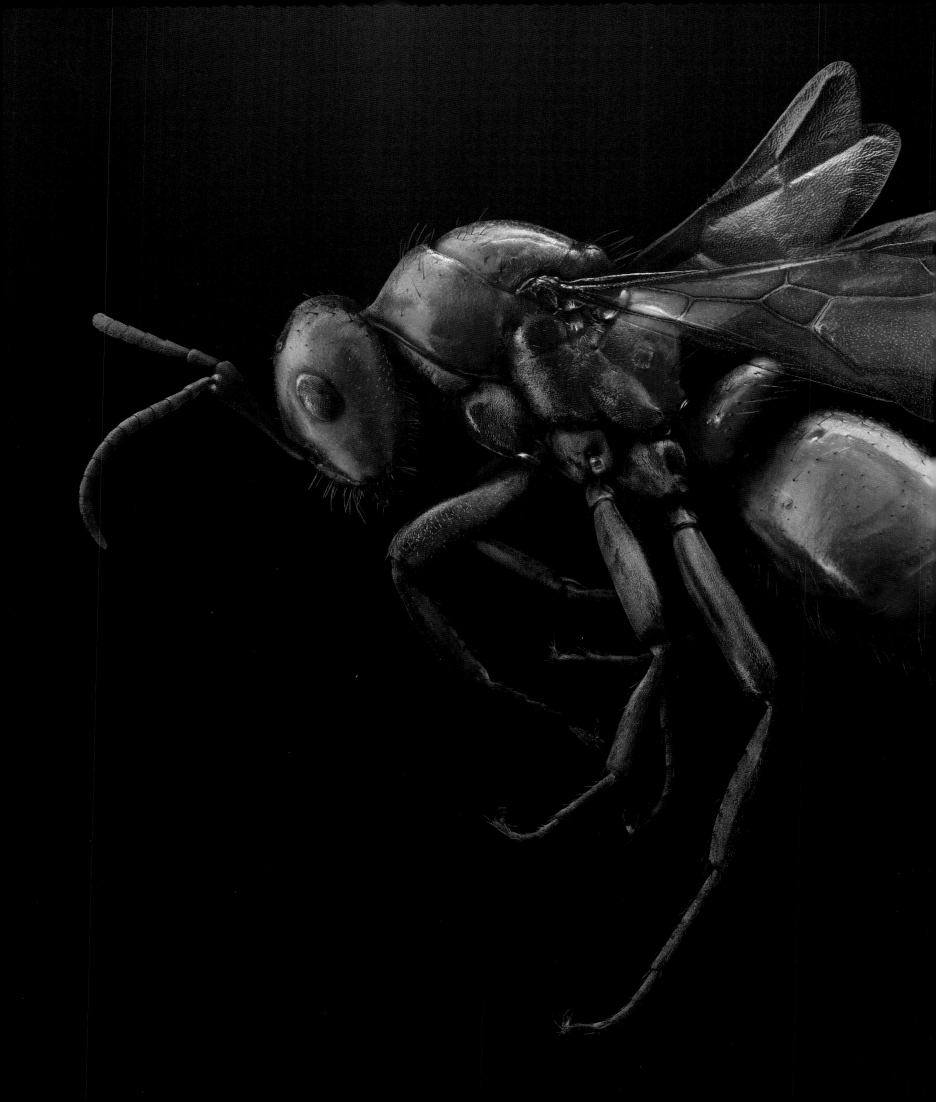

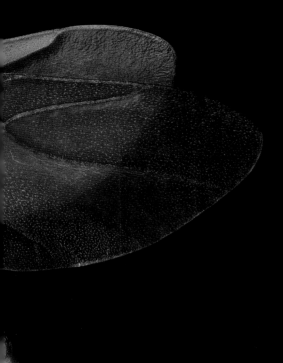

SHINING AMAZON ANT
Polyergus lucidus

All ants live in social colonies, with a queen, female workers, and, for a time, males for reproduction. But unlike most ant species, *Polyergus lucidus*, found in meadows in the eastern U.S., has an extremely specialized way of rearing its young. A queen of *Polyergus lucidus* invades the nest of a different species, kills their queen, cloaks herself in the host queen's scent, and then becomes the new queen. Worker ants also kidnap members of the other ant species to raise their offspring for them.

Researchers say it can take years for a colony to become established—and once it's gone, it is unlikely to be replaced. Shining Amazon ant colonies require large territories, but there is dwindling ideal habitat in which to create such underground homes. In Florida, for instance, barely 3 percent of the longleaf pine forests where the ants are found is intact, so continued protection of lands such as those in Apalachicola National Forest is key.

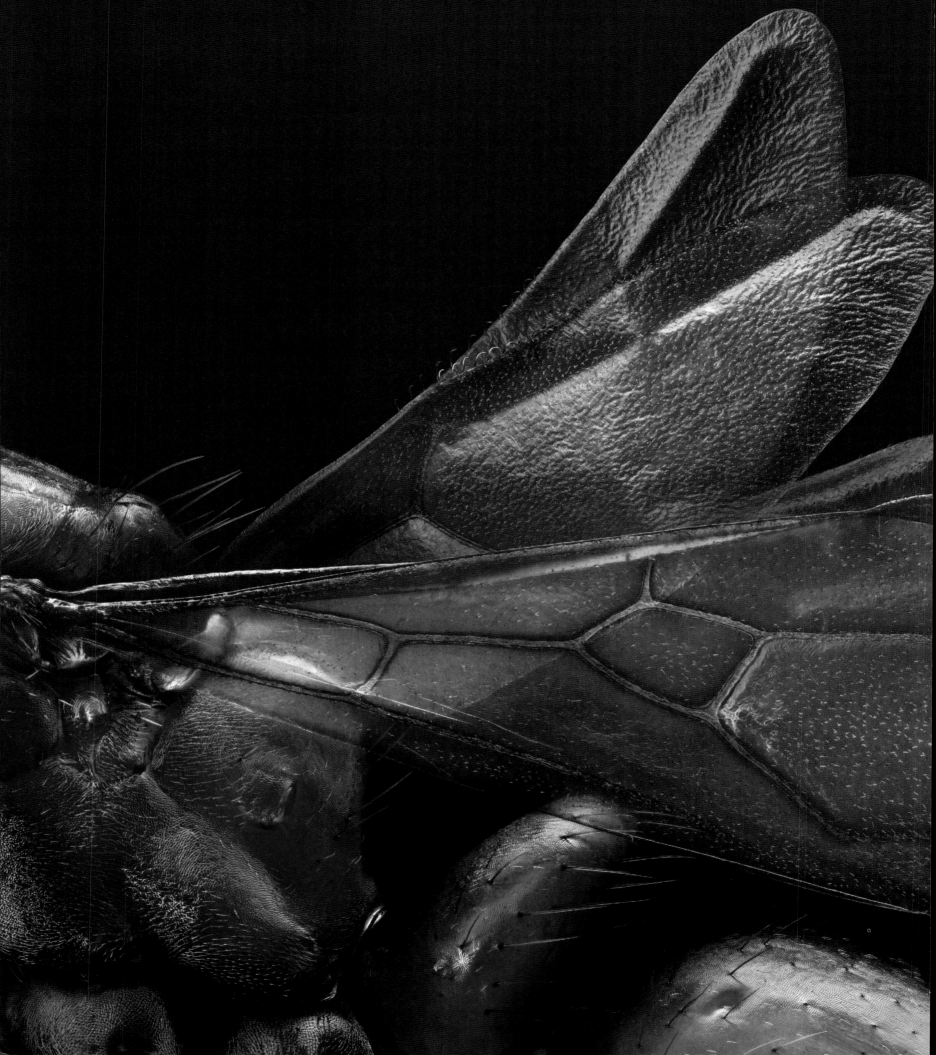

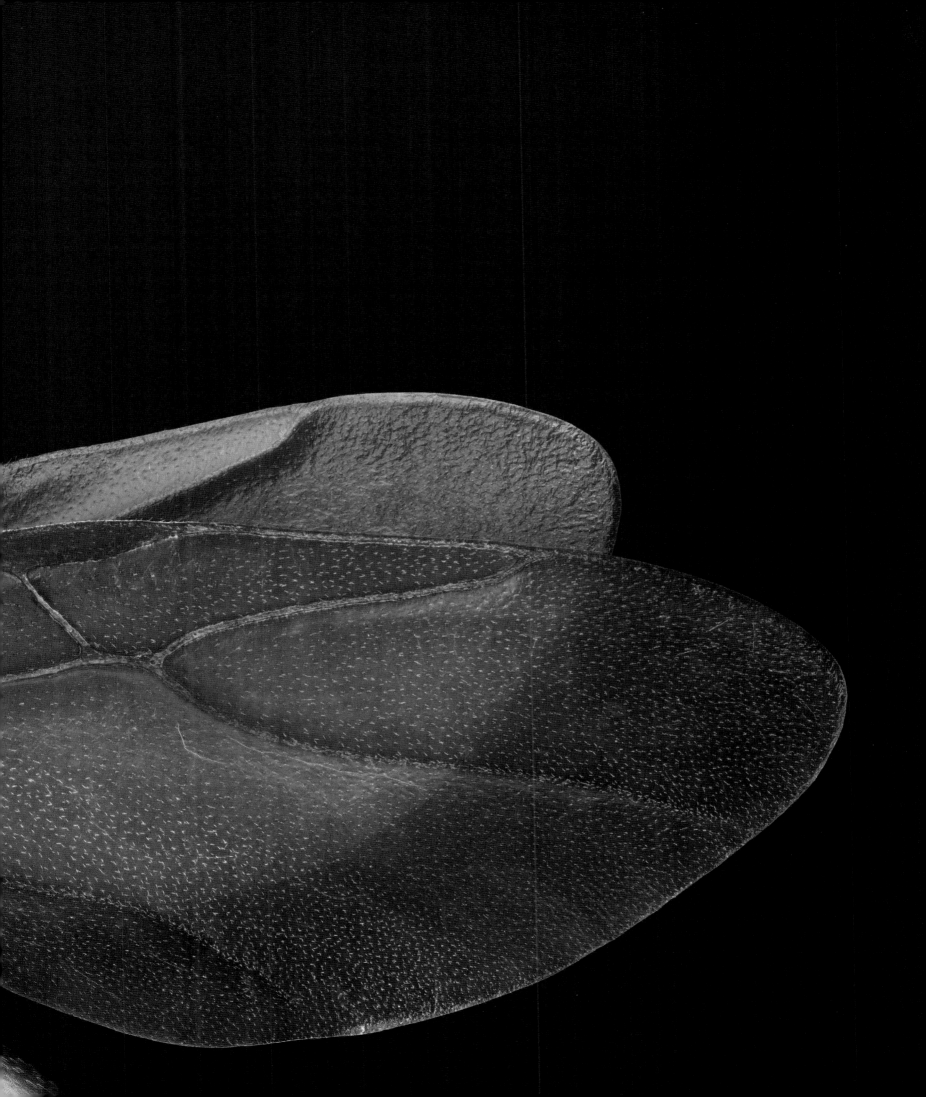

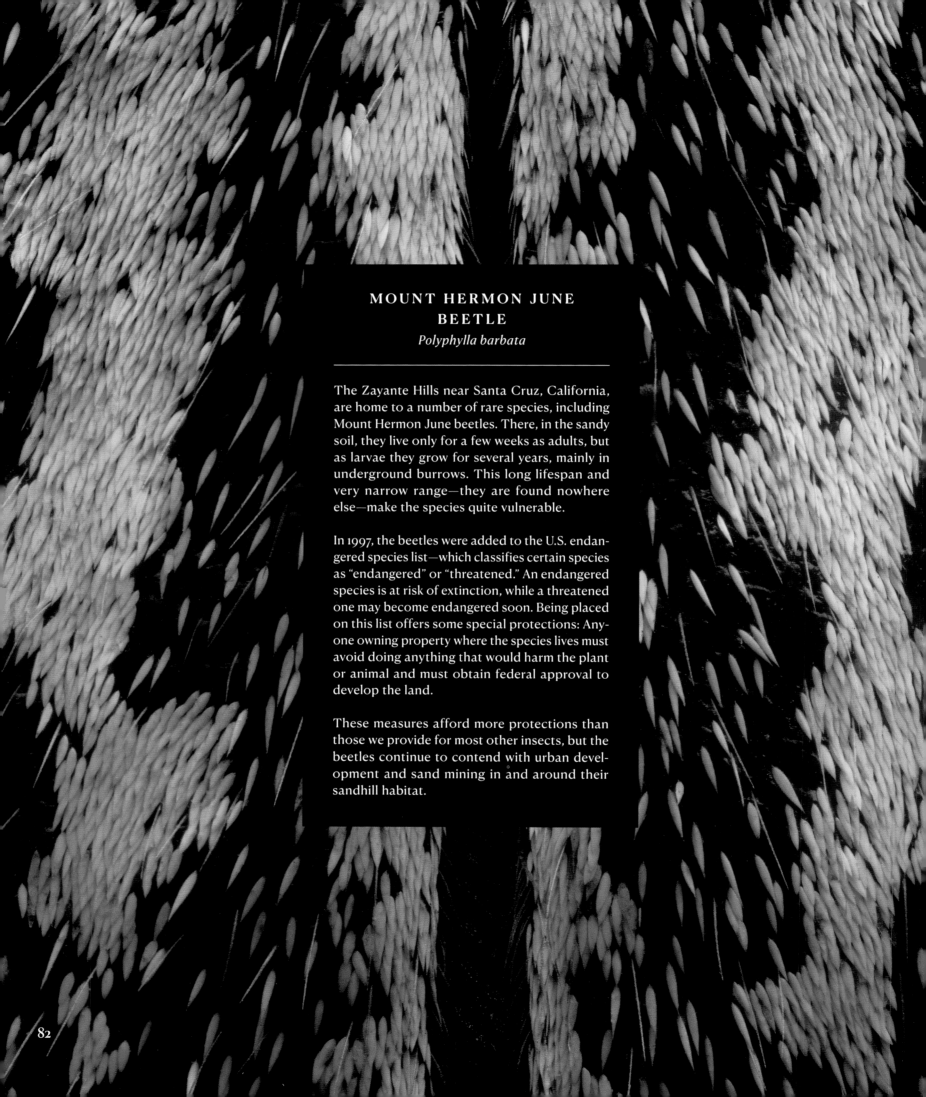

MOUNT HERMON JUNE BEETLE
Polyphylla barbata

The Zayante Hills near Santa Cruz, California, are home to a number of rare species, including Mount Hermon June beetles. There, in the sandy soil, they live only for a few weeks as adults, but as larvae they grow for several years, mainly in underground burrows. This long lifespan and very narrow range—they are found nowhere else—make the species quite vulnerable.

In 1997, the beetles were added to the U.S. endangered species list—which classifies certain species as "endangered" or "threatened." An endangered species is at risk of extinction, while a threatened one may become endangered soon. Being placed on this list offers some special protections: Anyone owning property where the species lives must avoid doing anything that would harm the plant or animal and must obtain federal approval to develop the land.

These measures afford more protections than those we provide for most other insects, but the beetles continue to contend with urban development and sand mining in and around their sandhill habitat.

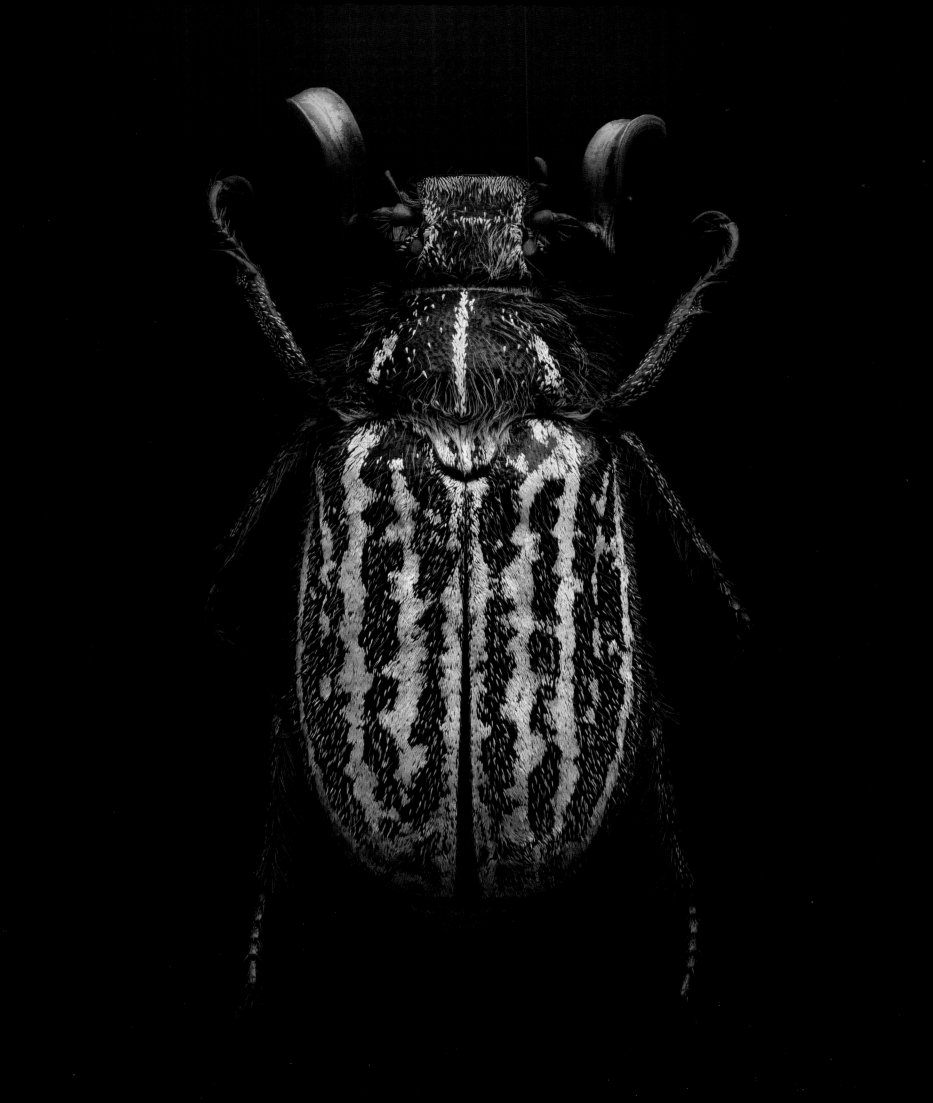

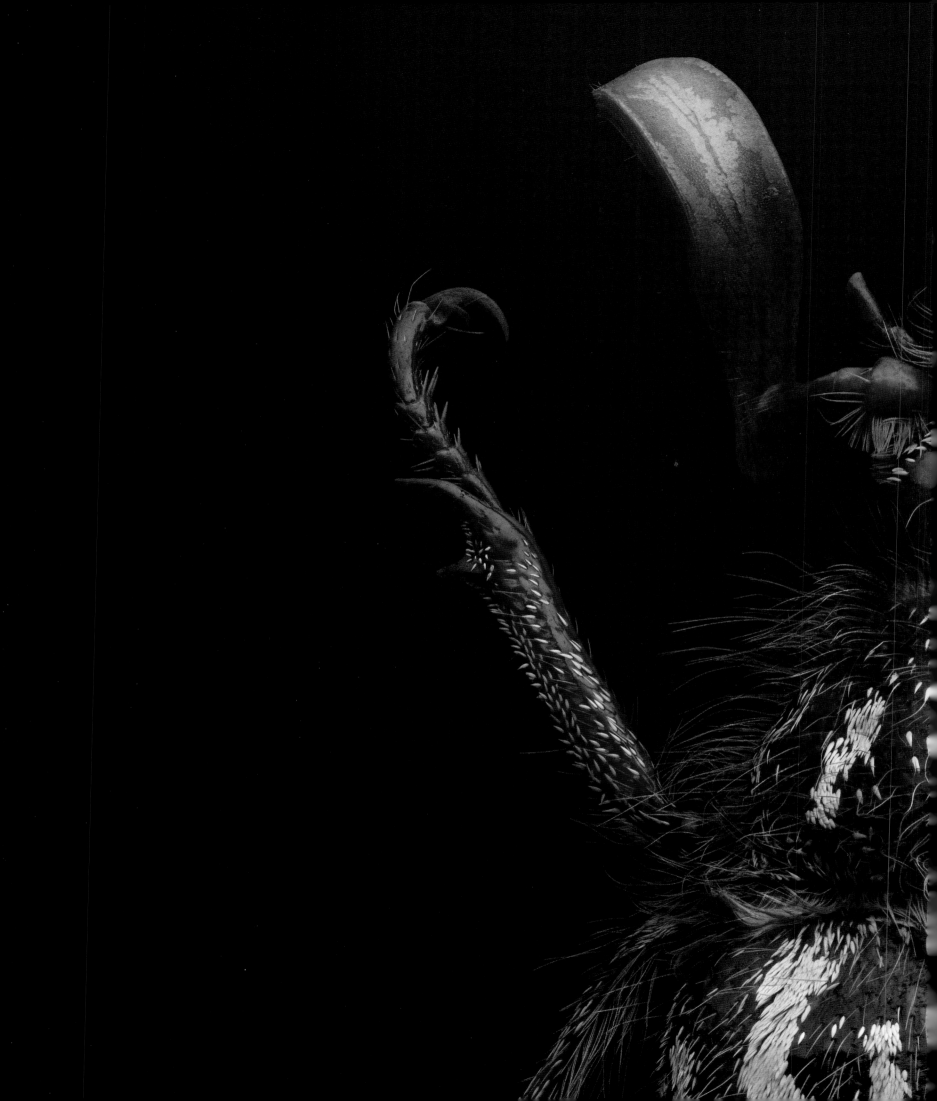

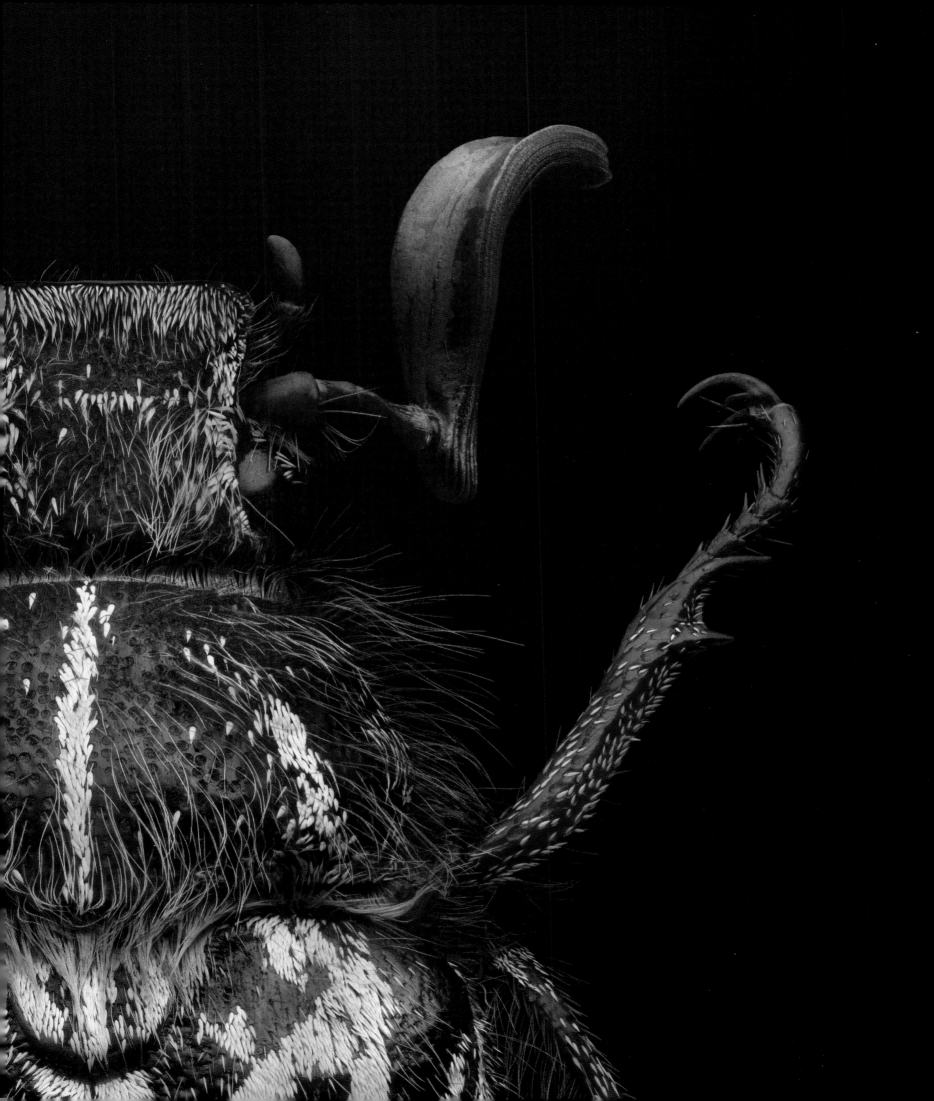

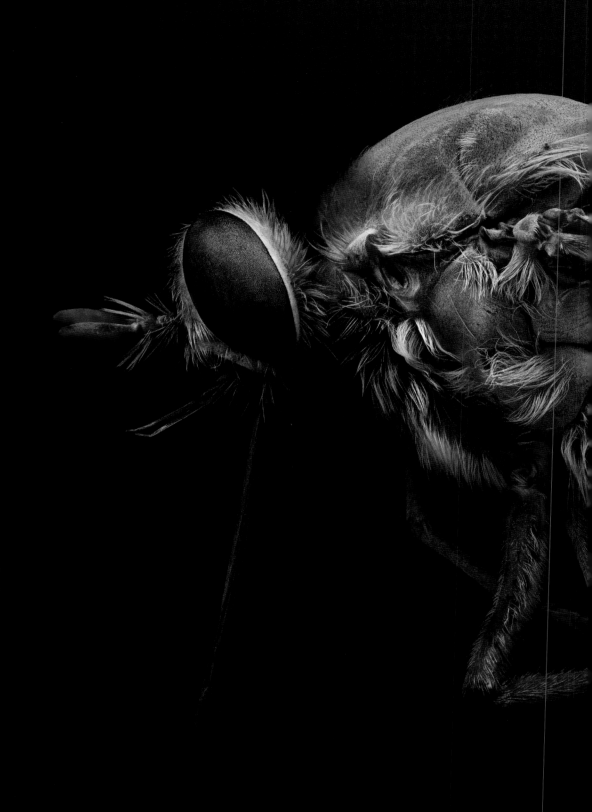

SAN JOAQUIN VALLEY
FLOWER-LOVING FLY
Rhaphiomidas trochilus

Below this fly's eye you'll see a long, thin probos-cis, pointing downward. Many flower-loving flies maneuver these tube-like probes to reach deep into desert wildflowers for nectar. Members of a group of large, silvery-gray flies found only in the southwestern U.S. and northern Mexico, they can fly quickly and hover over flowers, aerial abilities that also make them efficient pollinators.

Once thought to be extinct, this fly was rediscov-ered in 1997 in California's San Joaquin Valley. But scientists estimate that the remaining population is made up of only one hundred to one thousand individuals in a given year. Many factors con-tributed to its near-extinction: Ongoing sand mining threatens its larvae, which are predators of sand-living insects and worms. Centuries of agricultural development have thinned their favored plants. And in the American West, as elsewhere, climate change is intensifying drought and increasing heat waves, creating hazards for this fly—and many other organisms.

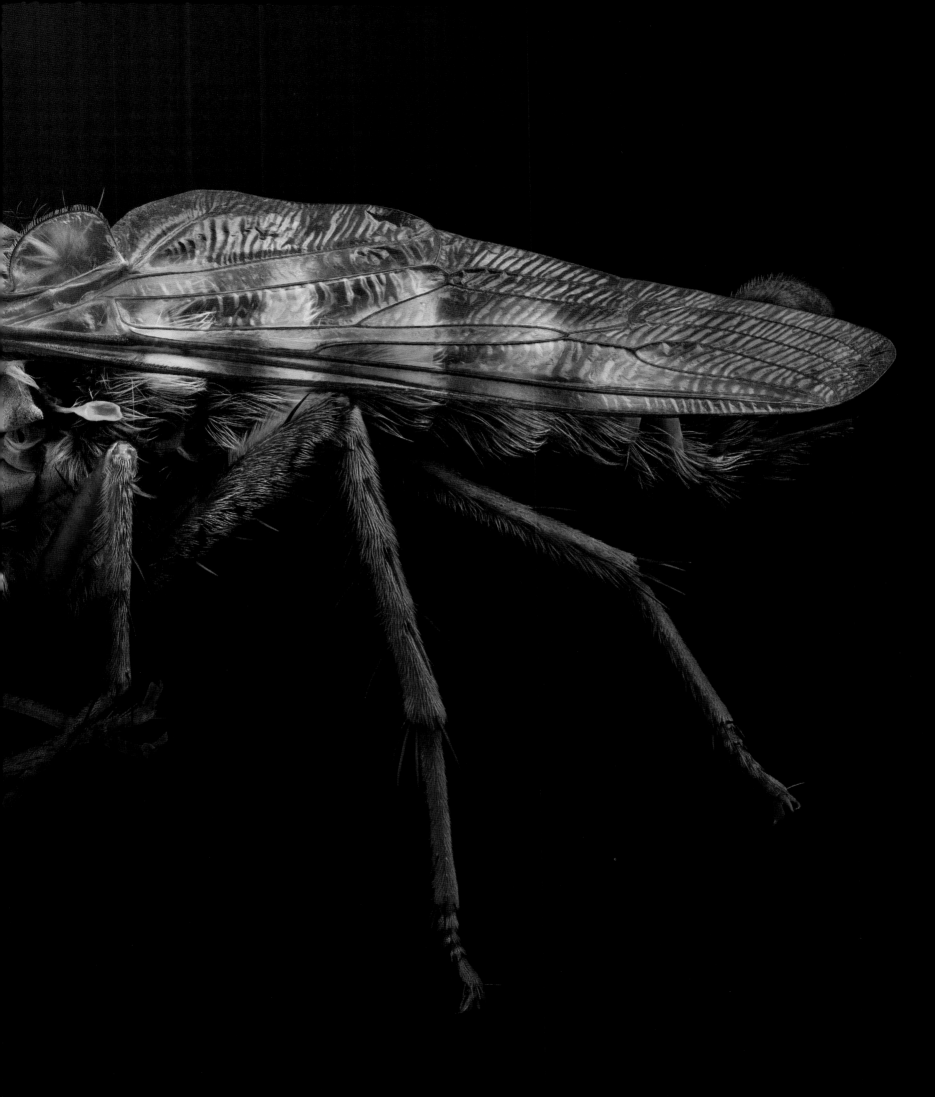

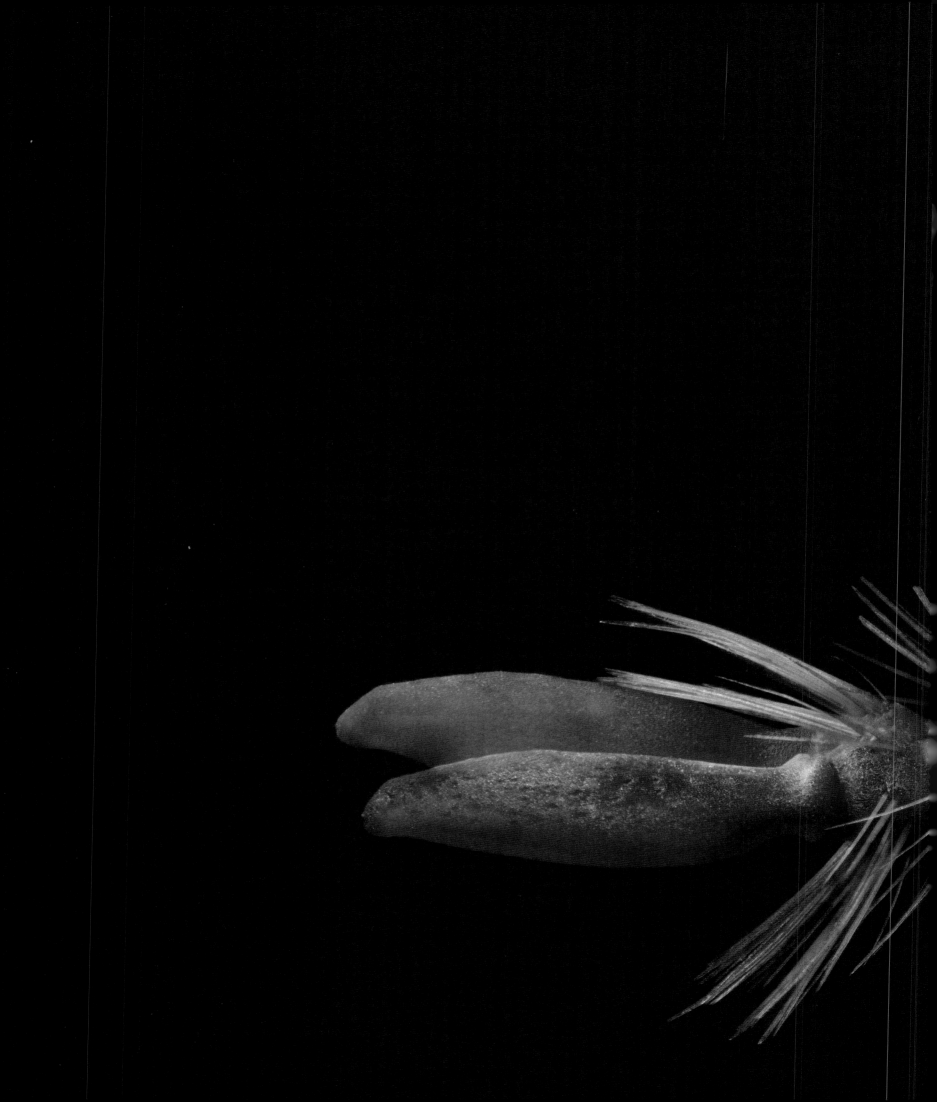

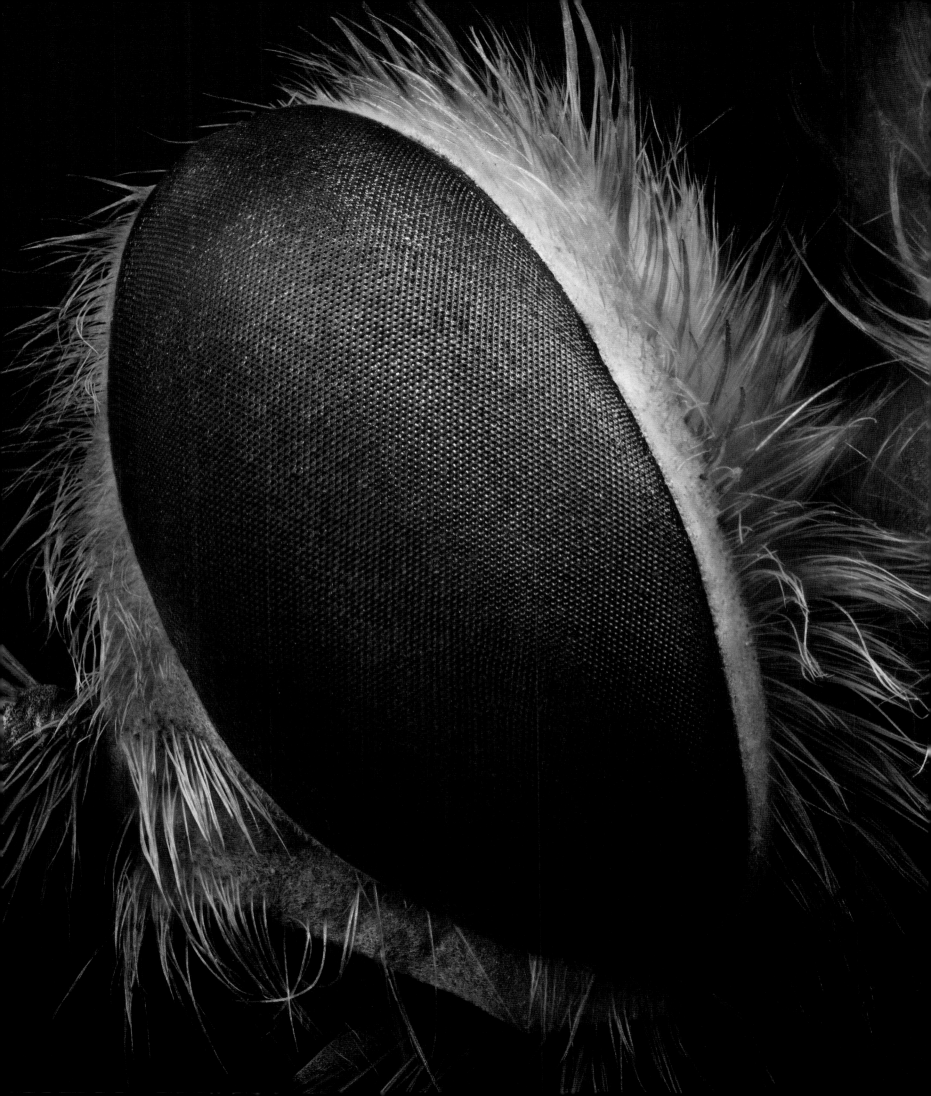

CORAL PINK SAND DUNES TIGER BEETLE

Cicindela albmissima

This colorful tiger beetle looks flashy, but in the pink sand dunes of its Utah habitat, its cream-and-green hues actually help the animal blend in. The cream forewings also help these beetles handle desert heat, by reflecting rather than absorbing sunlight. In the dunes, these tiger beetles are predators—note the insect's curving mandibles, used to capture ants, flies, and other small prey.

The beetles' tiny range lies on public lands, and researchers and wildlife officials there have for years closely monitored them. In low-rainfall years they have found the beetle population falls—a decline that may become even steeper with climate change. A different type of risk comes from people driving off-road vehicles over the dunes. To prevent the larvae in their burrows from being crushed, officials have set aside some conservation areas where the vehicles are now prohibited.

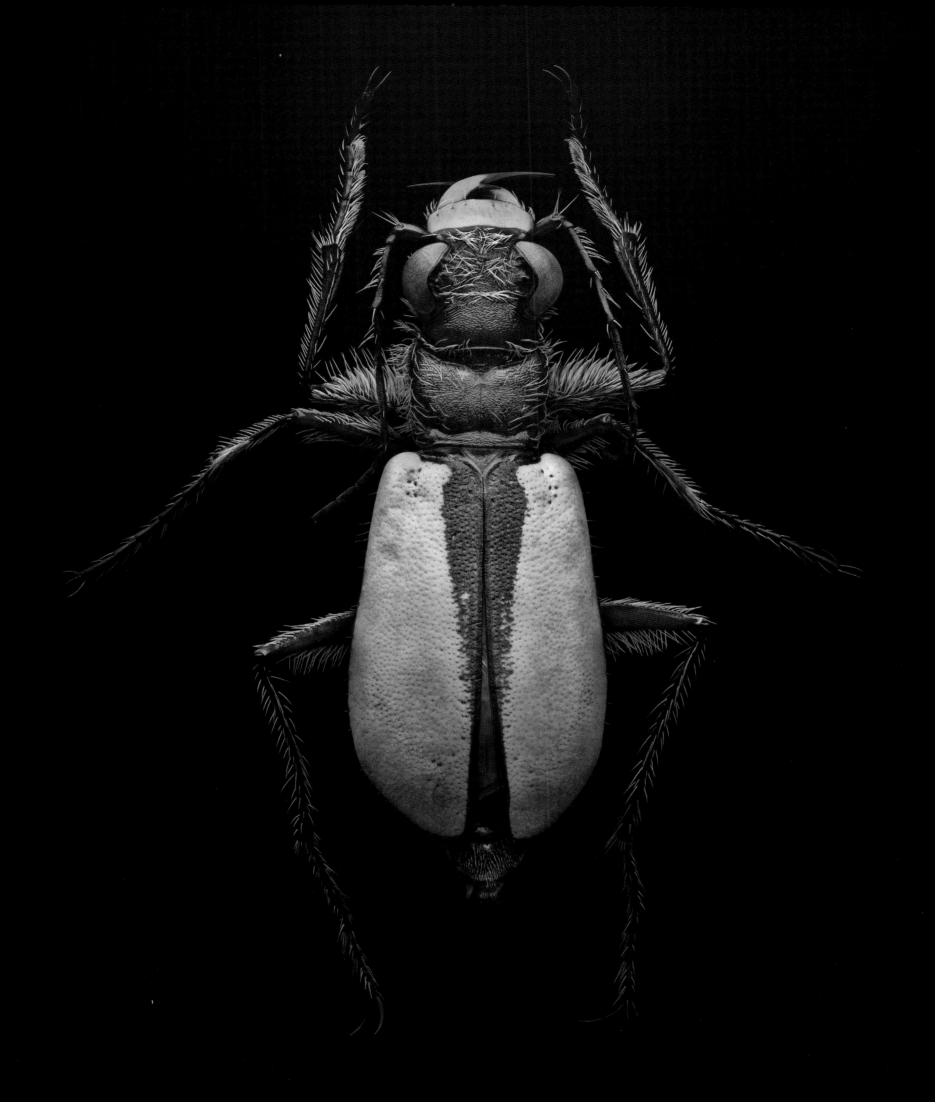

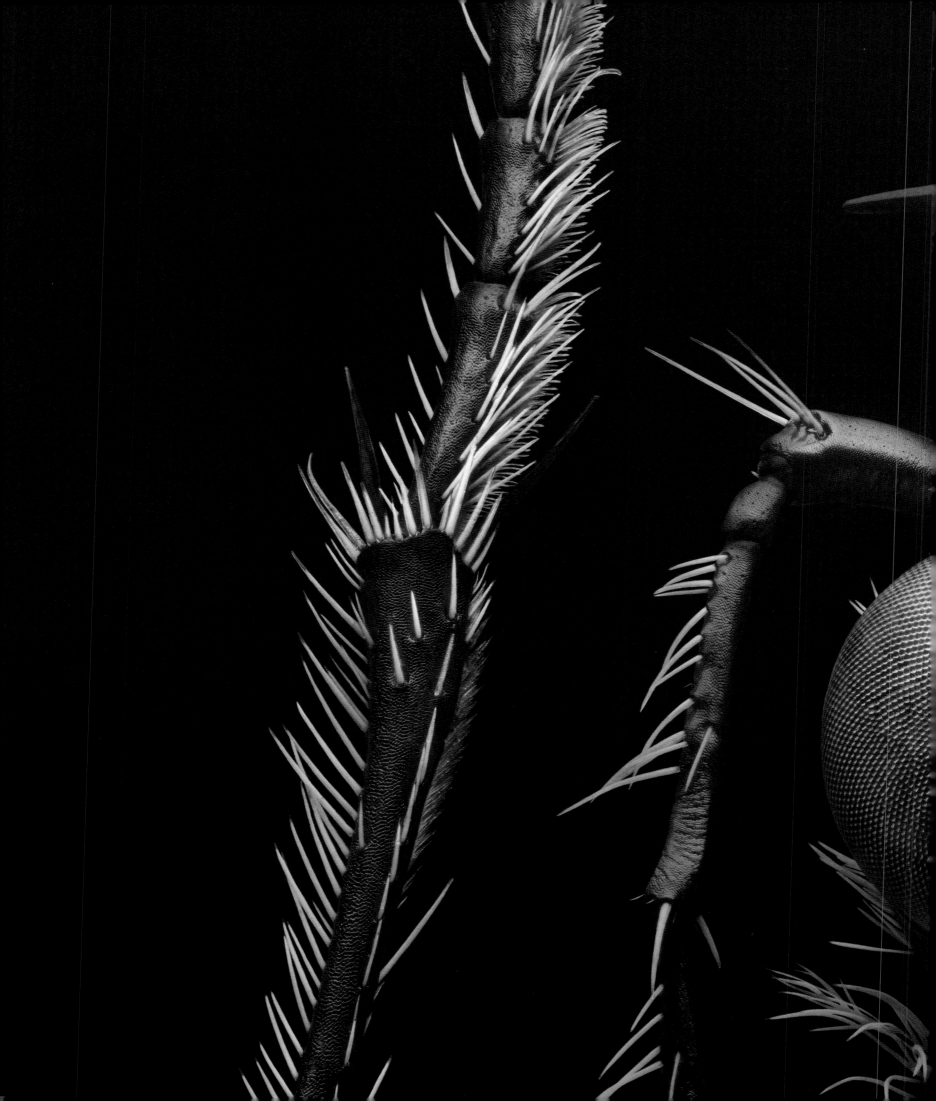

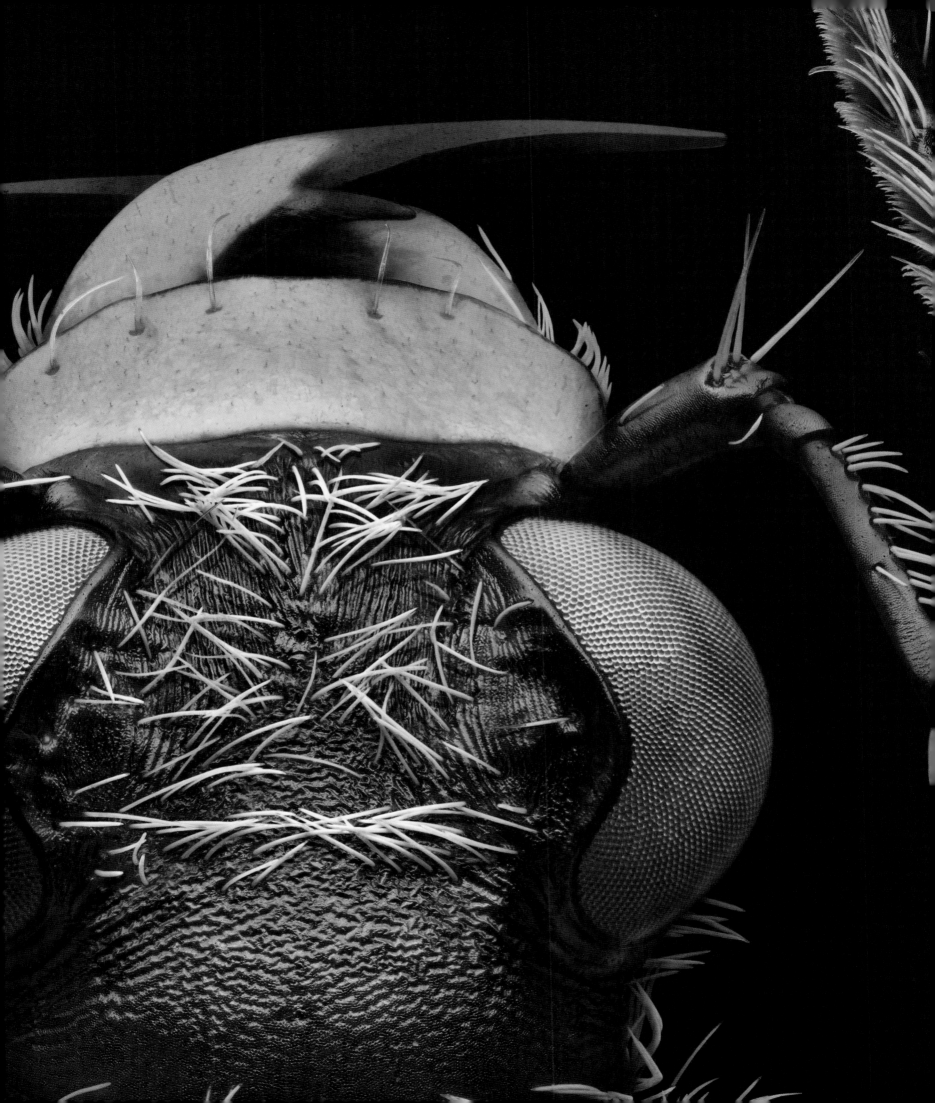

FLORIDA DARK CUCKOO BEE
Stelis ater

We often think of bees living together in a hive, but about 90 percent of bee species are solitary. Among most solitary bees, single females create nests stocked with nectar and pollen for their own young to eat. Cuckoo bees, like *Stelis ater,* rely on different, specialized behaviors to feed their offspring. *Stelis ater* females invade the nest of another bee species and place their eggs inside. After the eggs hatch into larvae, the larvae kill the host bees' offspring and eat their food.

In 2011, researchers at the University of Florida and the American Museum of Natural History identified *Stelis ater*'s host bee for the first time, using a painstaking process to document the bee's nest-raiding behavior. Studies like this one can help researchers figure out how to protect species from extinctions. But for this rare, all-black Florida bee there are no specific protection efforts underway now. Prioritizing preservation of wild landscapes could help this bee—as well as other species.

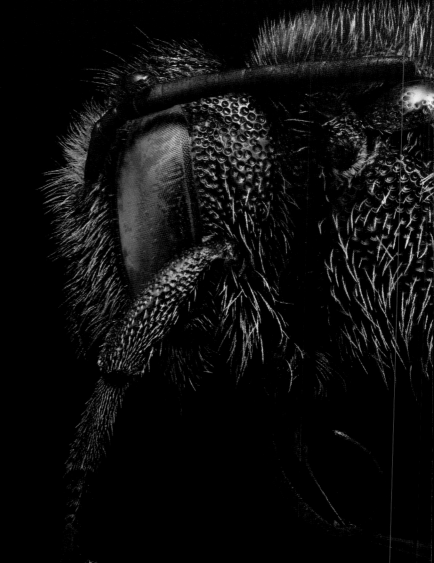

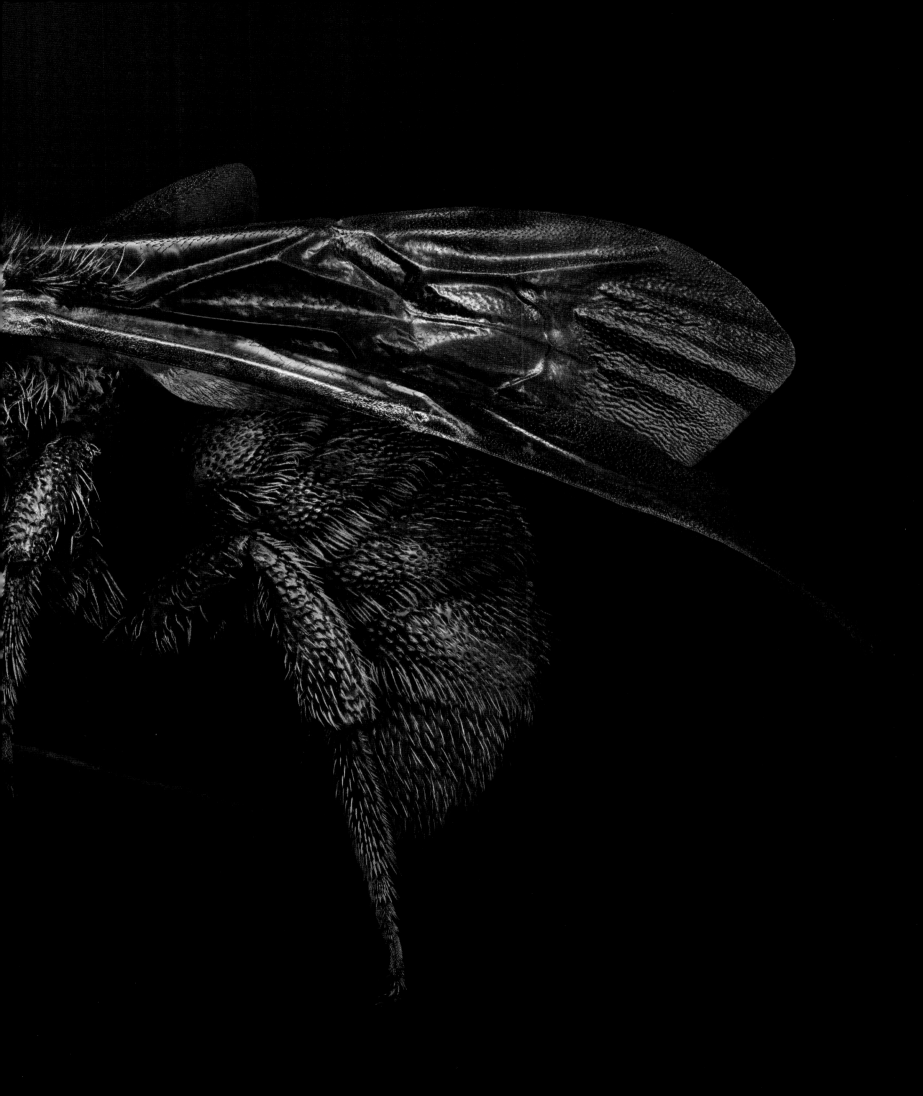

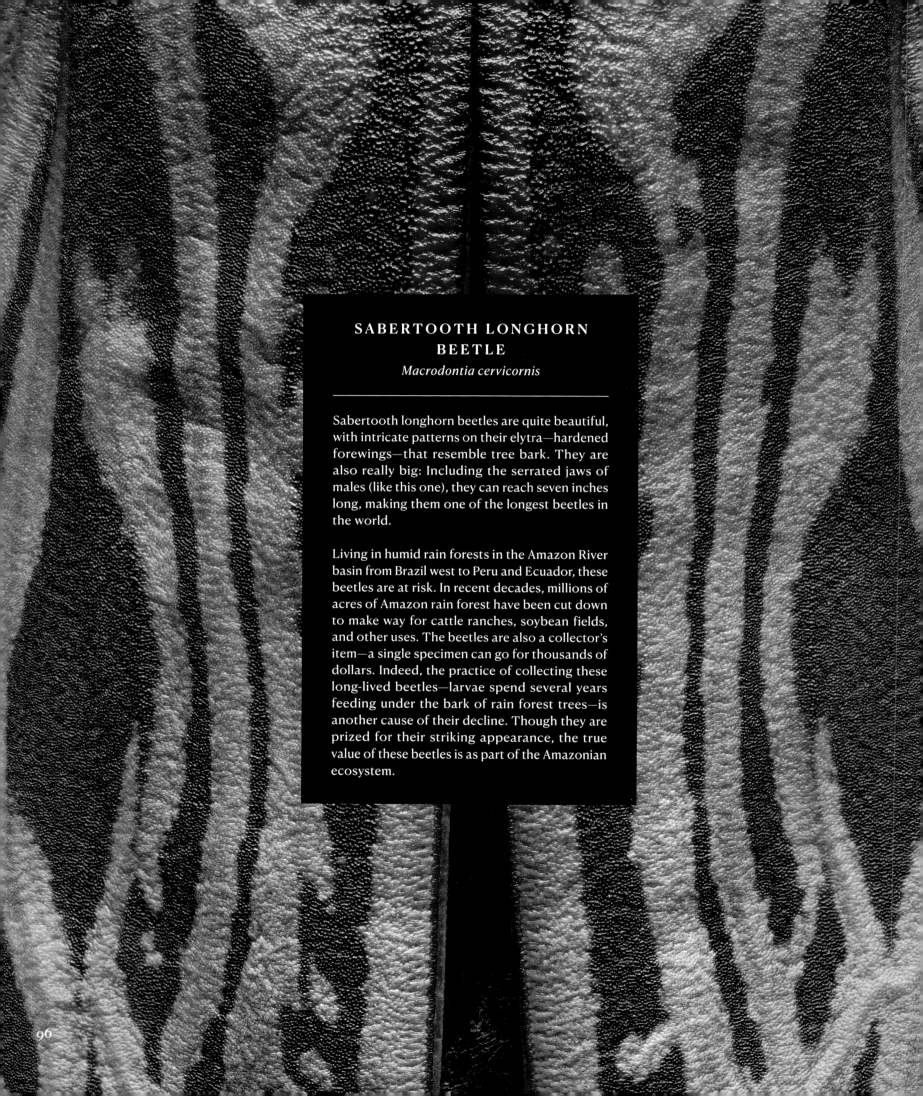

SABERTOOTH LONGHORN BEETLE

Macrodontia cervicornis

Sabertooth longhorn beetles are quite beautiful, with intricate patterns on their elytra—hardened forewings—that resemble tree bark. They are also really big: Including the serrated jaws of males (like this one), they can reach seven inches long, making them one of the longest beetles in the world.

Living in humid rain forests in the Amazon River basin from Brazil west to Peru and Ecuador, these beetles are at risk. In recent decades, millions of acres of Amazon rain forest have been cut down to make way for cattle ranches, soybean fields, and other uses. The beetles are also a collector's item—a single specimen can go for thousands of dollars. Indeed, the practice of collecting these long-lived beetles—larvae spend several years feeding under the bark of rain forest trees—is another cause of their decline. Though they are prized for their striking appearance, the true value of these beetles is as part of the Amazonian ecosystem.

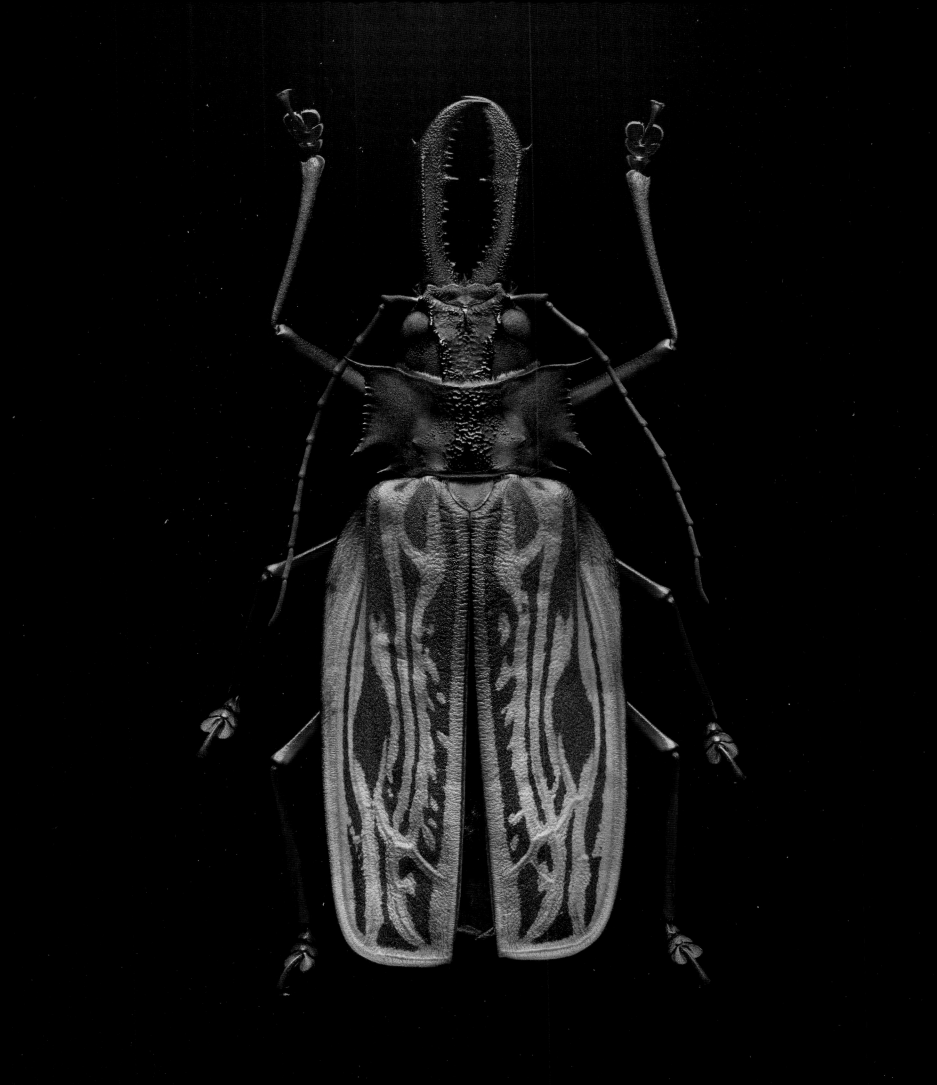

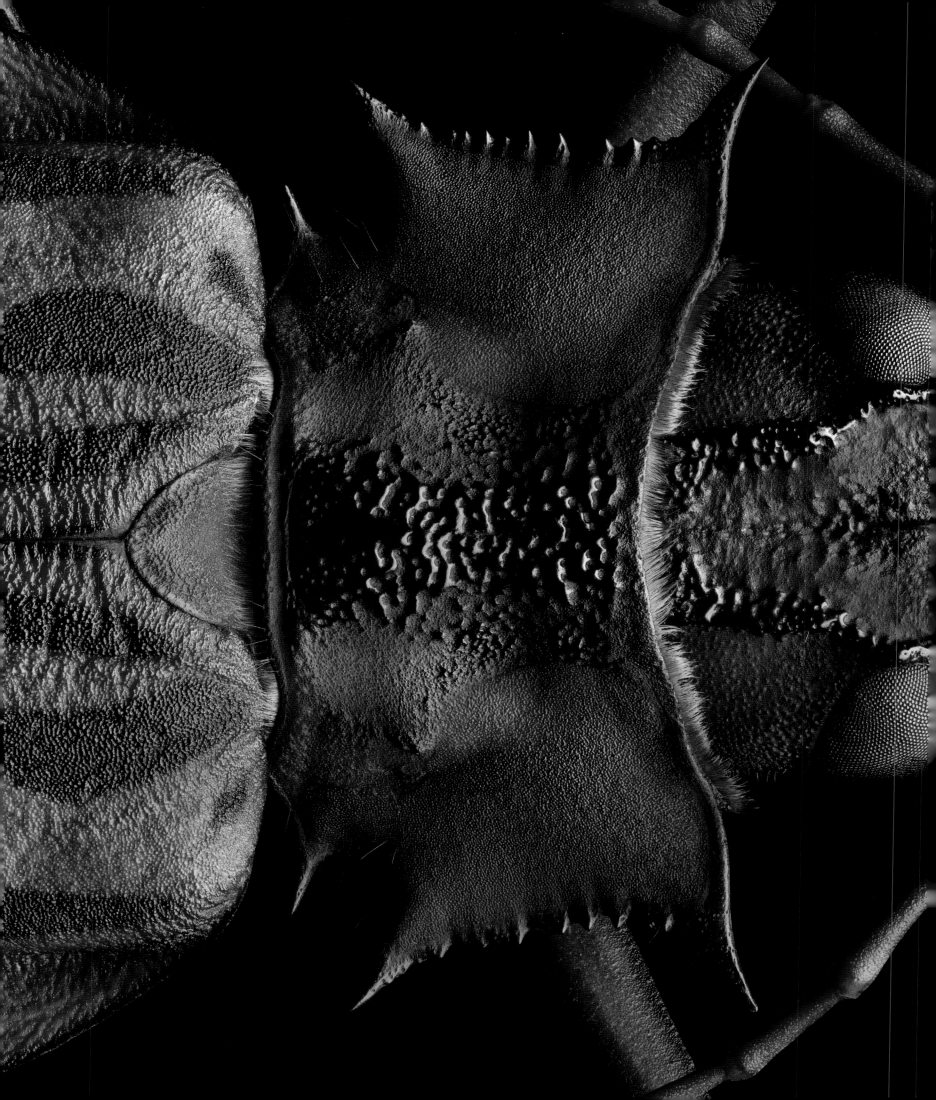

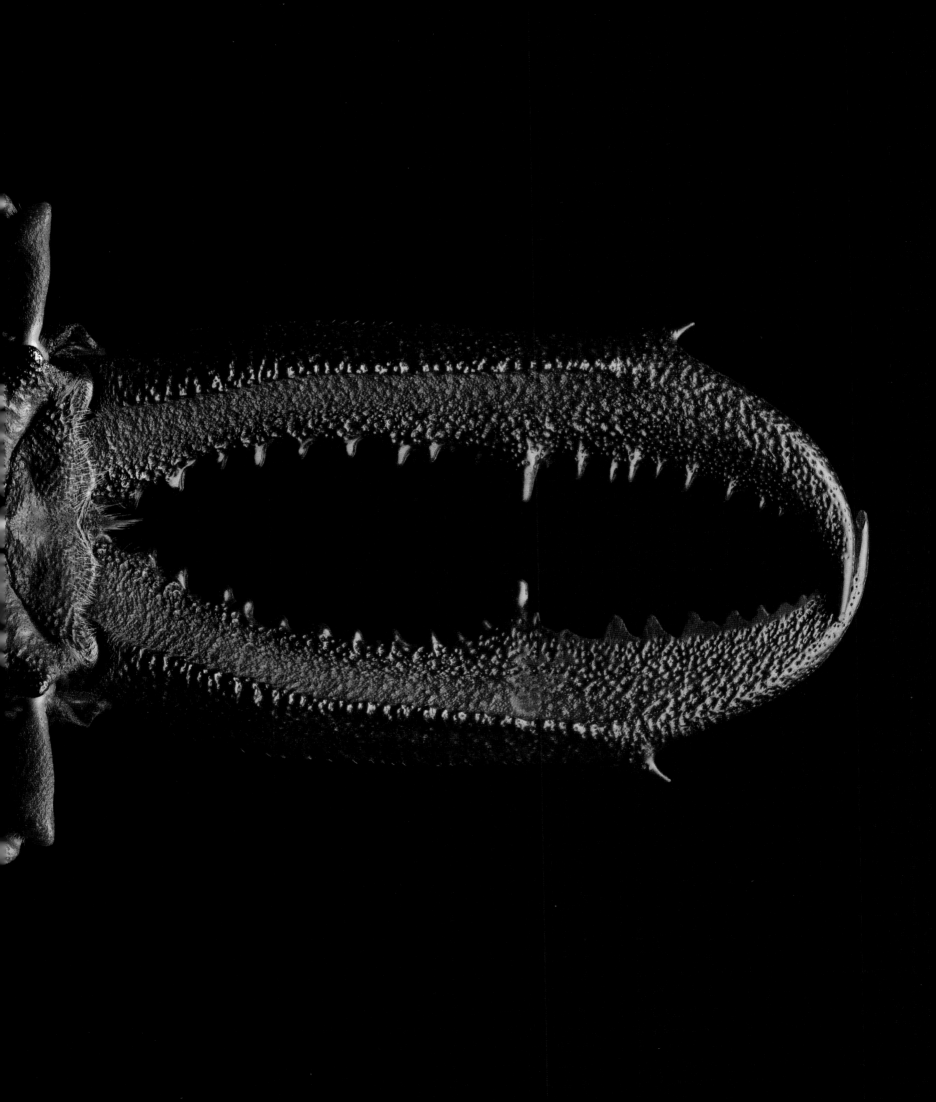

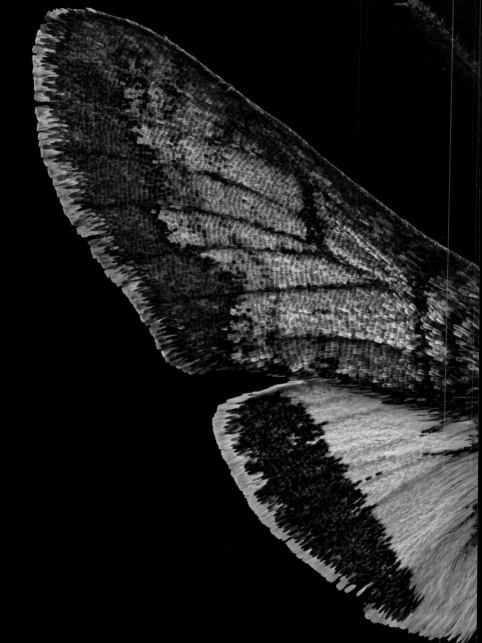

PHAETON PRIMROSE SPHINX MOTH

Euproserpinus phaeton

Most people think of moths flying at night—but some, including the one pictured here, are active in the daytime. In arid, sandy areas of California and Baja Mexico, *Euproserpinus phaeton* moths take wing on early spring days. They fly rapidly, just inches from the ground, often in search of mates or evening primrose flowers, for nectar and on which their caterpillars later feed.

But in populated areas in California, the moths' range seems to be shrinking: Entomologists no longer see them in places they used to thrive, where people have built new homes over open land. Meanwhile, a very closely related moth, *Euproserpinus euterpe,* is found in just two small areas in rural central California. For that imperiled species, even a minor disruption to its tiny habitat could be enough to spell doom.

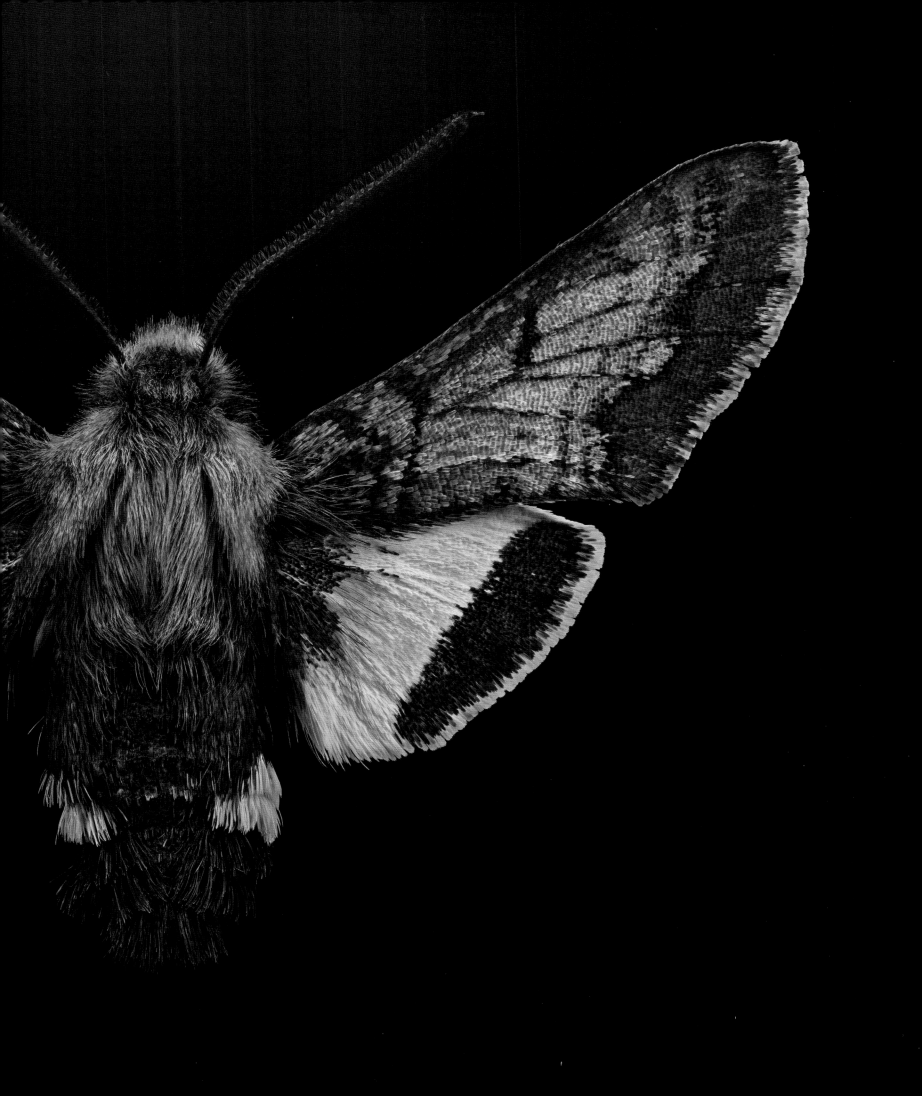

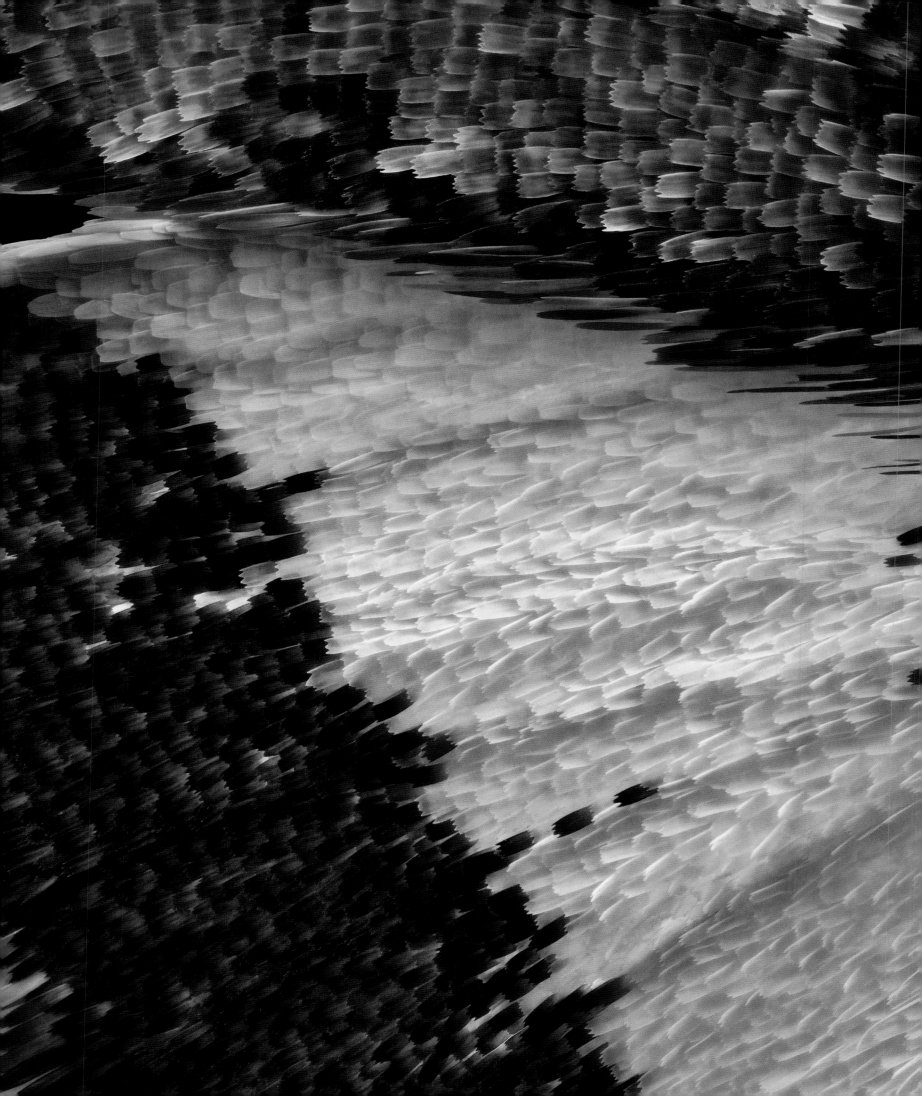

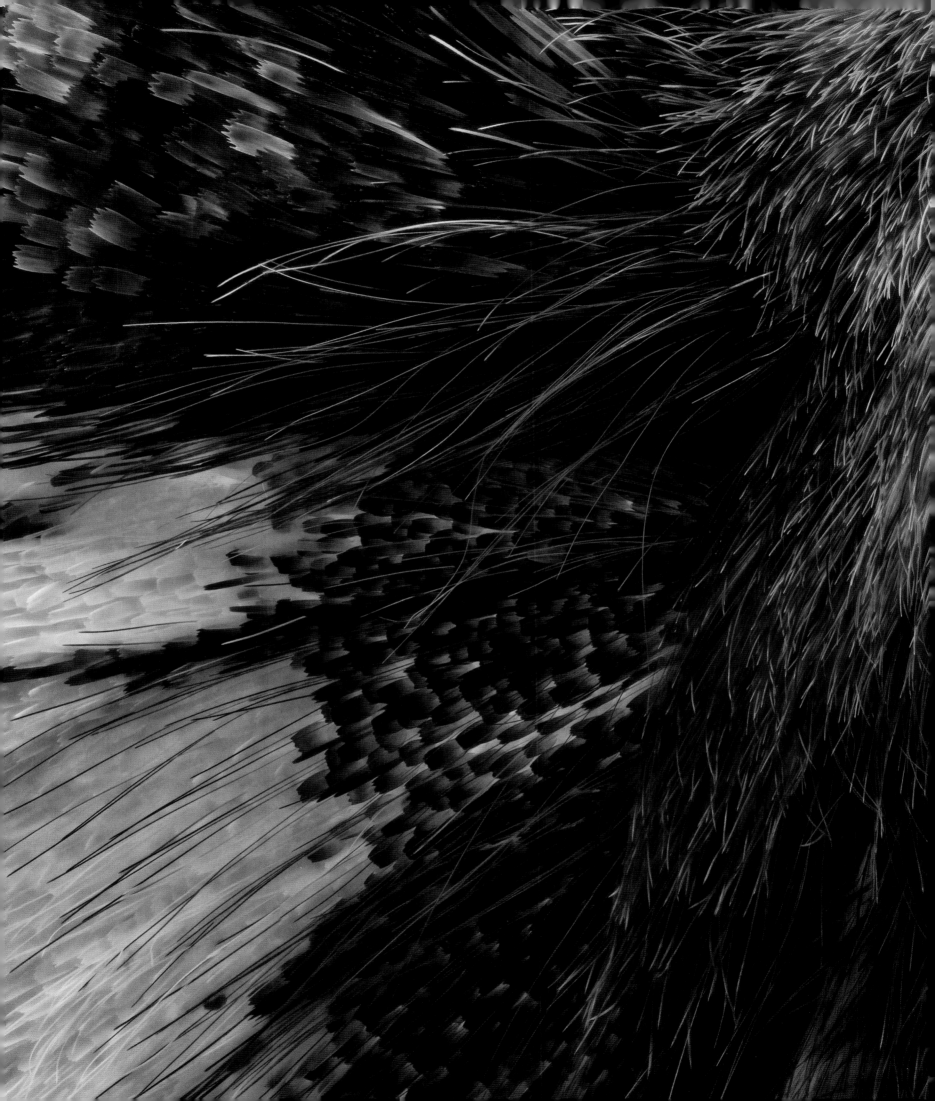

HAWAIIAN HAMMERHEADED FRUIT FLY

Idiomyia heteroneura

The Hawaiian Islands have the greatest number of modern extinctions anywhere on Earth, in part because organisms on remote islands easily succumb to species introduced from other places. But the island's isolation also means it is home to many species found only there—including more than five hundred species of fruit flies. This male Hawaiian hammerheaded fruit fly has a distinctive head with wide-set eyes, a bit like that of a hammerhead shark. In a display to compete for mates, the males almost butt heads, the way bighorn sheep do—but they actually do not quite touch.

This fly was formerly common throughout the wet, mountainside forests of the "Big Island" of Hawaii, where its larvae would feed beneath the bark and on stems of several plants. But its numbers have fallen dramatically. Today it lives in just one forest reserve, and researchers attribute this drop in part to the loss of its host plants due to fungal diseases. In response, in 2006 this and other Hawaiian flies were added to the U.S. endangered species list—providing them some needed protections.

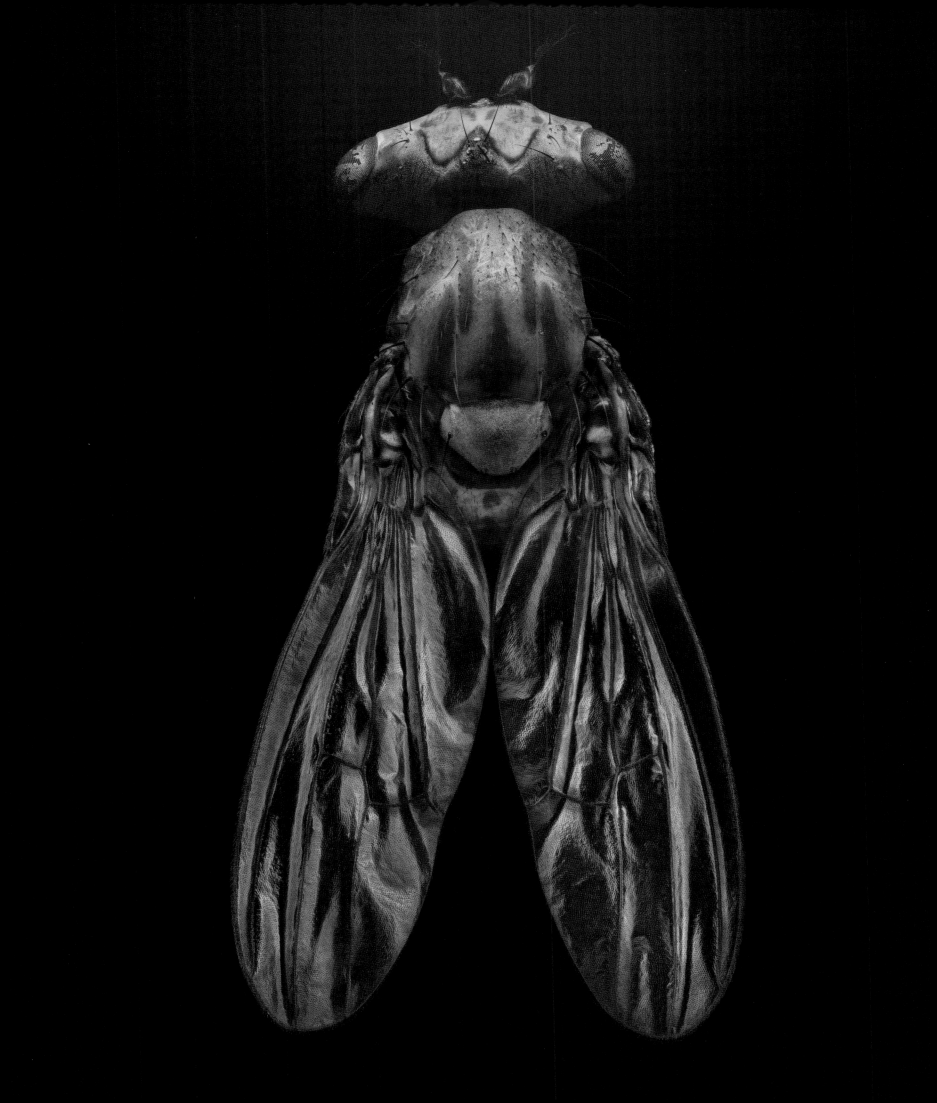

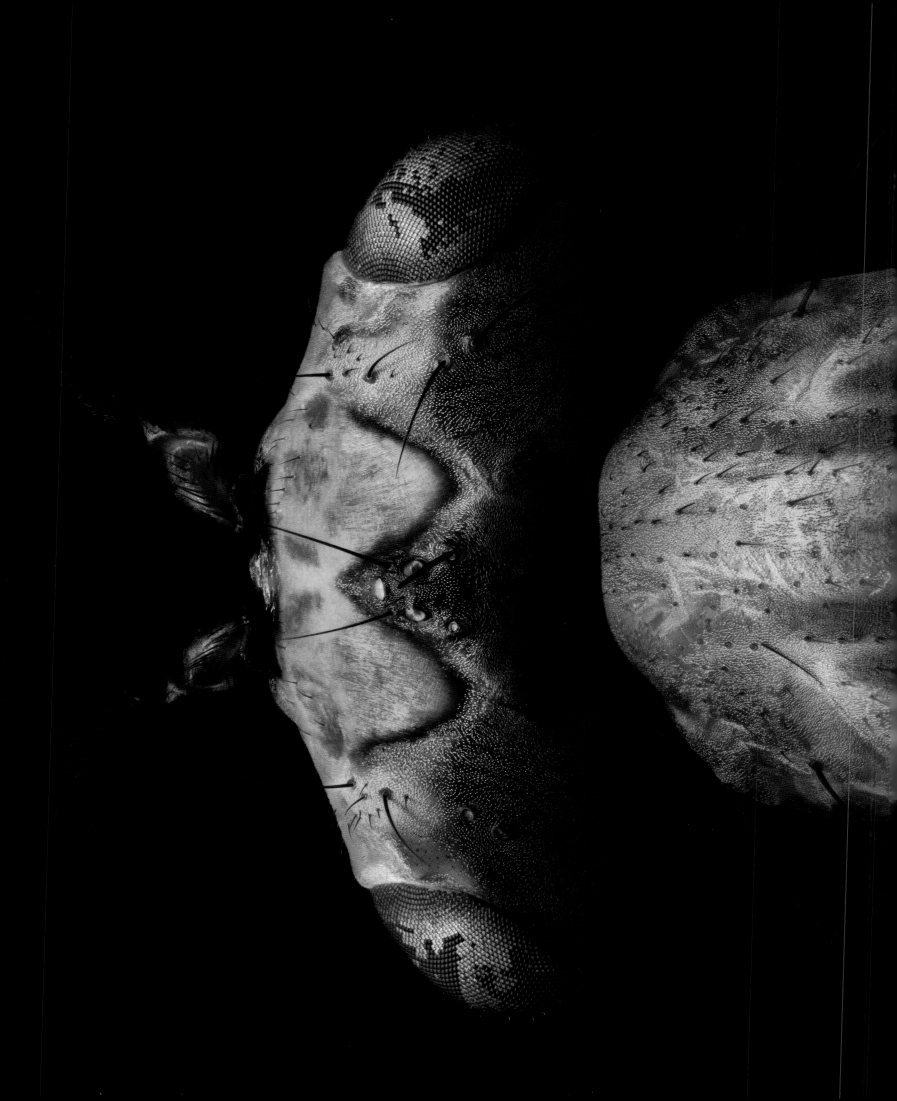

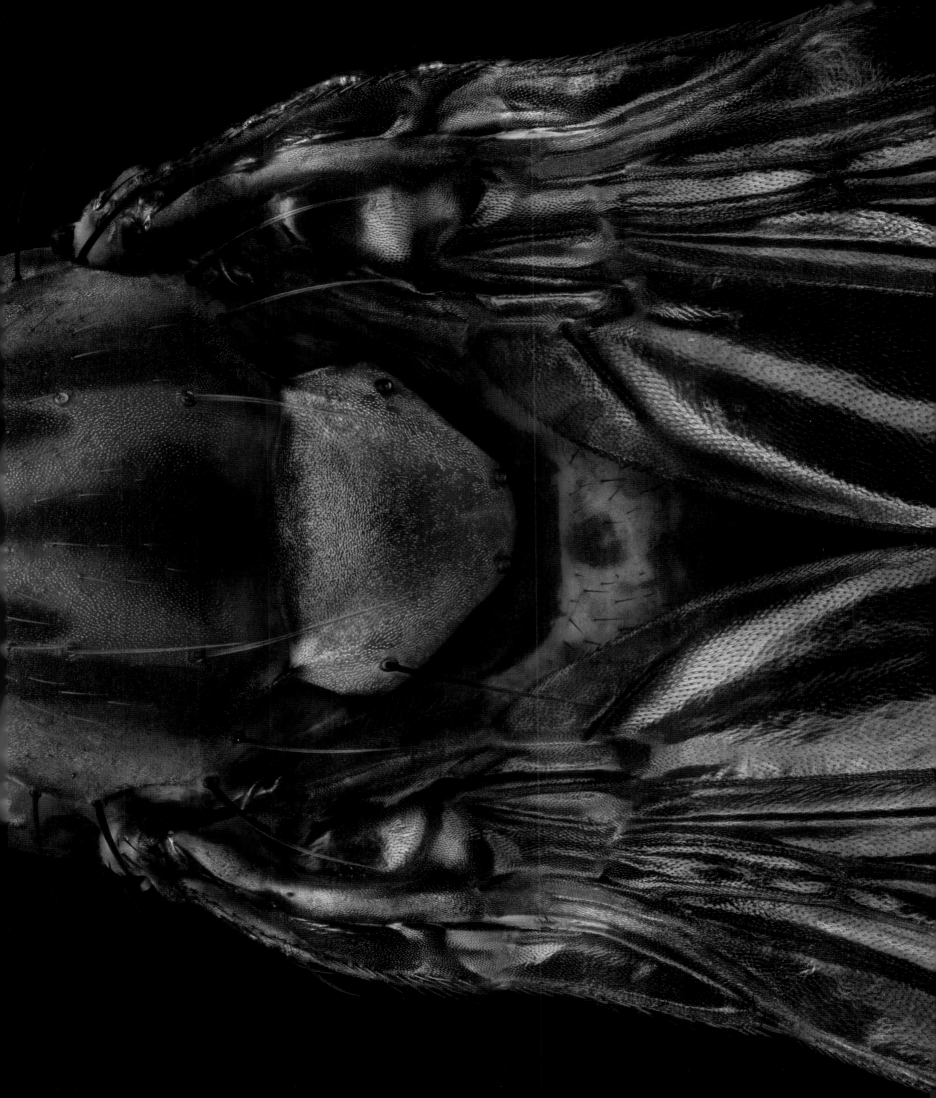

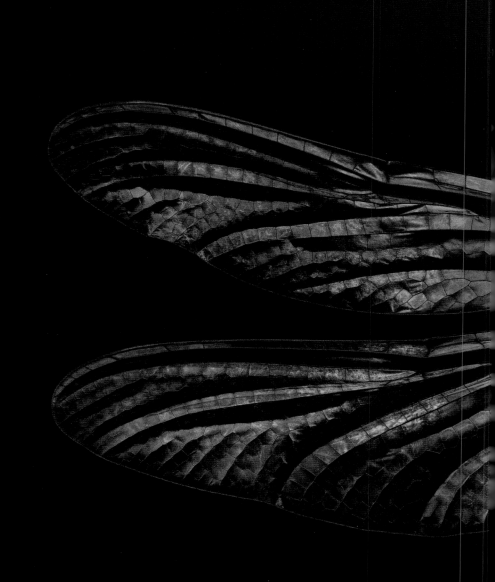

STYGIAN SHADOWDRAGON
Neurocordulia yamaskanensis

Dragonflies may be the most acrobatic fliers in the insect world, and stygian shadowdragons are no exception. Late in the twilight, they soar high above dark waters, swooping down to capture mosquitoes and other insect prey. Living near lakes and rivers in the eastern U.S. and Canada, stygian shadowdragons start out life in the water. Females lay their eggs and larvae develop there, breathing through internal gills.

For now, their numbers appear stable in some parts of their range, but in other areas they have completely disappeared. In coming years, climate change could have many detrimental effects on remaining populations. Much remains to be learned about how dragonfly larvae manage in northeastern rivers and lakes, and if those waters warm dramatically, the larvae may not be able to survive. Depending on how the waters are affected by heat, drought, and other factors such as water pollution, researchers have estimated that more than 50 percent of this dragonfly species's preferred river habitat could be lost as the climate shifts.

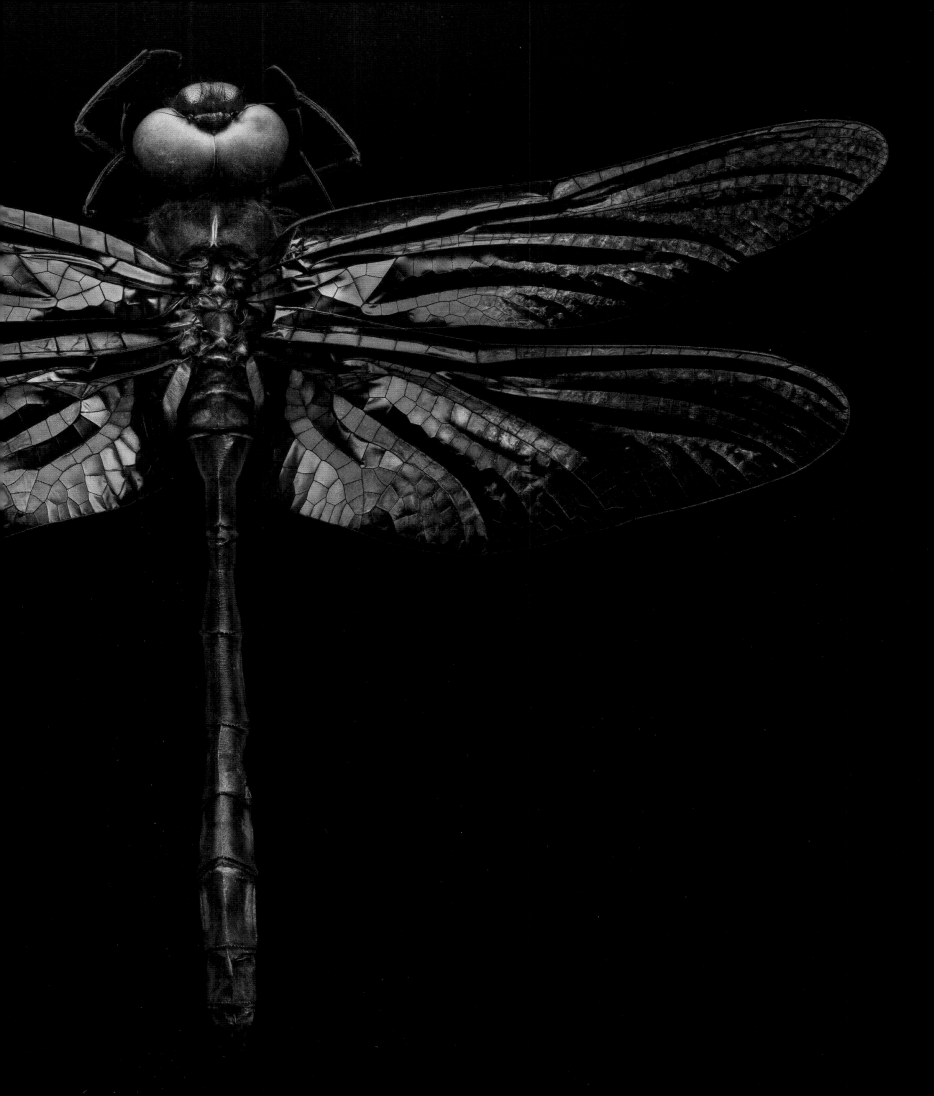

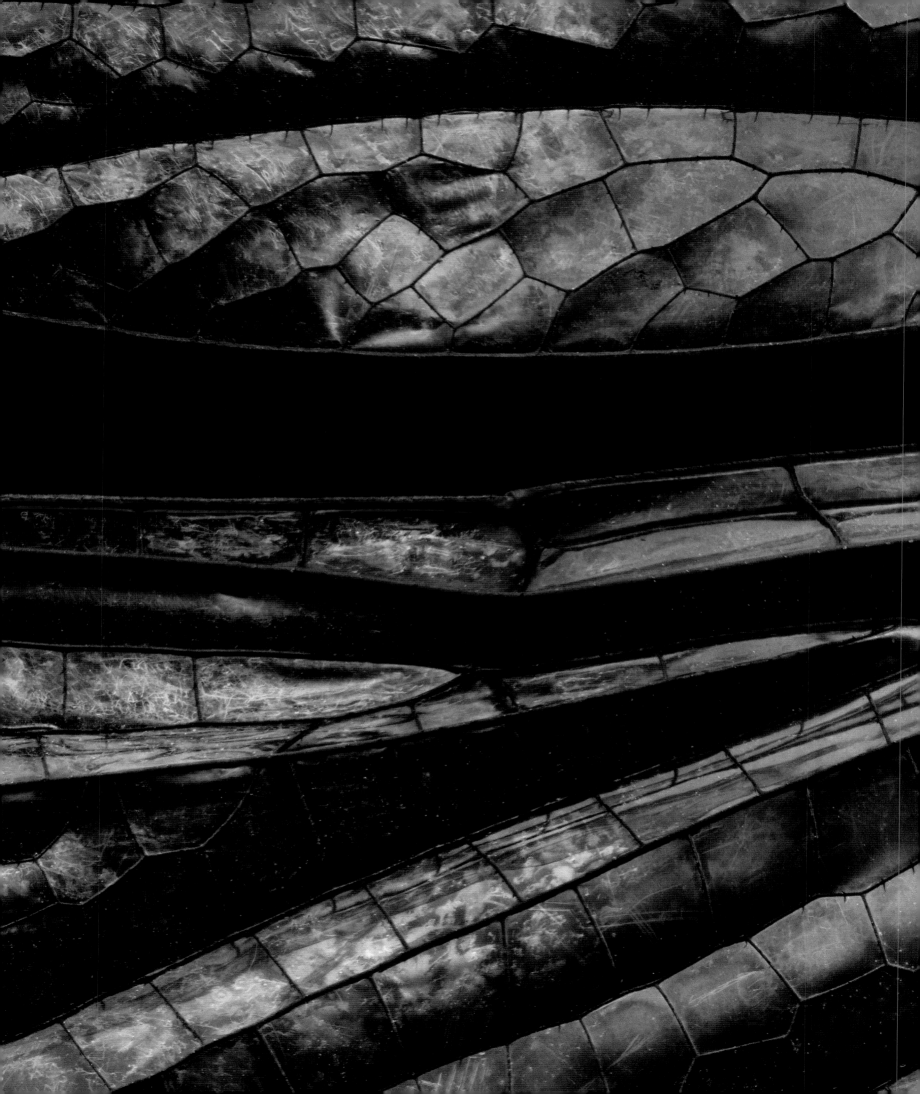

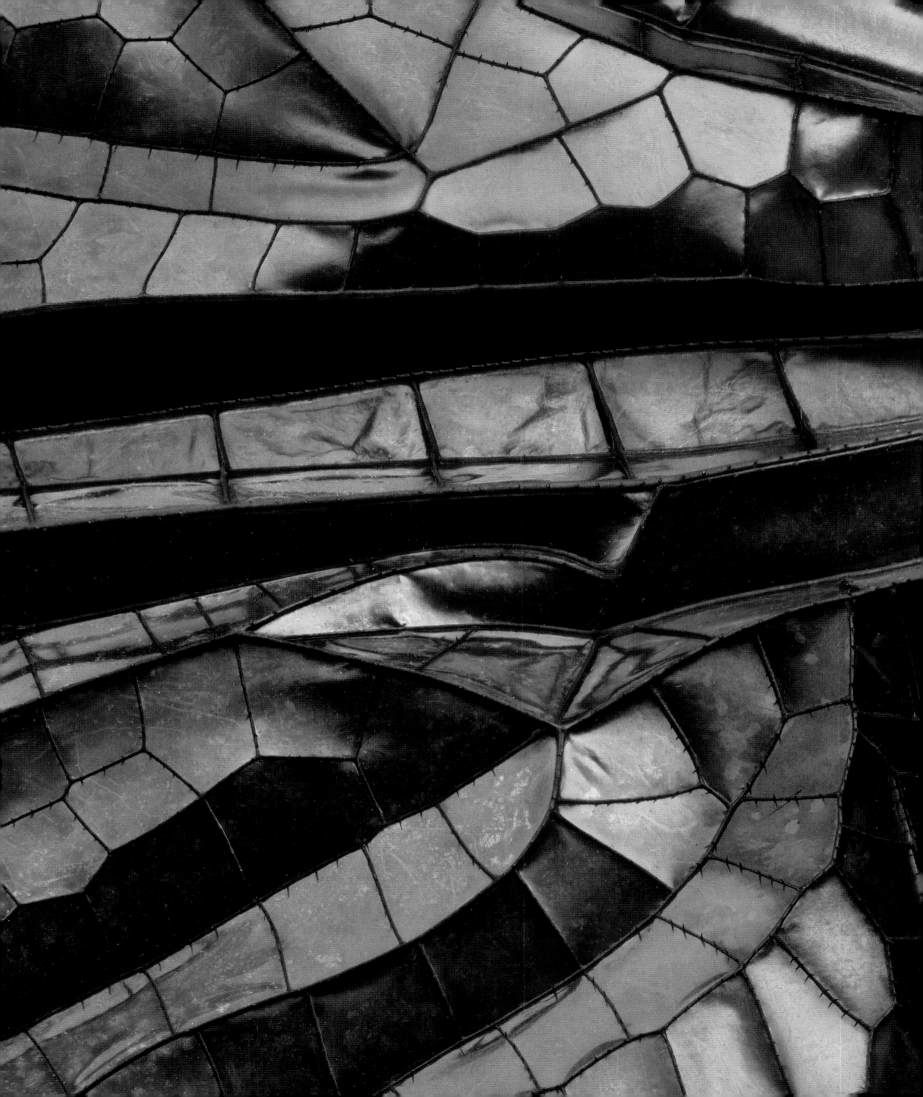

ESPERANZA SWALLOWTAIL
Papilio esperanza

In certain mountaintop cloud forests in Oaxaca, Mexico, this swallowtail butterfly is a rare, glorious sight. The undersides of its wings, shown here, glow with pattern and color—perhaps drawing in potential mates. Atop the wings is a simpler pattern—possibly providing a bit of camouflage.

Today, though, the species is endangered. Wet, cool cloud forest ecosystems harbor many rare species; the isolated environment acts like an island, with the lowland forest serving as a hot, dry barrier. As a result, even small changes to the butterflies' environment could leave them with nowhere to go. But climate change threatens Mexico's cloud forests, which have already been fragmented, due to logging, ranching, and farming. To stem the losses, people living in neighboring communities have started to manage forests for biodiversity. In some places, they communally own large tracts of land, where they have prohibited butterfly collecting and closely monitor the health of the forests.

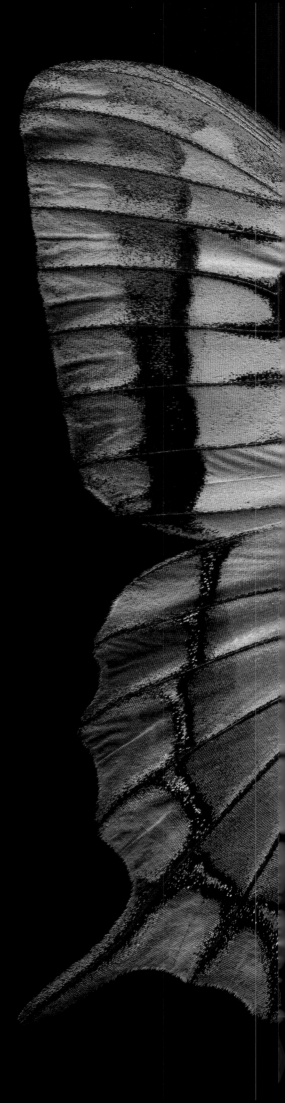

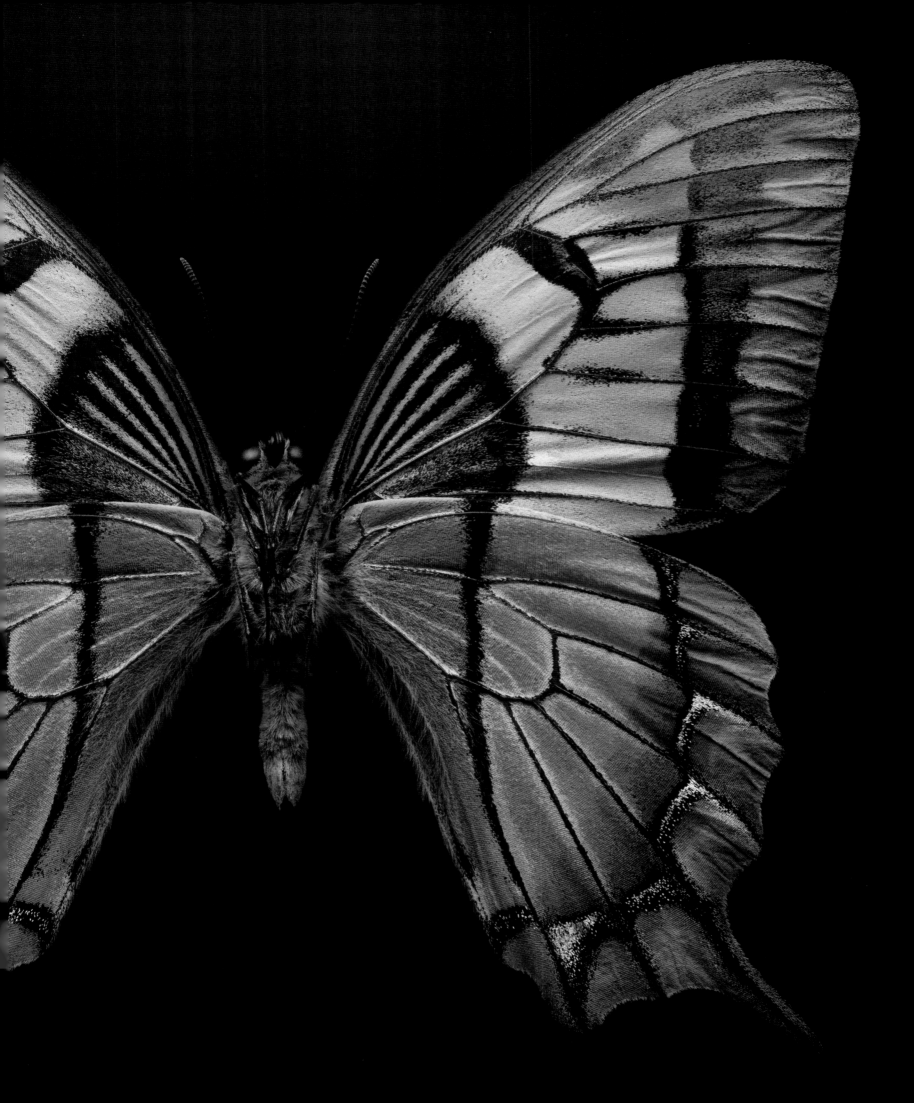

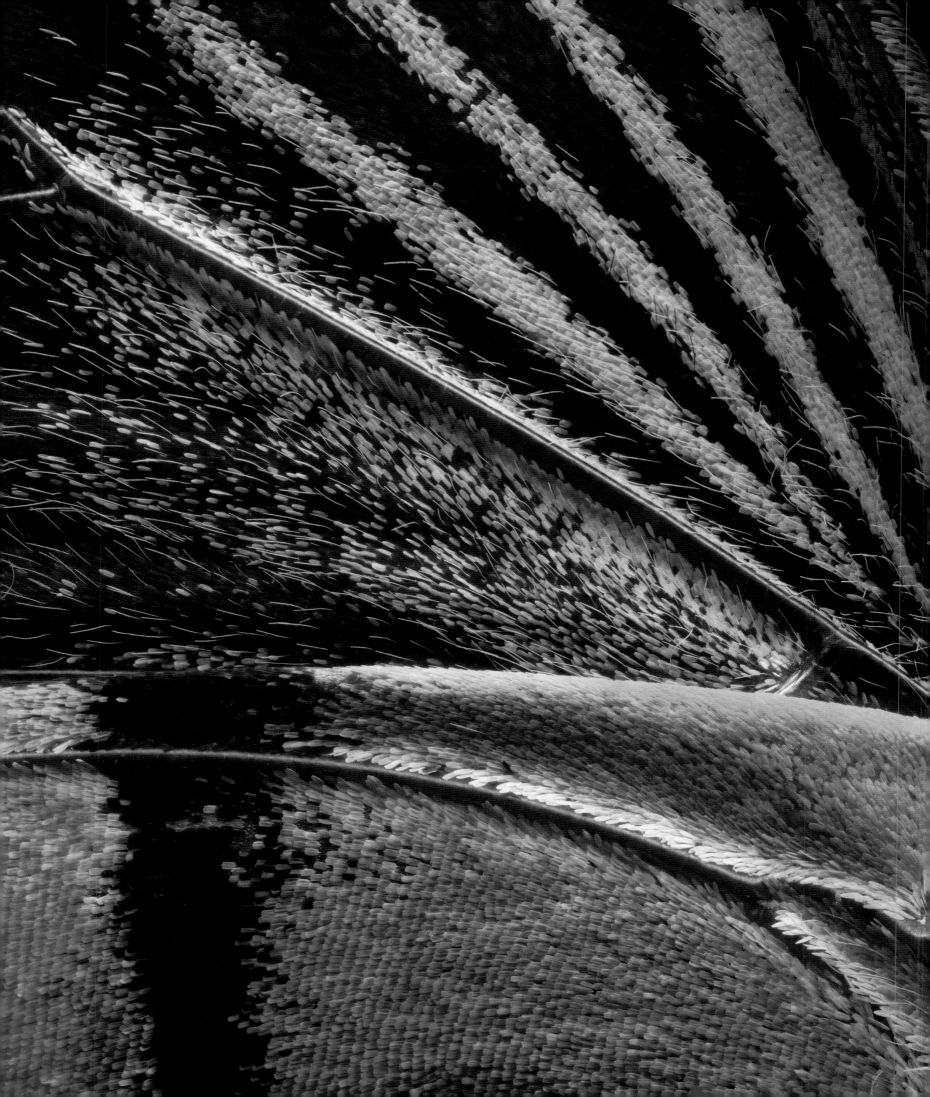

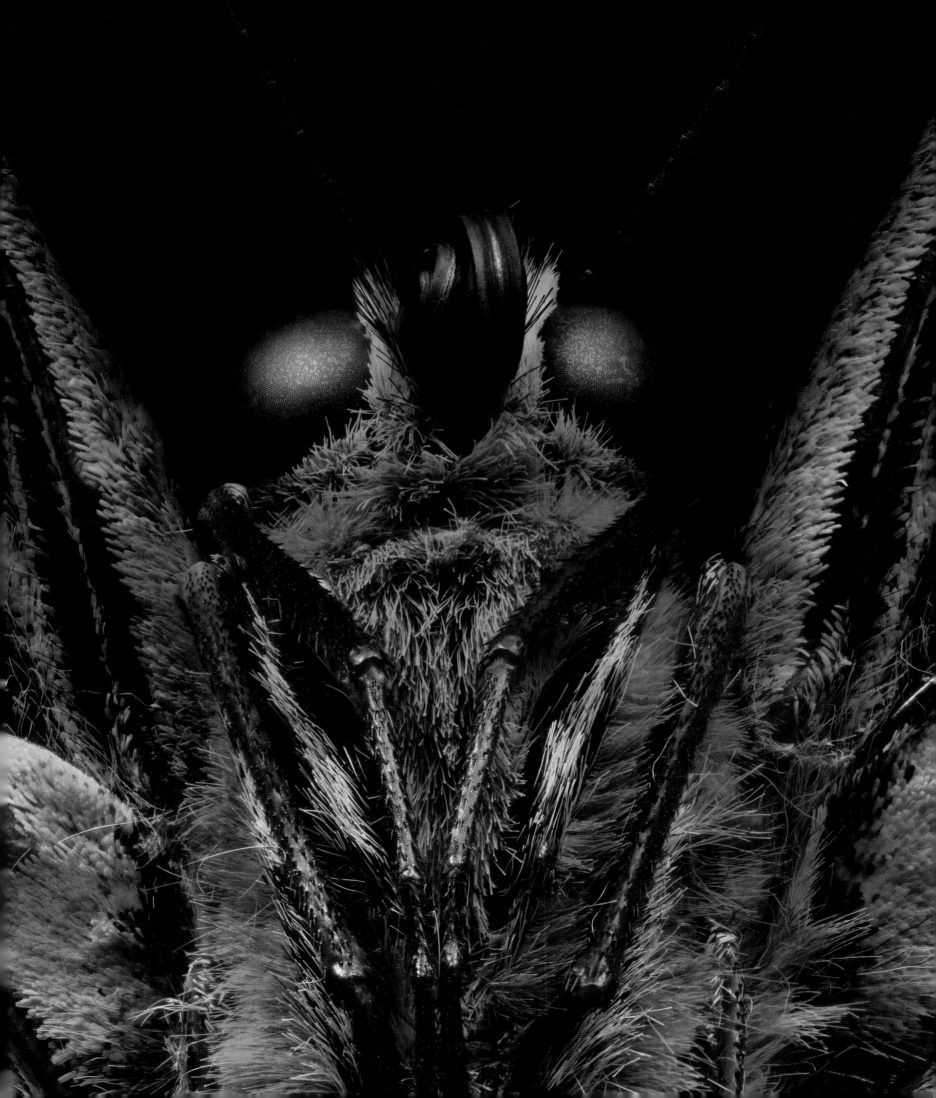

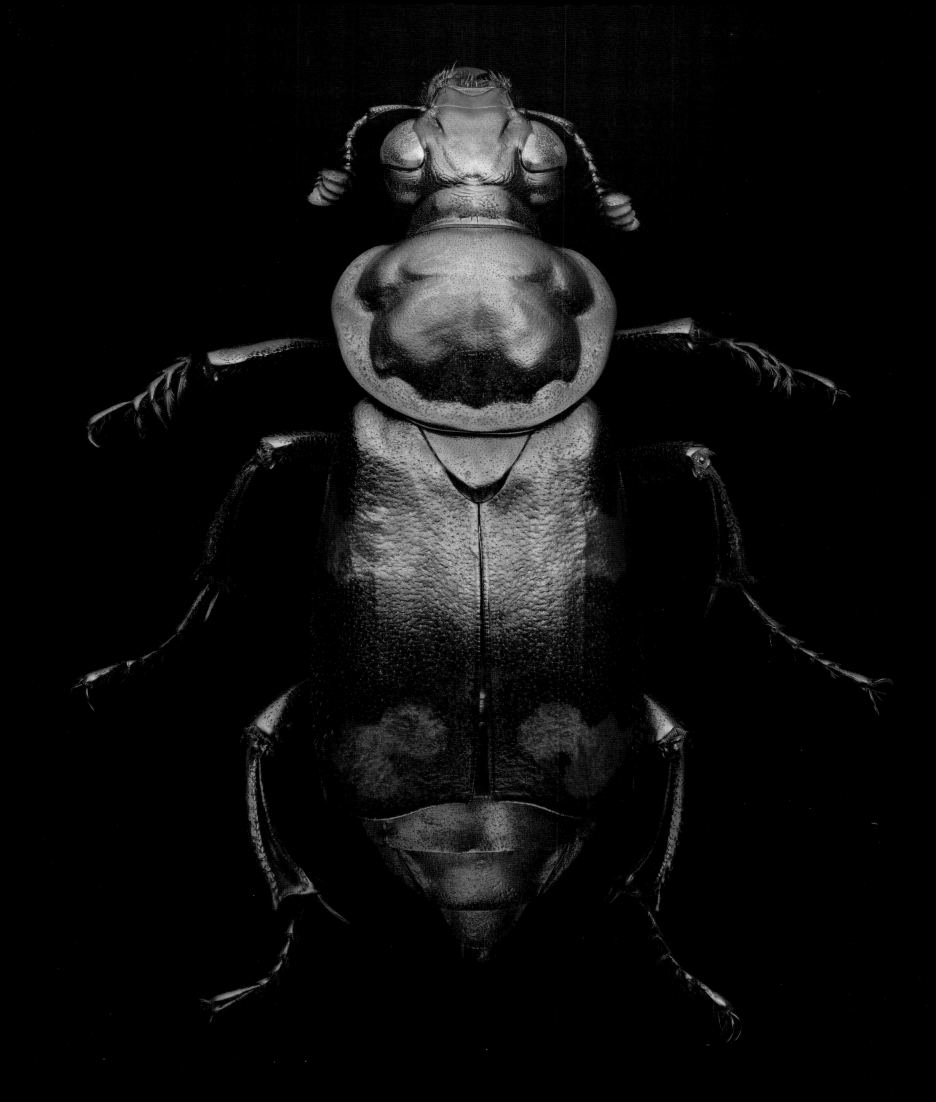

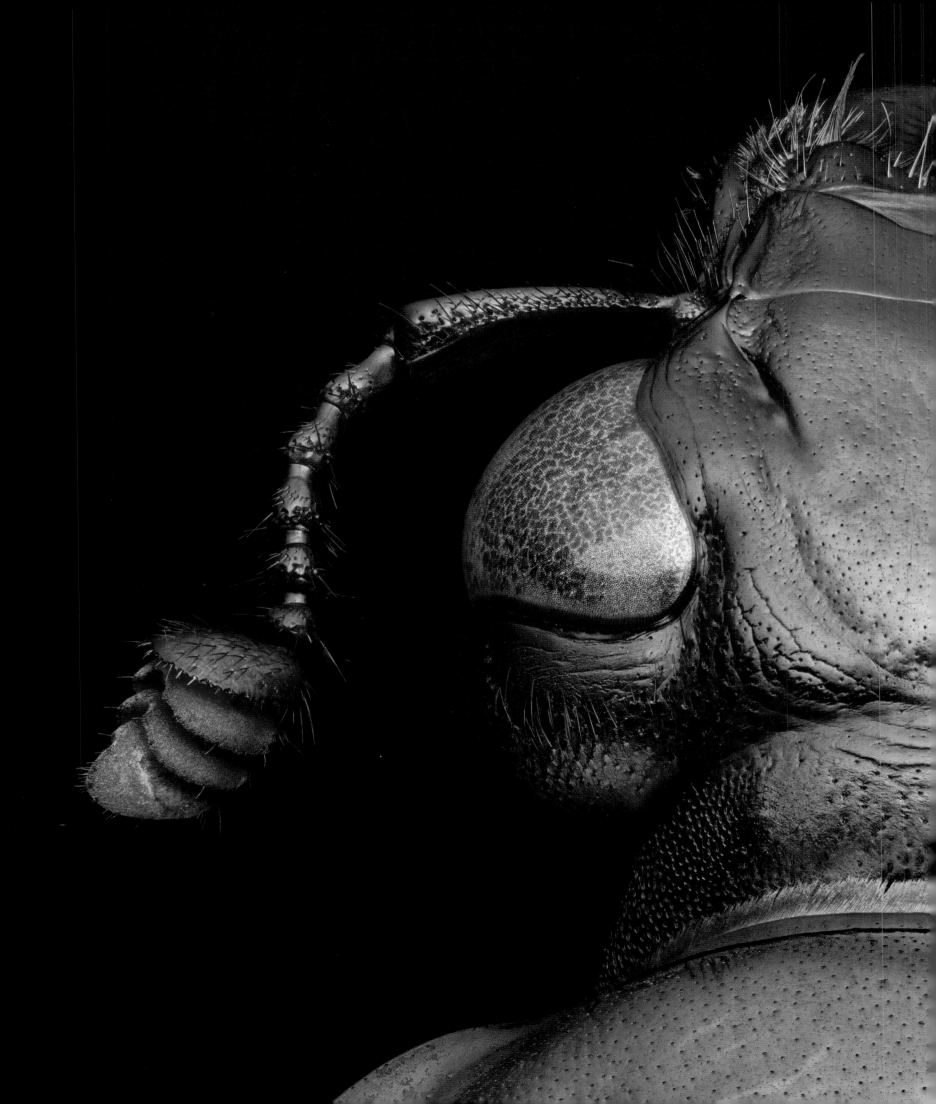

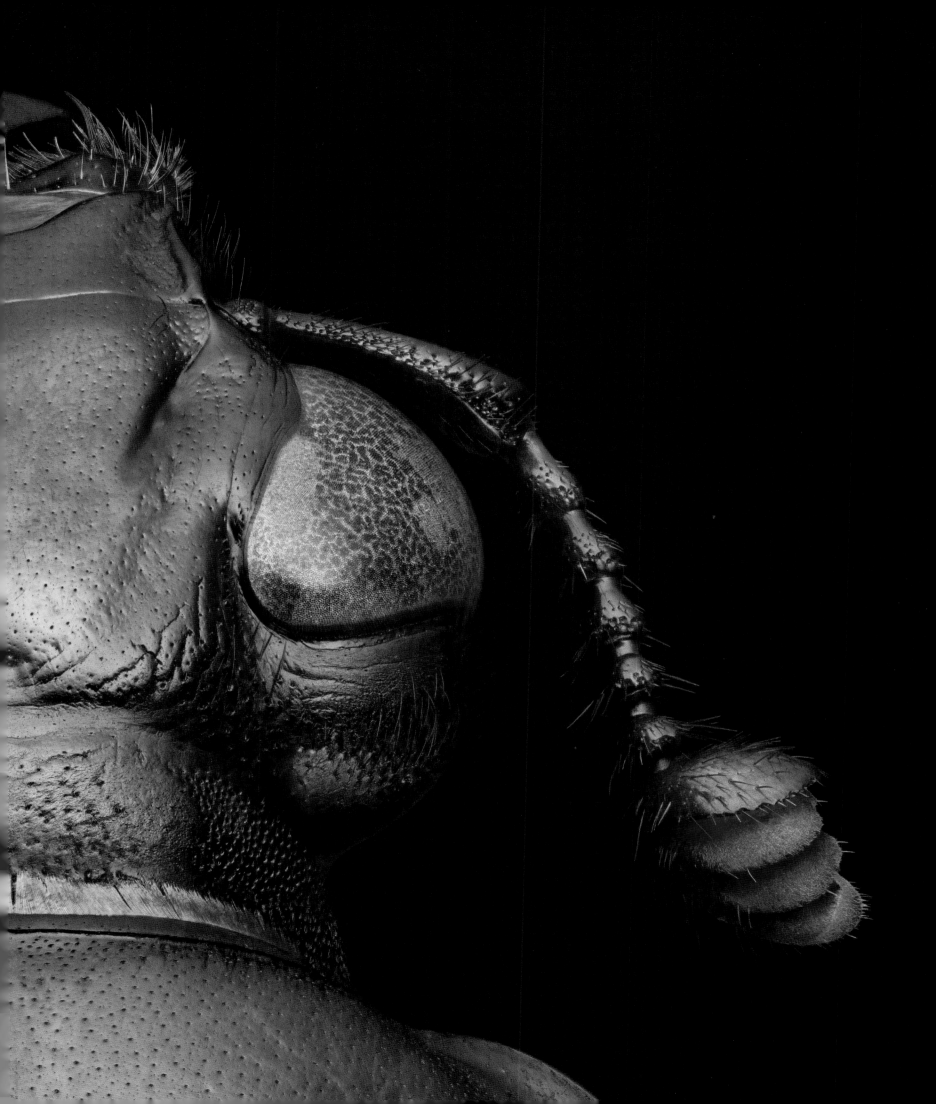

MADEIRAN LARGE WHITE
Pieris brassicae wollastoni

Situated in the Atlantic Ocean hundreds of miles west of the Moroccan coast, the islands of Madeira are home to only about twenty species of butterflies. So in the 1980s, when the Madeiran large white butterfly began to disappear, entomologists took notice. Living exclusively in the island's wet, mossy laurel forests, the butterflies were found nowhere else on Earth.

Reasons for its decline include habitat loss as well as the arrival of an invasive butterfly that brought viruses with it. An introduced, tiny wasp that breeds in, then kills, caterpillars in this butterfly family may also have contributed. Though entomologists have made serious efforts to find any remaining populations, the Madeiran large white is probably extinct.

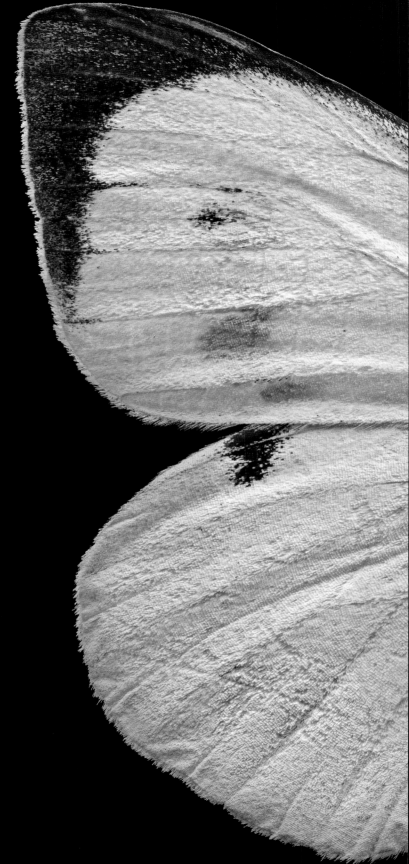

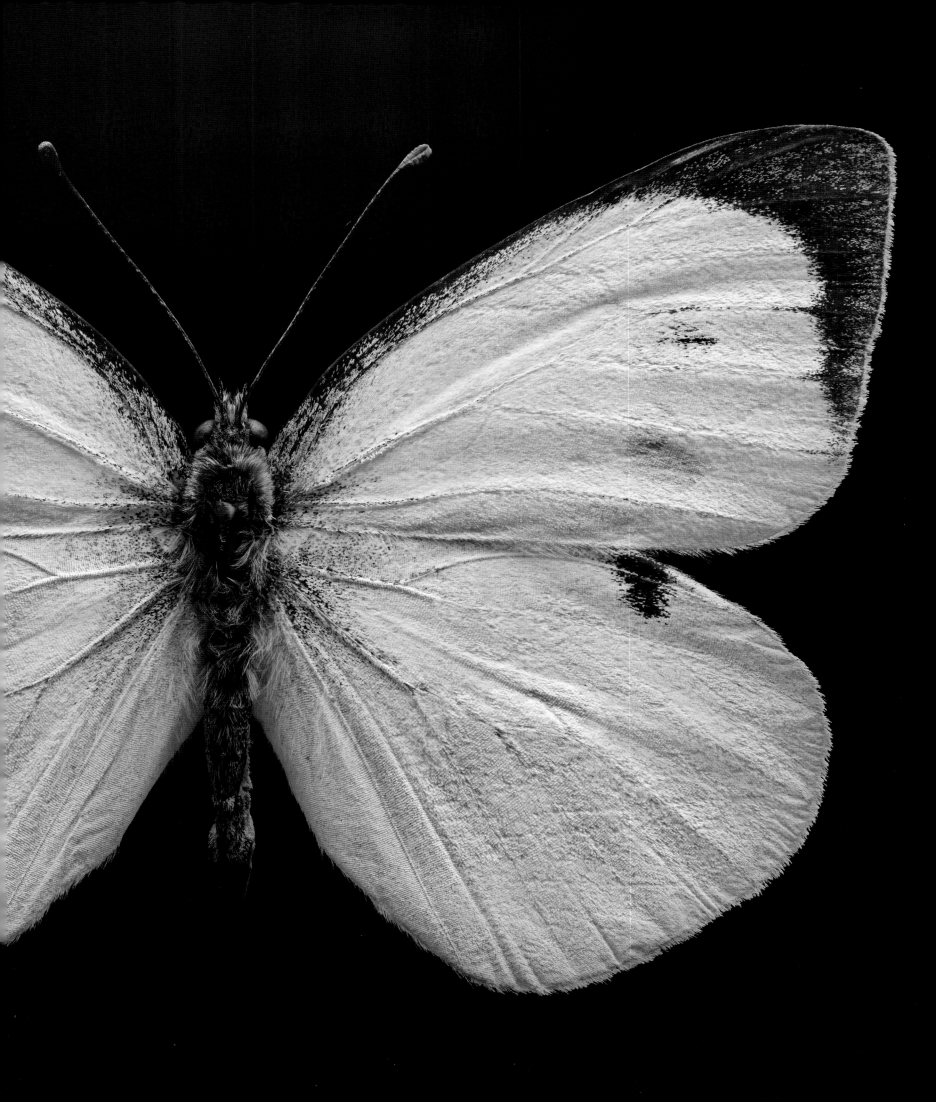

MADEIRA BRIMSTONE
Gonepteryx maderensis

In the steep mountains of the Madeira islands are evergreen laurel forests, called *laurisilva*, where these vivid butterflies spend much of their time high in the forest canopy. Their fiery yellow hues match those of the element sulfur, once known as brimstone—thus their common name.

But the butterflies that provide such lovely splashes of color are endangered. Madeira draws many tourists, and urban development has led to habitat loss. The life cycle of Madeira brimstones naturally limits their population growth: Adults can live for several months—a long time for a butterfly—and there is likely only one new generation each year. Their caterpillars feed on just one type of tree, which is itself threatened by an invasive plant species. But there may be a bit of protection: Madeira has a vast nature preserve, and remaining *laurisilva* areas are now officially protected in a UNESCO World Heritage Site.

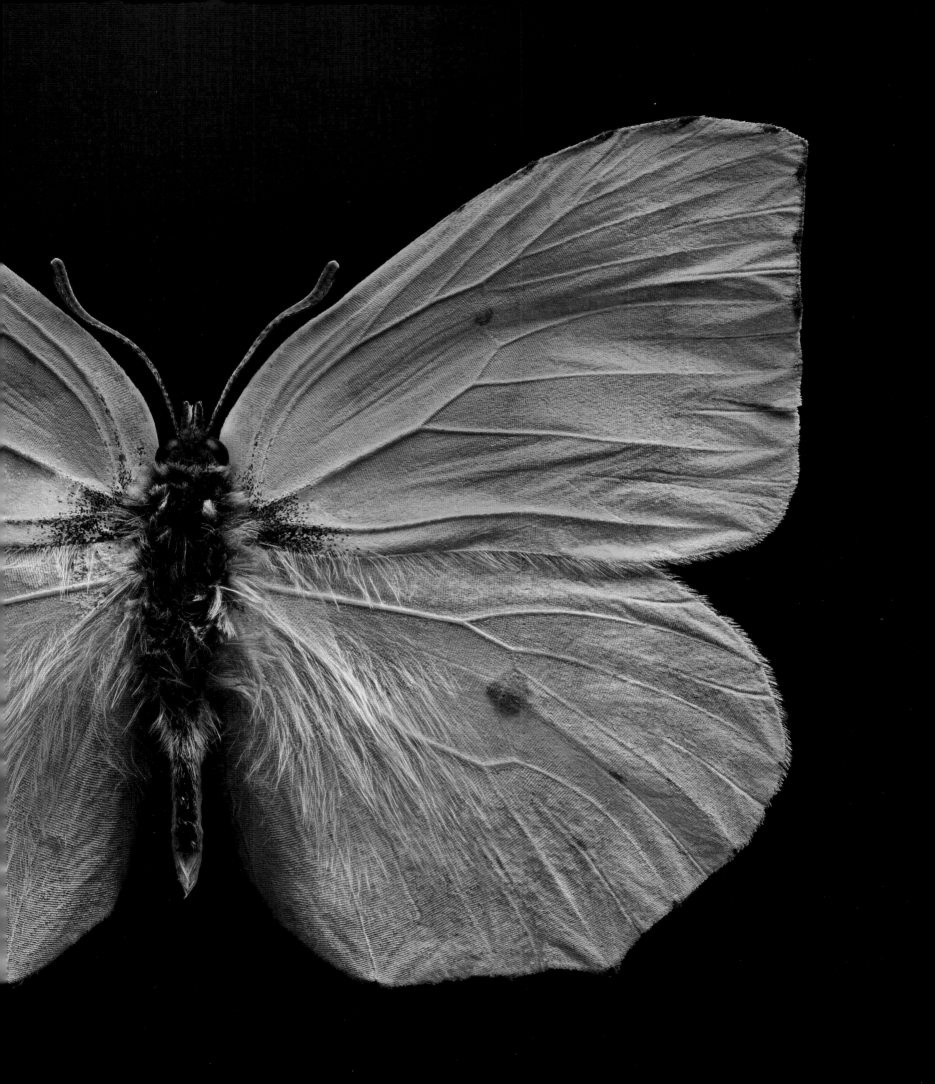

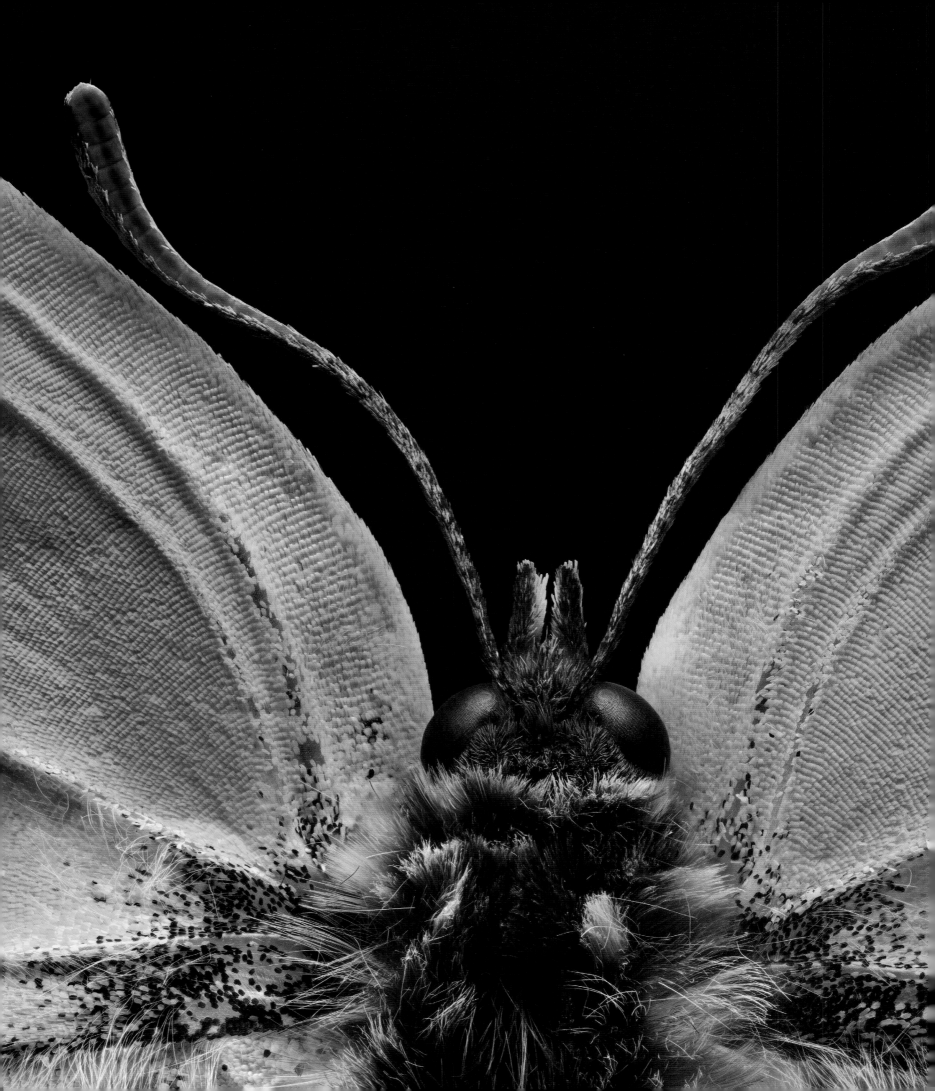

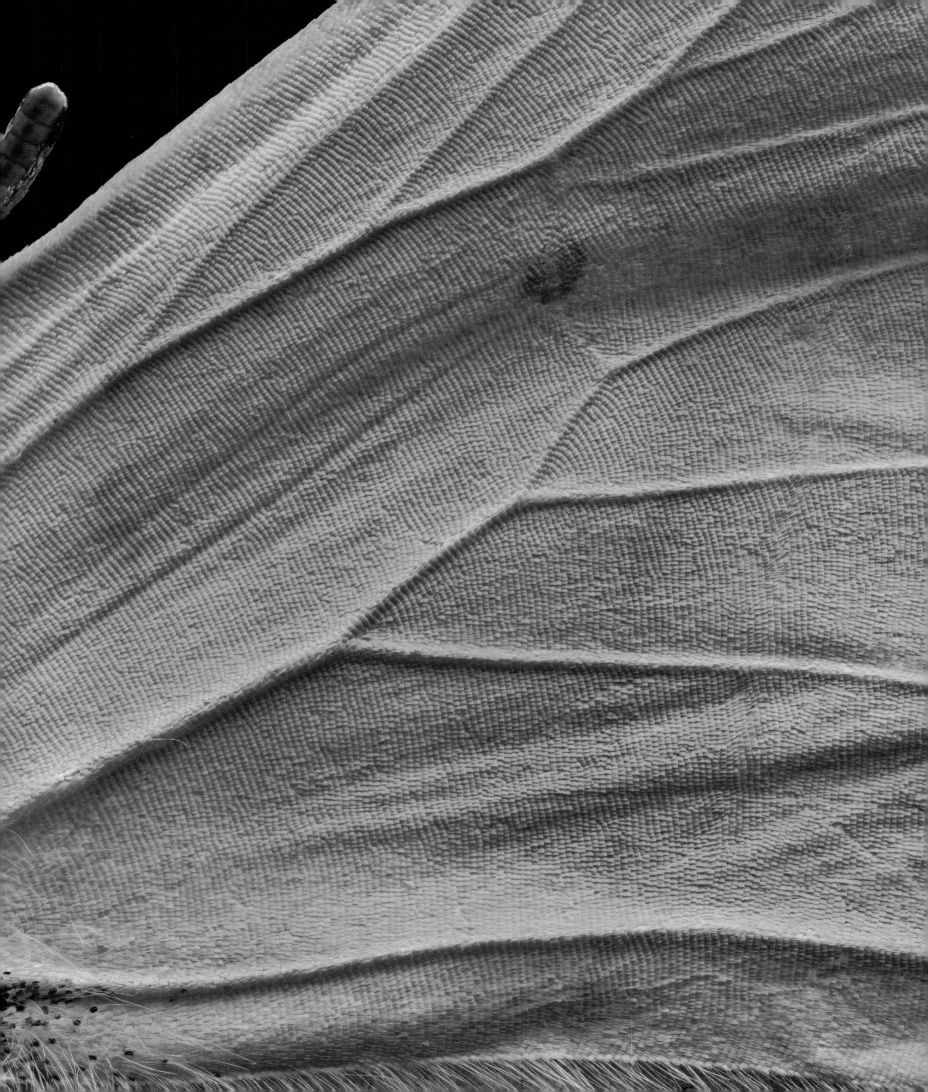

ROCKY MOUNTAIN LOCUST
Melanoplus spretus

Sky-darkening swarms. Ruined harvests. Until the late 1800s, billions of Rocky Mountain locusts periodically descended on the Great Plains, ravaging prairie plants and decimating farmers' crops. But then—the swarms stopped flying, and the locusts, last seen in 1902, never returned.

What caused this sudden, mysterious extinction? Not long ago, a University of Wyoming research team proposed an answer, which involves the locusts' life cycle and their interaction with humans. Locusts are grasshoppers, and they have the capacity for two distinct adult phases: a solitary phase, and a gregarious, swarming one. (They develop into a gregarious phase only when specific weather, population, and other conditions align.)

The Rocky Mountain locusts' demise likely came during a solitary phase when their numbers were low. Starting in the mid-1800s, as settlers moved into Native lands in the West, they plowed and planted over the insects' nesting areas. Today, these locusts no longer fly over North America, but other species sometimes swarm in vast numbers across parts of Africa, Australia, Asia, and the Middle East.

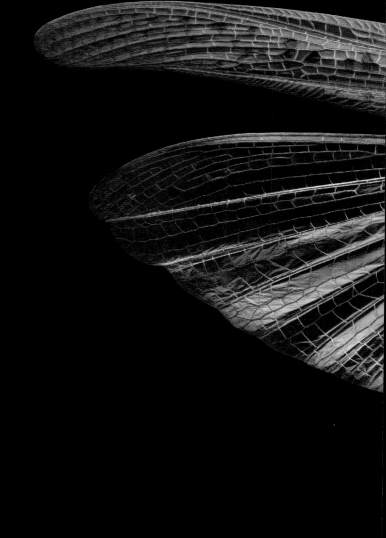

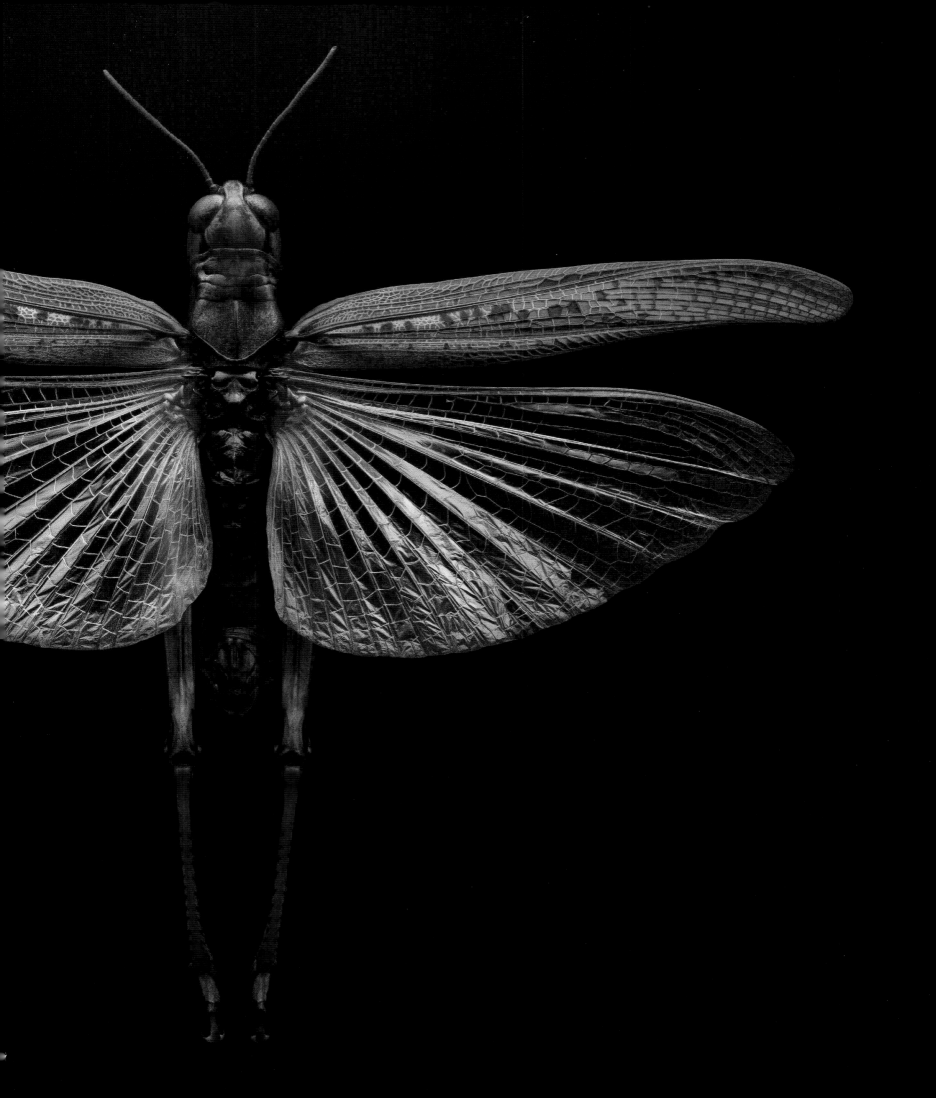

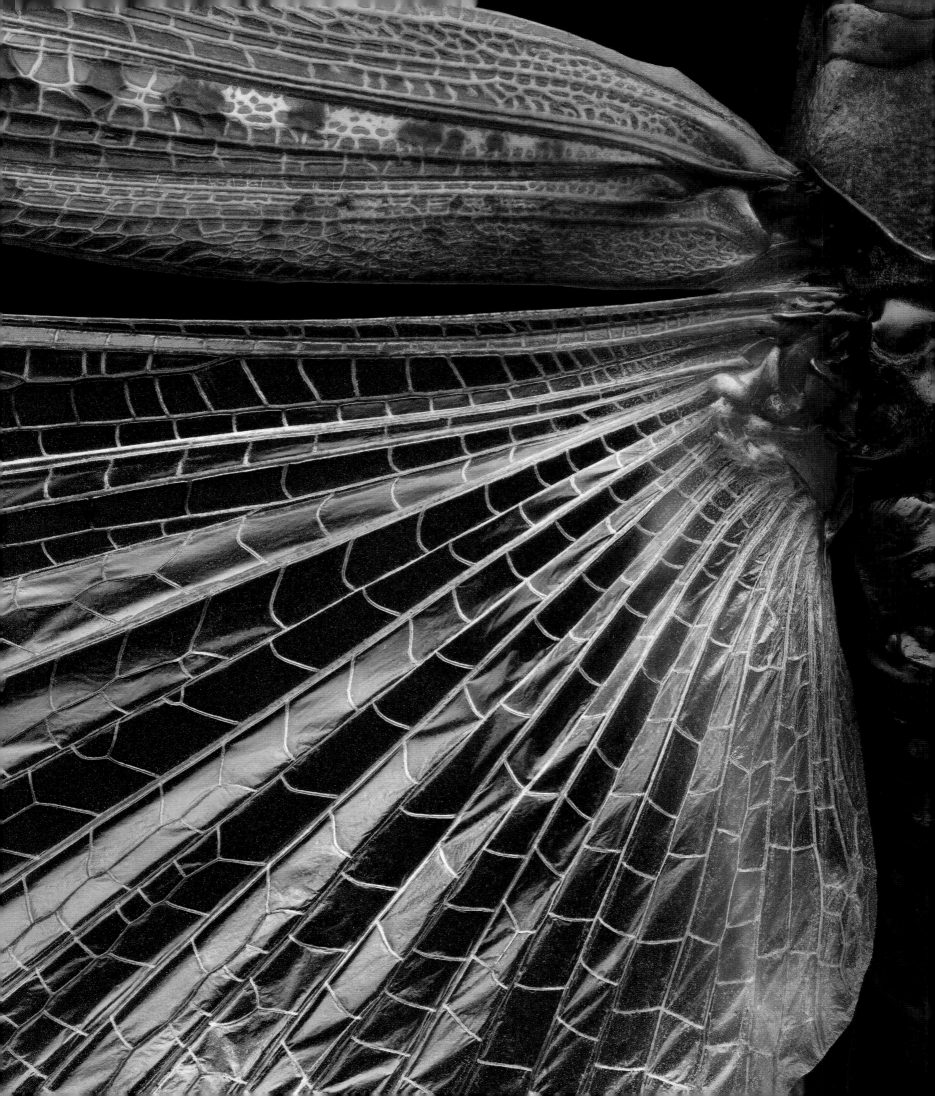

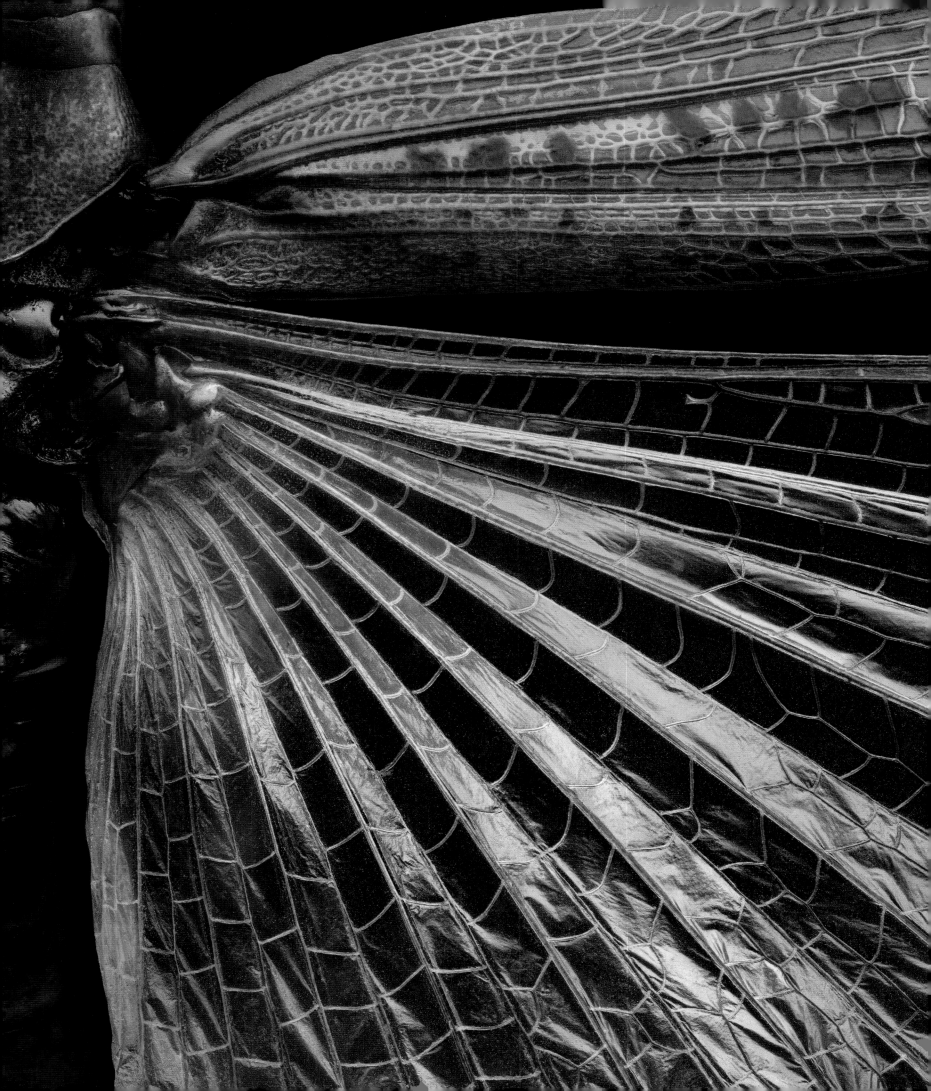

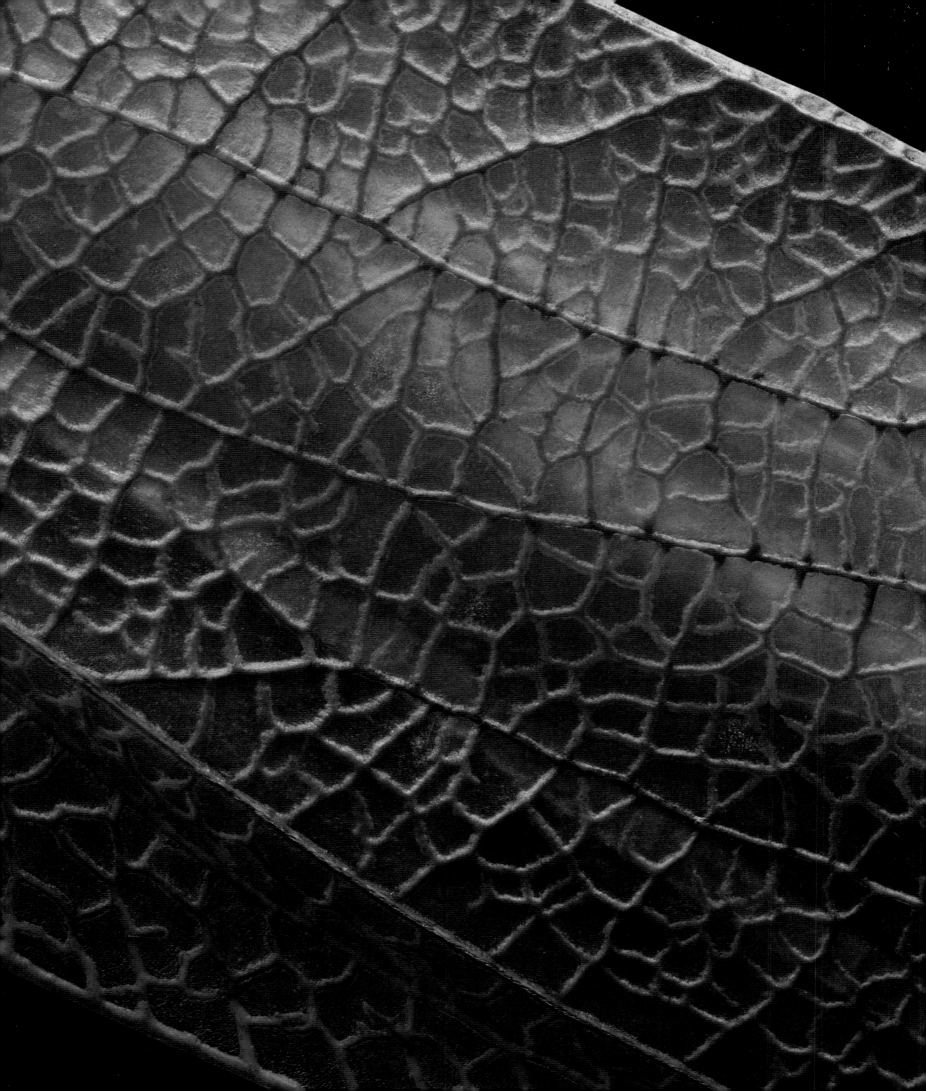

Acknowledgments

Extinct & Endangered was always a hugely ambitious project, and the results belong to the dedicated and talented individuals who unsparingly gave their energy and expertise.

First, I'd like to thank the American Museum of Natural History and say it was a privilege to partner with this great institution on *Extinct & Endangered*. In particular, I wish to express my gratitude to Lauri Halderman, who championed the project from day one with unfaltering energy. My only regret is that I cannot work with Lauri on all my projects. Dr. David Grimaldi stepped up as the enthusiastic entomology lead curator, while Eliza McCarthy crafted the story of each species in writing that is clear and vivid.

I'm grateful to many others at AMNH whose talents made this book possible: daily project coordination by Dina Langis, deft editing by Sasha Nemecek, research by Debra Everett-Lane and Allison Hollinger, and project management by Melissa Posen. Additional curatorial expertise was provided by Dr. James Carpenter, Dr. Lee Herman, and Dr. Jessica Ware. Scientific support in research, specimen preparation, and permitting came from Christine Johnson, Christine LeBeau, Ruth Salas, Corey Smith, and especially Suzanne Rab Green, whose dedication to this project was exceptional. Registrars Stephanie Carson and Heather Knapp facilitated international specimen loans; Denis Finnin, Corey Smith, and Stephen Thurston photographed specimens; Rhea Gordon provided legal support; and Dr. Michael Novacek and Dr. Scott Schaefer advised at key moments. Jennifer Caragiulo ably stewarded the project on behalf of AMNH institutional advancement.

Once again, I had the pleasure of working alongside Dr. James Hogan of the Oxford University Museum of Natural History. James selflessly agreed to receive the specimens sent to the U.K., and his willingness to come to our rescue—during the COVID-19 pandemic, no less—made these photographs possible.

New specimens of four captive-bred insect species were donated to the AMNH collections specifically for this project. Special thanks for these go to Dr. Rodger Gwiazdowski, University of Massachusetts Amherst; Lou Perrotti, Roger Williams Park Zoo; Dr. John Losey and Dr. Todd Ugine, Cornell University; and Paige Howorth, San Diego Zoo Wildlife Alliance, with the support of Hank Bower, Lord Howe Island Board.

At Abrams, the passion and expertise of editor Eric Himmel elevated this book to a new level, Darilyn Carnes provided the elegant graphic design, and Denise LaCongo shepherded the production.

Importantly, without the generous funding of Robert and Ipek Gibbins and Autonomy Capital, *Extinct & Endangered* simply would not have been possible. You believed in the project from the very start and stuck with us through challenging times. I will always be grateful.

Finally, I wish to thank Isla, Seb, and Elli. As always, your support whilst I embark on these long projects is invaluable, and you just make everything that little bit easier.

—Levon Biss

OPPOSITE: Northern bush katydid (see page 31).

Annotated Index of Insects

KEY
Common name, page number
 Scientific name
 Ecological status
 Size
 Conservation status
 AMNH specimen number
 Where found

Alpine longhorn beetle, 32–33
 Rosalia alpina
 Decomposer
 0.6–1.6 in (14–40 mm)
 Vulnerable (IUCN)
 AMNH_IZC 00292129
 France

American burying beetle, 126–129
 Nicrophorus americanus
 Scavenger, decomposer
 1.2–1.4 in (30–35 mm)
 Threatened (U.S. Fish and Wildlife Service)
 AMNH_IZC 00292284 and
 AMNH_IZC 00292285
 Rhode Island, U.S. (Roger Williams Park
 Zoo–reared)

Apacha sweat bee, 44–45
 Dieunomia apacha
 Pollinator
 0.6 in (15 mm)
 Vulnerable (NatureServe)
 AMNH_BEE 000244A A00
 Nebraska, U.S.

Aralia shield bug, 120–121
 Elasmostethus atricornis
 Herbivore
 0.35 in (9 mm)
 Vulnerable (NatureServe)
 AMNH_IZC 00263559
 Tennessee, U.S.

Blue calamintha bee, 64–67
 Osmia calaminthae
 Pollinator
 0.4 in (10 mm)
 Critically imperiled (NatureServe)
 AMNH_IZC 00328295
 Florida, U.S.

Christmas beetle, 2–3, 42–43
 Anoplognathus viridiaeneus
 Herbivore
 1.1–1.5 in (29–38 mm)
 Not listed
 AMNH_IZC 00292340
 Australia

Coral Pink Sand Dunes tiger beetle, 90–93
 Cicindela albmissima
 Predator
 0.4–0.6 in (11–15 mm)
 Critically endangered (IUCN)
 AMNH_IZC 00292135
 Utah, U.S.

Cousin tiger moth, 52–53
 Lophocampa sobrina
 Herbivore
 Wingspan: 1.95 in (49 mm)
 Vulnerable (NatureServe)
 AMNH_IZC 00368249
 California, U.S.

Elderberry longhorn beetle, 54–57
 Desmocerus palliatus
 Herbivore
 0.7–1 in (18–26 mm)
 Imperiled (Massachusetts, U.S.),
 Vulnerable (New Brunswick, Canada)
 (NatureServe)
 AMNH_IZC 00292130
 Massachusetts, U.S.

Esperanza swallowtail, 112–115
 Papilio esperanza
 Herbivore (as caterpillar),
 pollinator (as adult)
 Wingspan: 4 in (10.2 cm)
 Endangered (IUCN)
 AMNH_IZC 00329539
 Oaxaca, Mexico

European hornet, 72–75
 Vespa crabro
 Predator, pollinator
 1–1.4 in (25–35 mm, queens)
 Protected (Germany)
 AMNH_IZC 00238266
 Connecticut, U.S.

Florida dark cuckoo bee, 94–95
 Stelis ater
 Herbivore, social parasite
 0.4 in (10 mm)
 Imperiled (NatureServe)
 AMNH_BEE 000280966
 Florida, U.S.

Florida least spurthroat grasshopper, 34–37
 Melanoplus puer
 Herbivore
 0.4–0.8 in (10–21 mm)
 Vulnerable (NatureServe)
 AMNH_IZC 00321202
 Florida, U.S.

Giant Patagonian bumblebee, 4–5, 50–51
 Bombus dahlbomii
 Pollinator
 1.2–1.4 in (30–35 mm, queens)
 Endangered (IUCN)
 AMNH_IZC 00328297
 Concepción, Chile

Hawaiian hammerheaded fruit fly, 104–107
 Idiomyia heteroneura
 Herbivore
 About 0.25 in (6 mm)
 Endangered (U.S. Fish and Wildlife Service)
 AMNH_IZC 00329551
 Hawaii (from culture)

Hourglass drone fly, 18–19
 Eristalis brousii
 Pollinator as adult, decomposer as larva
 Wingspan: 0.4–0.5 in (9–13 mm)
 U.S. (Possibly extinct), Canada, Manitoba:
 Critically imperiled (NatureServe)
 AMNH_IZC 00329561
 Colorado, U.S.

Johnson's waterfall ground beetle, 68–69
 Pterostichus johnsoni
 Predator
 0.7 in (17 mm)
 Sensitive (Oregon–Washington)
 AMNH_IZC 00292136
 Oregon, U.S.

Lesser wasp moth, 60–63
 Pseudocharis minima
 Pollinator, Herbivore
 Wingspan: 1.2–1.4 in (30–36 mm)
 Vulnerable (NatureServe)
 AMNH_IZC 00329555 and
 AMNH_IZC 00329556
 Florida, U.S.

Lord Howe Island stick insect, 116–119
 Dryococelus australis
 Herbivore
 4.3–7 in (11–18 cm)
 Critically endangered (IUCN)
 AMNH_IZC 00329546
 Australia (Reared at San Diego Zoo from
 eggs imported from Melbourne Zoo
 in 2016.)

Louisiana eyed-silkmoth, 6, 58–59
 Automeris louisiana
 Herbivore
 Wingspan: 2.5–3.5 in (6.4–8.9 cm)
 Imperiled (NatureServe)
 AMNH_IZC 00329553
 Louisiana, U.S.
Luzon peacock swallowtail, 122–125
 Papilio chikae
 Herbivore (as caterpillar),
 pollinator (as adult)
 Wingspan: 3.7–4.3 in (9.5–11 cm)
 Endangered (IUCN)
 AMNH_IZC 00329537
 Luzon, Philippines
Madeira brimstone, 10, 132–135
 Gonepteryx maderensis
 Herbivore (as caterpillar),
 pollinator (as adult)
 Wingspan: 2–2.4 in (5–6.1 cm)
 Endangered (IUCN)
 AMNH_IZC 00329542
 Madeira
Madeiran large white, 130–131
 Pieris brassicae wollastoni
 Herbivore (as caterpillar),
 pollinator (as adult)
 Wingspan: 2–2.5 in (5–6.4 cm)
 Critically endangered (IUCN)
 AMNH_IZC 00329543
 Madeira
Monarch butterfly, 114–117
 Danaus plexippus
 Herbivore (as caterpillar),
 pollinator (as adult)
 Wingspan: 3–4 in (7–10 cm)
 Endangered/threatened (candidate)
 (U.S. Fish and Wildlife Service)
 AMNH_IZC 00368246 and
 AMNH_IZC 00368247
 Connecticut, U.S., New York, U.S.
Mount Hermon June beetle, 82–85
 Polyphylla barbata
 Herbivore
 0.8 in (20 mm)
 Endangered (U.S. Fish and Wildlife
 Service)
 AMNH_IZC 00292220
 California, U.S.
Nevares Spring naucorid bug, 11–13
 Ambrysus funebris
 Predator
 About 0.25 in (6 mm)
 Critically imperiled (NatureServe)
 AMNH_IZC 00224027

California, U.S.
Ninespotted lady beetle, 24–25
 Coccinella novemnotata
 Predator
 0.2–0.3 in (5–7 mm)
 Special concern (New York State);
 Endangered (Canada)(COSEWIC)
 AMNH_IZC 00292341 and
 AMNH_IZC 00292342
 New York, U.S. (lab reared)
Northern bush katydid, 30–31, 140
 Scudderia septentrionalis
 Herbivore
 0.8–1.5 in (20–37 mm)
 Vulnerable (NatureServe)
 AMNH_IZC 00321206
 Pennsylvania, U.S.
Phaeton primrose sphinx moth, 100–103
 Euproserpinus phaeton
 Pollinator, Herbivore
 1.3–1.6 in (32–42 mm)
 Vulnerable (NatureServe)
 AMNH_IZC 00329558
 California, U.S.
Puritan tiger beetle, 76–77
 Ellisoptera puritana
 Predator
 0.4–0.6 in (10–15 mm)
 Threatened (U.S. Fish and Wildlife Service)
 AMNH_IZC 00292283 and
 AMNH_IZC 0029286
 Connecticut, U.S.
Raspa silkmoth, 20–23
 Sphingicampa raspa
 Herbivore
 Wingspan: 2.6–3.2 in (6.6–8.2 cm)
 Imperiled (NatureServe)
 AMNH_IZC 00329554
 Mexico
Rocky Mountain locust, 136–139
 Melanoplus spretus
 Herbivore
 1.1–1.4 in (30–36 mm)
 Extinct (IUCN)
 AMNH_IZC 00343433 and
 AMNH_IZC 00343435
 U.S.
Sabertooth longhorn beetle, 96–99
 Macrodontia cervicornis
 Decomposer
 3.9–7 in with mandibles (10–17.7 cm)
 Vulnerable (IUCN)
 AMNH_IZC 00292290
 Brazil
San Joaquin Valley flower-loving fly, 86–89

 Rhaphiomidas trochilus
 Pollinator as adult, predator as larva
 1–1.4 in (25–35 mm)
 Critically imperiled (NatureServe)
 AMNH_IZC 00329562
 California, U.S.
Seventeen-year cicada, 46–49
 Magicicada septendecim
 Herbivore
 1.1–1.2 in (27–30 mm)
 Near Threatened (IUCN),
 Secure (NatureServe)
 AMNH_IZC 00131214
 Pennsylvania, U.S.
Shining Amazon ant, 78–81
 Polyergus lucidus
 Scavenger, social parasite
 Up–0.3 in (4–7.7 mm, workers)
 Vulnerable (IUCN)
 AMNH_IZC 00177686 and
 AMNH_IZC 00177688
 New York, U.S.
Stygian shadowdragon, 108–111
 Neurocordulia yamaskanensis
 Predator
 1.8–2.2 in (4.6–5.6 cm)
 Critically imperiled (Mississippi, other
 states, U.S.), Apparently secure
 (Ontario, Canada) (NatureServe)
 AMNH_IZC 00329548
 Ontario, Canada
Thick-horned plant bug, 70–71
 Pronotocrepis clavicornis
 Herbivore
 0.2 in (5 mm)
 Imperiled (NatureServe)
 AMNH_PBI 00058377 and
 AMNH_PBI 00058442
 California, U.S.
Xerces blue butterfly, 26–29
 Glaucopsyche xerces
 Pollinator, Herbivore
 Wingspan: 1.1–1.2 in (27–30 mm)
 Extinct (IUCN)
 AMNH_IZC 00329559 and
 AMNH_IZC 00329560
 California, U.S.
Yellow-edged pygarctia moth, 38–41
 Pygarctia abdominalis
 Herbivore
 Wingspan: 1.2–1.6 in (30–40 mm)
 Vulnerable (NatureServe)
 AMNH_IZC 00368248
 New Jersey, U.S.

Editor: Eric Himmel
Designer: Darilyn Lowe Carnes
Managing Editor: Glenn Ramirez
Production Manager: Denise LaCongo

Library of Congress Control Number: 2022933710

ISBN: 978-1-4197-5963-5
eISBN: 978-1-64700-860-4

Printed and bound in the United States
10 9 8 7 6 5 4 3 2 1

Abrams books are available at special discounts when
purchased in quantity for premiums and promotions as
well as fundraising or educational use. Special editions
can also be created to specification. For details, contact
specialsales@abramsbooks.com or the address below.

Abrams® is a registered trademark of Harry N. Abrams, Inc.

ABRAMS The Art of Books
195 Broadway, New York, NY 10007
abramsbooks.com